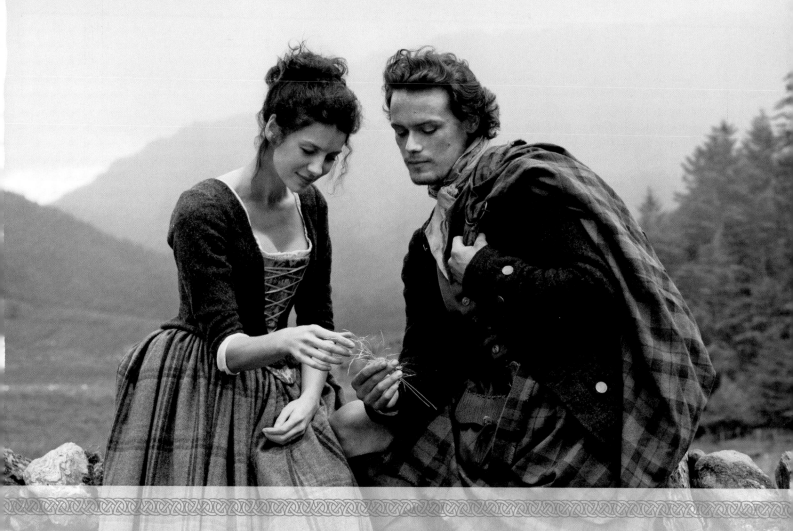

THE MAKING OF
OUTLANDER

THE SERIES

TARA BENNETT

SONY
PICTURES
TELEVISION

DELACORTE PRESS | New York

THE MAKING OF
OUTLANDER

THE SERIES

THE OFFICIAL GUIDE TO SEASONS ONE & TWO

The author would like to especially thank Ron Moore, Maril Davis, and Terry Dresbach for being so gracious in welcoming us into their creative fold. Thanks to the entire writing staff, for their time and stories, as well as to *Outlander's* family of cast and crew, who were incredibly giving of their time. A special thanks to Diana Gabaldon for her interview, her lovely introduction, and for writing the *Outlander* books that captivated me years ago.
A great many assisted in helping this book come to life; thanks in particular to: Christopher Lucero, Jessica Nubel, Chris Van Amburg, Kathryn Thompson, and Robyn Harney at Sony. Wendy Kidd, who helped coordinate the talent interviews. Ben McGinnis and Richard Kahan from the Tall Ship Productions office. John Grannan from Bear McCreary's office. My dear friends Hope Willis, for her speedy fingers, and Alex Falcone, for his French translation. Anne Speyer, for her encouragement and editorial leadership. My cousin Denise Vannoz, who gifted me a signed copy of *Voyager* when it first came out, thus igniting my *Outlander* love. Kerry Trainor, Petra Deluca, and my mom, for their *Outlander* love and feedback. And, last but never least, my frequent collaborator, Paul Terry, who kept me going when I was exhausted and never fails to inspire me to do more than I can imagine.

Published in the United States by Delacorte Press, an imprint of Random House,
a division of Penguin Random House LLC, New York.

DELACORTE PRESS and the HOUSE colophon are registered trademarks of Penguin Random House LLC.

ISBN 978-1-101-88416-4
ebook ISBN 978-1-101-88417-1

Printed in the United States of America on acid-free paper

randomhousebooks.com

2 4 6 8 9 7 5 3 1

First Edition

Endpaper background image by iStock.com/Pierrot46
Book design by Caroline Cunningham

CONTENTS

SEASON ONE

SEASON TWO

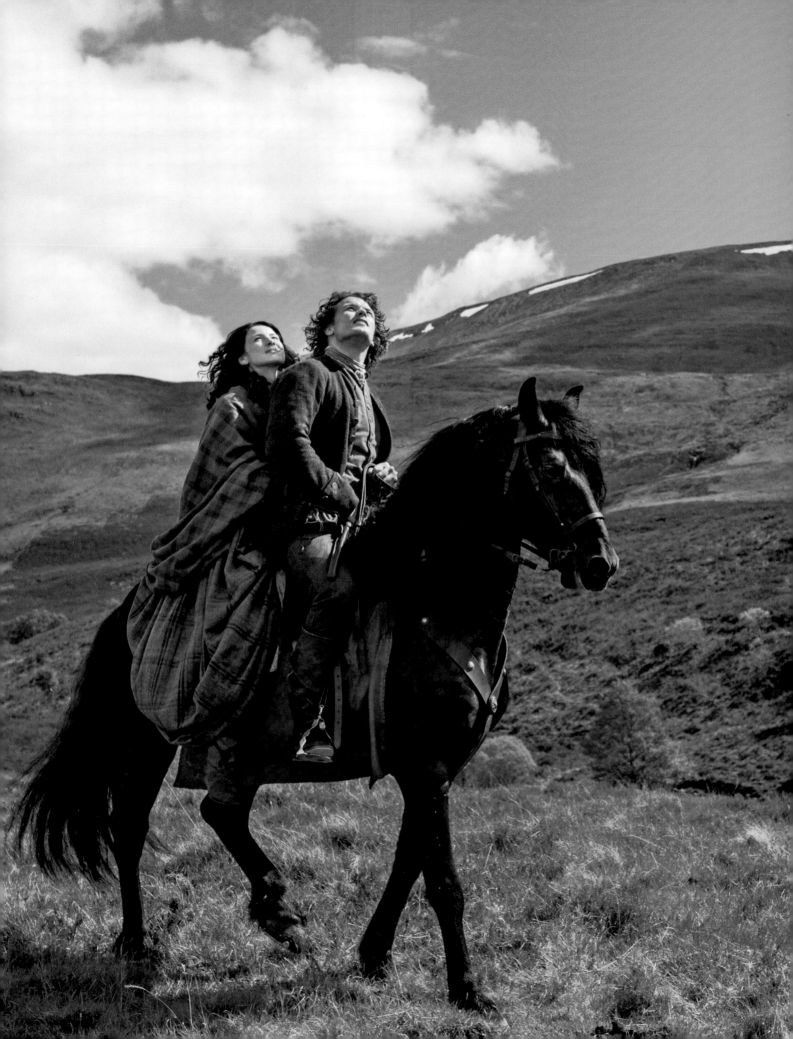

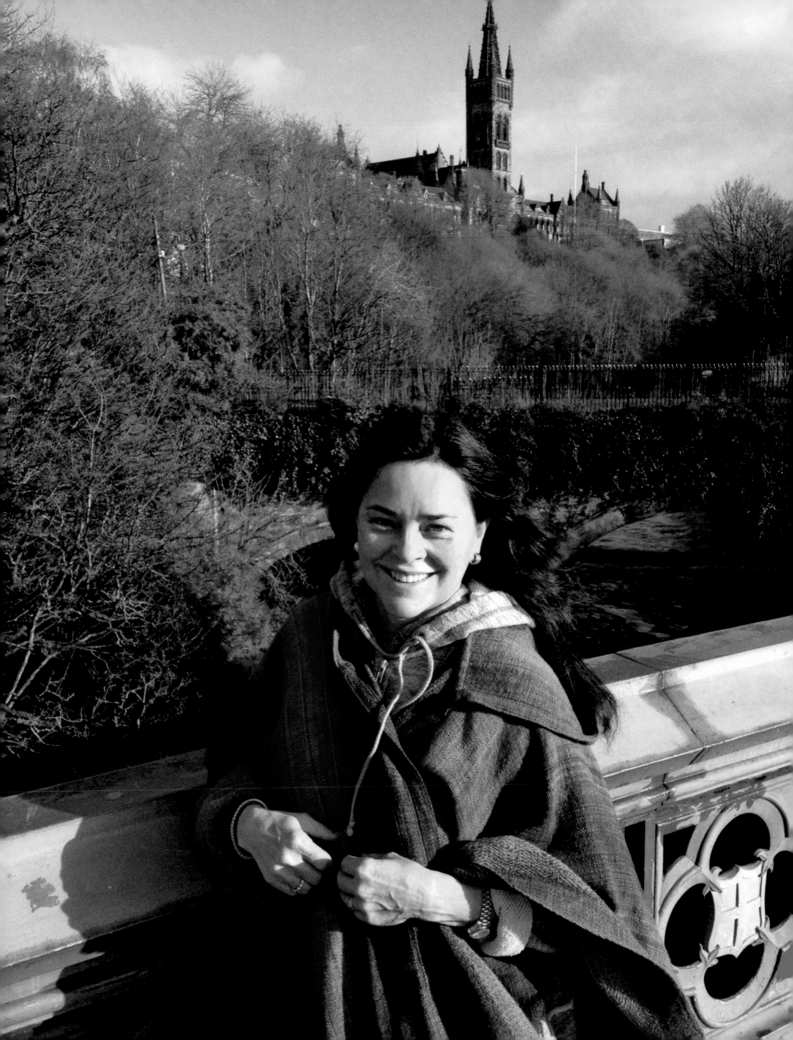

INTRODUCTION

DIANA GABALDON

I get a lot of totally undeserved praise for the *Outlander* show. Granted, I *did* write the books. And I did give the world Jamie, Claire, and Black Jack Randall (and a few hundred-odd other people). But my only part in the evolution of this fantastic show was to be Extremely Lucky.

"You were so smart to hold out for Ron!" all the fans exclaim. "How did you approach him? Or did he come looking for you?"

To be perfectly honest, I'd never heard of Ronald D. Moore prior to the film rights being acquired by Sony and hadn't the slightest idea what a showrunner was or what one might do.*

So what *did* happen?

Well, you've probably heard of a film option. In essence, this means that a production company pays a writer a modest amount of money in return for a period of time. During this period, the producer has the exclusive right to kill themselves trying to put together the necessary financing, staffing, and logistical package needed to make whatever film adaptation they have in mind.

If they succeed, they pay you a slightly larger sum, which is the purchase price of the film rights. (Thereafter, they own it in perpetuity, throughout the universe, forever.† You'll never get it back.)

This is a hard thing to do, though, and most options lapse without anything happening. But

there's always an outside chance that one *will* come to fruition—and this is why you don't want to do option agreements with people unless you trust them to *do* a reasonable adaptation of your work.

Frankly, most film people don't have the slightest intention of making a faithful adaptation of your work, though some are more honest than others about saying so. It therefore behooves a writer (and a writer's agents) to be careful about whom you do options with.

That being so, in spite of constant requests, we'd optioned the books only four times since *Outlander* was published in 1991. The first three options lapsed without result, as expected. The fourth was a guy named Jim Kohlberg.

We liked Jim (and we still do); he'd made some very good small films, he genuinely loved the book,

* When people would ask me how I managed to write books while holding down multiple jobs and raising a family, I'd give them the stock answer: "I don't do housework, and I don't sleep. Also, I don't watch television."

† No kidding, this is actually what the contract says.

and he had a lot of persistence. I did tell him (as I've told people for the last twenty-five years) that I didn't think it was possible to make a two-hour movie out of *Outlander* that had anything to do with the actual book—but he had my blessing to try.

And try he nobly did, through several years, several option renewals, and several scripts done by really good scriptwriters. Let's just say that I was right about the two-hour-movie thing.

Somewhere in this process, though, a lightning bolt hit the biological soup in some remote primordial swamp, and something new stirred in the depths. . . .

Ron Moore finished *Battlestar Galactica* and began looking for a new television project that he could be passionate about.

Introduced to *Outlander* by his production partner, Maril Davis (backed up by his wife, Terry Dresbach, who'd also read and loved the books), Ron read it and got interested. He found out who had the option on the books and called Jim. Jim still wanted to make a two-hour movie, and Ron, ever a patient man, bided his time, he or Maril calling back every six months, until at last Jim conceded that it *might* be a TV show.

And lo, Sony spake, the ground shook, and . . .

. . . two *years* of intense negotiation ensued, ending up (finally) in a baroque five-sided agreement involving Sony, Ron, Jim Kohlberg, Starz, and . . . me.

I didn't know Ronald D. Moore from a hole in the ground at this point (in all fairness, he didn't know me from a hole in the ground, either . . .). But he wanted to make a ten-episode TV show out of *Outlander,* and that was obviously a more feasible prospect than a two-hour movie, so I was all for it.

Very slowly, things started to happen. Ron and Maril, bless them, came out to my house and spent two days talking through characters, story lines, backstory, my thoughts on things, their thoughts on things . . . and we turned out to be very much on the same wavelength as to what constituted a good story.[‡]

And then Starz took on the show and things started happening faster. Actors began to be cast, a studio was being built in Scotland, and suddenly it all started to be Real.

And the fans, who had been waiting impatiently for twenty-five years to see a screen version of the story they loved, went *nuts.*

About two months after Sam Heughan was cast to play the part of Jamie Fraser, when the fans' demonstrations of enthusiasm and creativity online began to be Truly

[‡] As I told Ron when he showed me the pilot script he proposed to take to the networks, "This is the first *Outlander* script I've ever seen that didn't make me turn white or burst into flame."

Visible, Sam emailed me and asked, *What will they do when they actually see the show?*

To which I replied, *Either they'll collectively wet their pants, or they'll march down the street waving torches and demanding Ron's head on a pike.*

You know, if there's something you want urgently to do in life—do it. The universe will usually come out to meet you. In my case, I knew I was meant to write novels, and when I was thirty-six—about the age Sam and Caitriona Balfe are now—I took my courage in both hands and wrote a novel. And, among other things, the universe brought me a TV show.

Along with it came the acquaintance—sometimes the friendship—of a lot of magic people. Not only Ron and Maril and Terry, not only Sam and Cait and Tobias Menzies and Graham McTavish and Lotte Verbeek and Gary Lewis . . . but all of you who've loved the books for so long and have longed to see them brought to life.

It's your love—all of you: the fans, the producers, the actors, the crew—that's made this happen. All I did was open the door.

So now it's open, and the world can come in. And I can't say more than I did the night of the first premiere in San Diego: "Ladies and gentlemen . . . you've done me proud."

Nice to know that Ron's head is safe, too. . . .

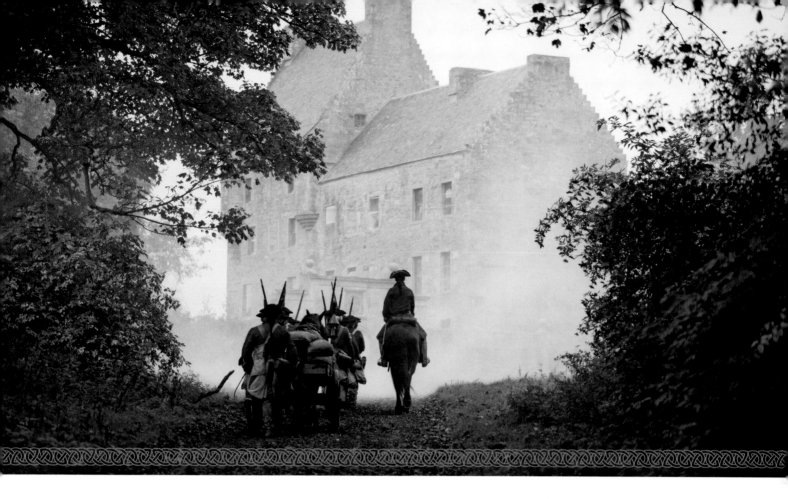

OUTLANDER: THE ORIGINS

"Will we ever get to see *Outlander* adapted for the screen?"

Since the novel first came out in 1991, author Diana Gabaldon has fielded that question from enthusiastic readers almost daily. The story of Claire Beauchamp Randall and Jamie Fraser seemed an obvious choice for a cinematic retelling, but the project was not without its logistical challenges. With the novel weighing in at more than 600 pages, the core dilemma always centered on how much of the action-packed adventure would have to be cut just to fit the traditional cinematic window of two hours. With too much to lose to the proverbial cutting room floor, the world of *Outlander* remained strictly in the realm of print.

It wasn't until around 2010 that a possible solution started to present itself: a television series. Maril Davis, a development executive/co-executive producer for Ronald D. Moore's Tall Ship Productions, was looking for potential properties to produce and had the books recommended to her by friend and softball teammate Matthew B. Roberts.

"[Roberts] had read the books as a reader during one of his first jobs," Davis explains. "He passed on

the books because they wanted to do movies but told me they would be great for TV. I took him up on that and read them all the way through.

"I loved them," Davis says with unabashed adoration. "This to me was my passion project."

But the television landscape at the time wasn't yet the haven for high-concept sci-fi series it seems to be today. "*Game of Thrones* was not on at that point. Ron had tried to do *Dragonriders of Pern*. It just didn't feel like the timing was right."

Cut to a personal dinner Davis was having with Moore and his wife, Terry Dresbach, where the three started talking about the projects they had always longed to do. "I said, 'My passion project is this book series called *Outlander*, and I would love to do them,'" Davis recalls. "I didn't realize Terry was also a fan. So we talked, and Ron seemed intrigued."

"Terry and I talked about it after the dinner a few times," Moore remembers. "But it wasn't really until I sat down and started reading the book that I saw the potential." From that first read, he says, he was struck by how Gabaldon's writing kept surprising him. "By the time I got to the end of the book, there had been some significant twists and turns that I didn't see coming. In my head, I could definitely see a season of television and how it works through a season. Plus the fact that, at that point,

there were multiple books in the series just meant that it had a life beyond season one. I remember thinking, *If the other books are anywhere near as good as this, then essentially I'm in.*"

Davis was thrilled to get the go-ahead to pursue. "I got in touch with the rights holder, Jim Kohl-

berg. We had a great meeting, but it was very obvious that they wanted to do this book series as films." Davis left the meeting convinced a film would not do justice to the books. "Reluctantly, we walked away," she says.

"But I was like a dog with a bone," she continues, laughing. "I just kept checking back every once in a while. One of the times, they were open to doing TV. So Ron and I went back in there and had a fabulous meeting, and it kind of started there."

Davis says they pitched Chris Parnell, executive vice president of Sony Pictures Television, to be their studio partner, but he was un-

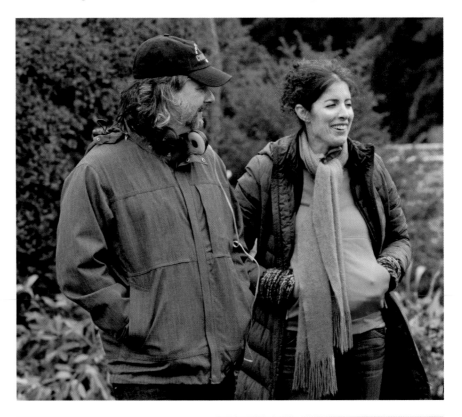

Ron Moore and Maril Davis

familiar with the books. "To his credit, Chris went out and bought the book on tape and listened in his car, which was so cute," she says. "He would call me every once in a while and be like, 'I am sitting in my car blushing,' which was hilarious." By the book's end, Davis says, Parnell was on board and ready to champion the show to the networks.

The next step for Moore and Davis was to officially visit Gabaldon at her Scottsdale, Arizona, residence. "Just from the fan perspective, not even a producer perspective, I felt it was so important to get her approval," Davis says. "I wanted her approval and just to make sure she was comfortable that this book was in the right hands. I wanted to assure her that we weren't trying to exploit it and we understood what it was. There was Ron's track record, certainly as an amazing writer but also as someone who obviously writes very strong female characters, from *Battlestar Galactica* to *Carnivàle*. I also wanted her to know that I was going to protect the series as well, it being so close to my heart and near and dear to me."

For Gabaldon, having the books in serious development after so many years of thinking it couldn't work was beyond surprising. "People are always asking, 'Why is it that you held out for Ron?' The truth is that I didn't," she says with her trademark candor. "We were

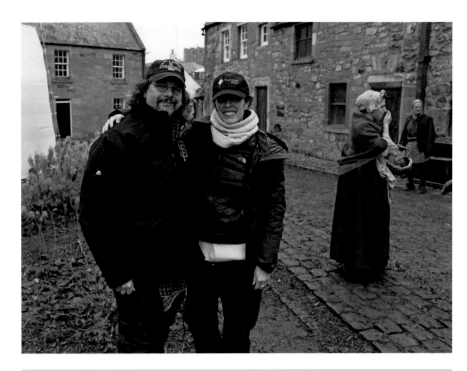

Ron Moore and Maril Davis on location for Season Two

very careful who we did options with, because there was always a possibility that they would succeed. In which case, you will never get the rights back. We had done this only four times and, luckily, none of the first three times took."

But it seemed an *Outlander* series was finally about to happen in earnest. Gabaldon recalls that she was very curious about the pair who made it happen. "They came and spent two days with me at my house, talking over story lines, characters, and backstory. Asking had I written anything that wasn't in the books that they should be aware of? Where did I see the story going? Ron was sharing with me his vision of storytelling and what he thought of the characters. I could tell that we were pretty much

on the same wavelength with regard to the importance of a central character in a story, which predisposed me to him."

Gabaldon was also impressed during those initial meetings by the clarity of the vision Moore had for the series. "He began to share his own philosophy and his take on how things would work," she goes on. "He said he would like to start [the series] with a little visual prologue that takes place before *Outlander* [the book] actually starts. He'd show Claire during World War II in a military hospital out in France, saving people's lives. She is a central character, and we need to fix her in people's consciousness immediately as the main person of interest. And I am sort of nodding as he is saying all this and going, 'Yes.

You are right.' I could tell he did know what he was doing and I approved the direction he saw for doing it.

"I gave them my blessing to start the script the way Ron wanted to," Gabaldon explains. A few days later, Moore sent over his pilot script. "I told him when I read it, this is the only thing that I have ever read based on my own work that didn't make me turn white or burst into flames, so I was favorably impressed."

Moore says gaining Diana's favor gave them reassurance that they were taking the right direction with her work, which he felt was important given how devoted the series' readers have proven themselves to be over the years. "We really wanted to engage and keep the fan base that was already there from the books and transfer them over to the TV show," Moore explains. "Diana had her finger on that pulse for many, many years. She knew them pretty intimately, communicated with them, and had a good sense of what was important to them. She was a good indicator of where we were. She kept us in the lane."

For Davis, Gabaldon's approval gave the series the ability to credibly move forward. "I don't know if we could have gone ahead, in my mind, without her approval in some way. We didn't technically need it, because obviously at that point we

had secured the rights. But I think for me, having her approval and having her on board with what we were doing was incredibly important, and I don't think we could have done it without her."

Finding the right home for the show was the next step, which required the ever-growing Team *Outlander*—at this point comprised of Davis, Moore, and Parnell as well as Sony executives Jamie Erlicht and Zack Van Amburg—to once again pitch the idea. But Davis says Starz impressed from the very first meeting. "We would walk into every pitch meeting—me, Ron, the Sony executives—with this huge stack of [Diana's] books to show them how much material there was. Starz was the only place we went that they had actually read the first book and were the only ones that also said to us, 'We want you to stick to the books.'" Following that

meeting, *Outlander* the television series was officially greenlit in November 2012 for development and a pilot.

Almost two years later, after hiring a writers' room in Pasadena, California, setting up a transatlantic production in Scotland, and casting the characters readers had been picturing in their minds' eyes for over two decades, Moore was able to share with Gabaldon the first footage of her world brought to life. Gabaldon remembers that it was behind the scenes at an *Outlander* fan event in January 2014 when Moore asked if she'd like to take a look. "I said, 'Yeah, I would.' He had it on his laptop and we were all sitting back there on this ratty old sofa. He opened his laptop and that is where I saw the first few scenes of *Outlander*. I was totally fascinated. It was beautiful and it was terrific."

Just shy of twenty-three years from when Gabaldon first put to paper her story about a woman traveling back in time through standing stones, that story was taking on a new form, as actors breathed life into the beloved characters and the vast beauty of Scotland served as its backdrop. *Outlander*, the series, takes the story of Claire Beauchamp Randall and James MacKenzie Fraser into a whole new realm, and in this book, that journey is our story. . . .

IN THE WRITERS' ROOM

The writers' room is the creative spine of any scripted television series. From it, all things are made. So when Ron Moore and Maril Davis set their sights on hiring the people who would write and produce each episode, they put a lot of thought into the creative balance of the series.

While Ron Moore is a veteran showrunner (*Battlestar Galactica*), *Outlander* was his first experience in adapting a TV series from a book, to say nothing of the pressure of pleasing the enthusiastic and exacting fandom that would be coming to the series from Gabaldon's books. Fortunately, his co−executive producer, Maril Davis, was a fan herself and relished the task of creating a series that readers would embrace.

"It was really important to do the fan/non-fans split in the room, because basically that's what you argue about when you are breaking the stories," Moore says. "You want to have the argument front and center about what is critical to the book and what can be changed without changing it too far—it was really important that we had both perspectives in the room so that we could get a coherent line of thought as we were structuring everything.

"Beyond that, I thought conceptually that I wanted a room that was half men and half women," Moore adds. "I thought that would be an important part of the mix, as it's a female narrative story written by a woman. Then it was just about figuring out who the players were."

Moore and Davis first looked to collaborators they had worked with before, including Matthew B. Roberts, who introduced Davis to the book years before. "Matt had come out of the *Caprica* [writers' room]," Moore explains. "He and I had developed and written a couple

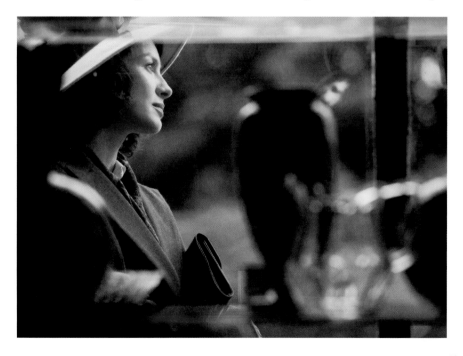

pilots together. So even though we had never formally been on the same staff before, I had a good sense of Matt and what his skill set was."

"He was a no-brainer, along with the fact that he is a male [book] fan, which was really important to us," Davis adds. As it turns out, Roberts also assumed the mantle of second-unit director, responsible for the episodic title-card segments and any needed pickup shots throughout the production year.

"Toni Graphia was somebody I had worked with on several shows, like *Roswell*, *Carnivàle*, and *Battlestar Galactica*," Moore says. "I really like her and thought this would be something she would cotton to.

"With Ira Behr, I had worked with him at *Star Trek* for many years, but then we had not worked on a project since that point," Moore explains. "He adds a completely different sensibility, which is great because he is not your typical fan," Davis says.

Last but not least was Anne Kenney. "She and I had never worked together directly, but Matt Roberts and I had gone out to pitch a series that the two of them had come up with, and they brought me into the development process," Moore says. "I thought she was smart, a good writer, and *Outlander* was a good fit for her."

Moore's last requirement was that each of them needed to be writer/producers, working in Scotland to help produce episodes on location. "They definitely had to

have that as part of their skill set, and each of them did," he adds. "Each of them had been in the business long enough and had enough familiarity with production that I felt confident that we could make this work."

When the Scotland production team was in place, producer David Brown suggested a block-shooting schedule, which would create a more efficient system for the aggressive filming needs of the series. Such a schedule, in which two episodes are shot together over five weeks, enables pre-production to have enough time to prepare for the two-episode block that follows.

"I would be lying if I didn't say this was by far the hardest show we have ever worked on," Davis says. "So you need some sort of consis-

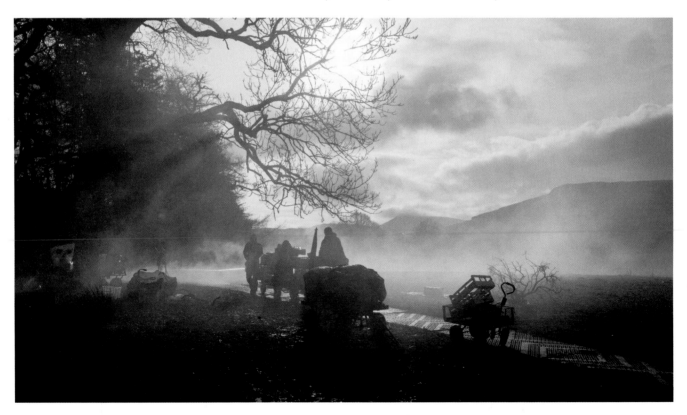

tency." The block system fulfills that need by assuring that each block is supported by at least one writer/producer who is there for the entire five weeks. "Because it is such a serialized show and such a complicated backstory, the writers are really the keepers of the flame in some ways," she adds. "We feel it's necessary that the director works with the writer/producer all the way through prep and production."

While filming is under way, Moore and Davis fly back and forth between the *Outlander* writers' room in Los Angeles and the Scottish production studio, sometimes multiple times a month. As season two progressed, Moore decided to spend more time in postproduction, finishing episodes on time and to his satisfaction. "I am

one of the few [executive producers] that follow the episode production from nose to tail, from the initial story and story breaks all the way to final delivery." Once Moore saw what his staff was accomplishing in the field, relinquishing some time in Scotland made sense. "You have to trust and empower the people who work for you to carry out those plans and to trust their creative takes on individual pieces," Moore says. "Sometimes that writer knows what has to happen in that script better than I do, because they have lived with it."

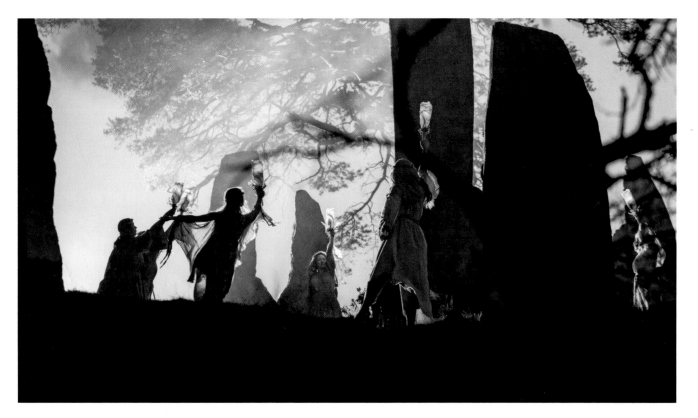

THE JOURNEY FROM BOOK TO SCREEN

CASTING

For two decades, Diana Gabaldon's *Outlander* novels existed exclusively on the page and in readers' heads. Fans had free license to imagine their own Claires, Jamies, Murtaghs, et al., mentally casting and recasting based on Diana's descriptions, celebrity crushes, or doppelgänger acquaintances until the cows came home. As with any beloved book or series, everyone has their own mental picture of what those characters look like. And suddenly the show's producers and the series' casting team had to find real-life actors to be the public, official face of those characters, shouldering a Mount Everest–size burden of fan expectation.

As one of those longtime readers and fans, executive producer Maril Davis felt the responsibility keenly as they embarked on the casting process with Emmy-winning casting director Suzanne Smith (*Band of Brothers*). "I love casting, but, normally, when we go into a project I pretty quickly have a prototype in my head of who some of these characters are," Davis details. "This is the first time I think I have approached a series where I literally had no idea in my head, because Jamie and Claire had been *in* my head for so long. That was a little daunting when we started the process."

From her London-based casting office, Smith admits she had not been familiar with the books before she began work on the show, which enabled her to approach the process with a clean mental slate. She was, however, very aware of how invested the fandom was in who these characters were and who should play them. "I know the fans have an idea that it has to be a certain set of eyes," she says, explaining that fans often focus on the physi-

cal descriptions provided in the books. "But it is the acting that comes into it and what each of those actors brings to the table."

Smith adds that often means that a high-profile actor who might seem like a dream casting might not be right for the role, or available, or even interested in a television series. "Sometimes 'names' are mentioned," she says of early casting talks. "Other times I mention names and then bring them in, or sometimes we get show reels for more-prominent actors. The lovely thing about Starz and Sony was I was given the opportunity to cast unknowns, which is wonderful, because casting is a bit like a jigsaw puzzle. Sometimes names take away from a character."

As it turns out, primary casting did lean toward unknowns and character actors, in part because Smith made it a priority to bring a

sense of authenticity to the casting. "We have utilized a lot of Scottish actors," she says. "There are some actors who are not Scottish pretending to be Scottish, but a Scottish friend of mine said their accents are great. I have a casting associate who is with a casting director up in Scotland, so we work together in tandem to create everything, and we discuss it with our writer/producers."

When it came to casting the core three characters—Jamie, Claire, and Black Jack/Frank—Davis and Smith said they were prepared to cast wide nets and potentially commit to a long search. Jamie, in particular, was assumed by all to be the casting unicorn of the bunch. "I said to Ron that there's no way we're going to find Jamie," Davis laughs. "We call Jamie 'the King of Men' in the writers' room. So it's strange that we found him so quickly."

When they released the casting call for Jamie, a process that Davis explains involves her and the writers collaborating on a character description and sending it out into the world, piles of taped auditions came back from actors around the globe, including from Scottish actor Sam Heughan.

"We saw Sam and we really liked him," Davis enthuses. The writers discussed his audition, which then prompted Davis and co-executive producer Ira Behr to book a Skype interview with Heughan. "We thought he was really good and we wanted to give him a little feedback about doing a scene. As soon as we got on the Skype call with him and I talked with him, I was like, 'Oh my God, he is so charming,'" Davis laughs. "Sam is naturally very charming and in some ways has a lot of Jamie there." Not long after, Heughan earned the title of first actor cast on *Outlander*.

Next came the alt-Randalls. Smith says she knew British theater and television actor Tobias Menzies very well from previous casting and asked him to audition. "He read a scene for Black Jack and he read a scene for Frank so [producers] could see the two sides to the characters," Smith details. "The Black Jack scene was quite long, as it was the interrogation scene with Claire. He did it seamlessly." Menzies was given some notes and a new scene to read for showrunner Ron Moore. "Ron met him, and we did a studio test with just him and some of the scenes. From that, he was chosen. It was very quick. Sometimes it's like that."

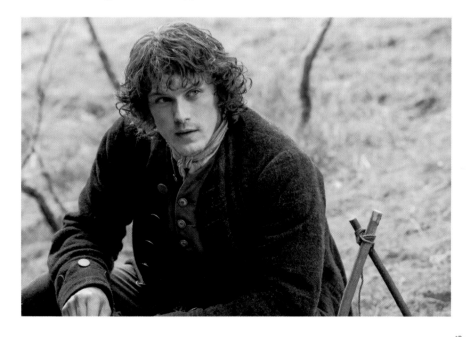

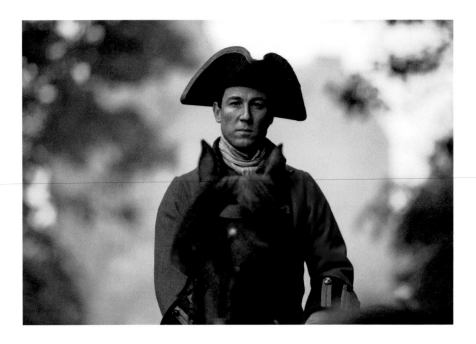

do the series. We will be dead before we start.'"

Producer Toni Graphia had seen pictures and video clips of Irish actress Caitriona Balfe online and, intrigued by her potential, flagged her audition tape for a second look. She was asked to do another self-tape, which Smith says made them decide to bring her in for a chemistry read with Heughan. When they first put the two actors together in a room, it was clear that the show had found its Jamie and Claire.

Moore says Balfe was committed to her role from the start. "You could see she was in it," he says, recalling the first day of filming. "Then in the scenes with Frank, there was a charm and fun to it. Then her running to the woods in the white shift. Then her scene with Jack Randall. With Cait, it was very apparent, very quickly, that this was going to work. She's it," he enthuses.

And, no, the violence and incredible darkness of Black Jack Randall's character was never a concern for either Smith or Menzies, Smith offers. "Starz asked me to ask Tobias and his agent whether he would be uncomfortable playing a sadist." She smiles. "He laughed and said, 'Of course not.' British actors don't think of it that way, because they want to be stretched. They know when it comes down to it that it will be handled in the right way."

With Jamie and Black Jack cast, all that was left of the core three characters was arguably the linchpin of the entire series, Claire Beauchamp Randall, and for some time she was nowhere to be found. "Weirdly, I thought she would be easier to cast, and I was so wrong," Davis reveals. "There are so few great parts like this for women, but so many amazing female actresses, I just assumed that we would find our person. We saw some amazing people, so that was not even a question, but it just wasn't Claire. I remember Ron and I were sitting in our office in Scotland and we were literally three weeks away from shooting and we didn't have Claire yet. We had a couple of female actresses on hold and said, 'If we don't get Jamie and Claire right, we might as well not

LOCATIONS

While Diana Gabaldon's original novel is set in Scotland, it wasn't clear from the start that filming there would ever be possible. The location, as with any show, would ultimately be decided by many factors, including budget, available crew, stage facilities, and a myriad of other issues. At various times, Eastern Europe and New Zealand were both in the running to simulate the Highlands, until Moore was able to persuade the network and studio to commit to filming in the wilds of Scotland.

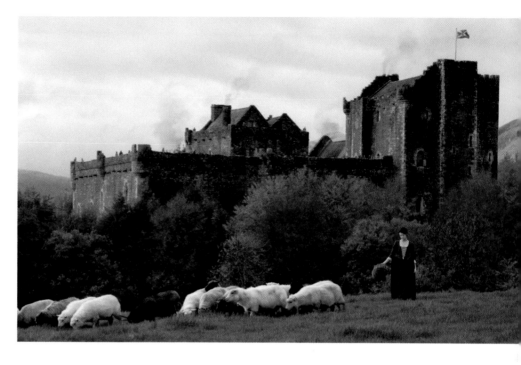

"The show is a love letter to Scotland in a lot of ways," Moore says. "It's a specific country with a specific look to it. We talk a lot with the director of photography, Neville Kidd, about the quality of light."

As a native of the country, Kidd was eager to present his home as one of the main characters of the show. "The good thing about *Outlander* is that there's very little of Scotland that has been filmed for U.S. television," he says. "So I think you generally feel like this is a new world that nobody has filmed or seen before."

In addition to showcasing his beloved country, Kidd says, he also wanted to keep the series feeling true to its eighteenth-century setting. "In 1743, it's an environment with no pollution," he explains. "Everything was very clean, though incredibly gritty. Yet, it still has a wonderful quality of light, which we wanted to pass across in our filming. So when we're filming 1743, we used a lot of reflected lights in the studios to re-create outside scenes and different colors of woods to give a unique feel and quality. We're also trying to maintain the real color palettes they would have had at that time."

With that goal in mind, Kidd says, they don't use contemporary lighting such as LED or fluorescents on the show. "We have avoided that for 1945 and 1743," he says. "When in 1743, we use a lot of candlelight flames. We use flame

> "We wanted to make the audience feel like you're in a different world. Claire's traveled across the channel into Europe, into a hotter, sunnier climate. There's a richer quality to the architecture, very different from Scotland, which is colder and older traditional country. There's more money. We wanted to make that come across, so the Paris interiors have far more light coming into them, because of the French sun and huge windows. Everything is brighter and more golden—more Parisian. The notes from Ron were that he wanted there to be no shadows."
>
> —NEVILLE KIDD ON CREATING THE LOOK OF
> PARIS FOR THE SECOND SEASON

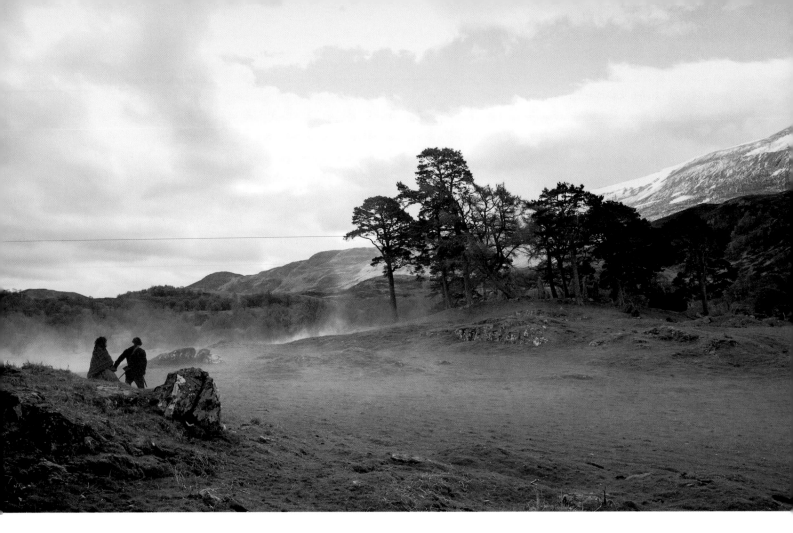

sources or tungsten lighting to replicate candle lighting. All of these techniques give a nice, warm, and inviting feel."

Kidd also explains that, whenever possible, the camera is used as an extension of Claire's point of view. "We make it feel like you're not on a set. If everybody thinks you're in a castle, then my job is done."

Making sure the series showcases as much of Scotland as possible was a task that fell on the shoulders of series producer David Brown and locations manager Hugh Gourlay. Both are longtime professionals in the UK production world, so they established *Outlander*'s studio base and the database of location partners the series features in any given episode.

"Being able to build an infrastructure for the show was really important," Brown says. Production began in an older warehouse complex near Glasgow that now features two hundred thousand square feet of soundstages, as well as workrooms for the costume, construction, and prop departments. "For season two, we built another two stages. So in the same time that we invented the show, we built the only studio in Scotland. And in terms of infrastructure, we've also employed over eight hundred different people. In a relatively small environment like Scotland, the show has an enormous impact."

Meanwhile, Gourlay was out exploring, cataloging, and brokering the use of towns, parks, museums, historical locations, and private properties that could be dressed to fit the needs of the show. *Outlander* is not a small production, so even when an ideal location is found, a lot of work goes into making it feasible. "We have so much equipment for the crew of a hundred twenty-five people," he says. "We need to be able to get them into these locations."

Adding to the logistical complications is the fact that many of the locations are protected historical sites, including Doune Castle and Blackness Castle. "Because these properties are ancient monu-

ments, there are a lot of restrictions on what you can, and can't, do in them. It's very important that they are left as we found them and there is no damage. Actually, it is a criminal offense to damage any of these monuments, so if we had damage, I could, in theory, end up in jail as the person looking after them," Gourlay explains.

As to the specifics of turning a twenty-first-century location into an eighteenth-century one, production designer Jon Gary Steele says it encompasses a variety of physical alterations. "We have greensmen work two to three weeks per location covering up all the things that are not period," he says. "We put our own windows in front of exist-

ing windows in every location, because they need to have leaded glass, which looks a little bit pebbly. We add shutters. We add thatched or tile roofs on some things. We add cobbles on some streets. There

are truckloads of dressing sometimes that come for locations that will play a day or two. I am blown away how much happens per location," he says.

> *"It's a very challenging production. There's a tremendous amount of location work in an environment that isn't very forgiving. It's very cold and often rains a lot. It's very far in the north, so in the winter the daylight hours are very short, and conversely, when shooting in the summertime, the nights are very short. We create a lot of interiors in our soundstages, but we also go out quite a bit. We've taken the company out for a week at a time in the Highlands to do some bigger landscapes and traveling stuff. Craigh na Dun is not an easy location to get to. We've literally had to winch down cameras and actors on sheer rock faces to get the shots we want."*
>
> —RON MOORE

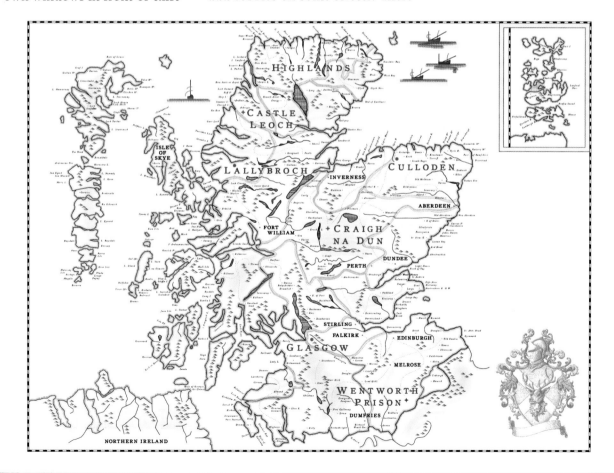

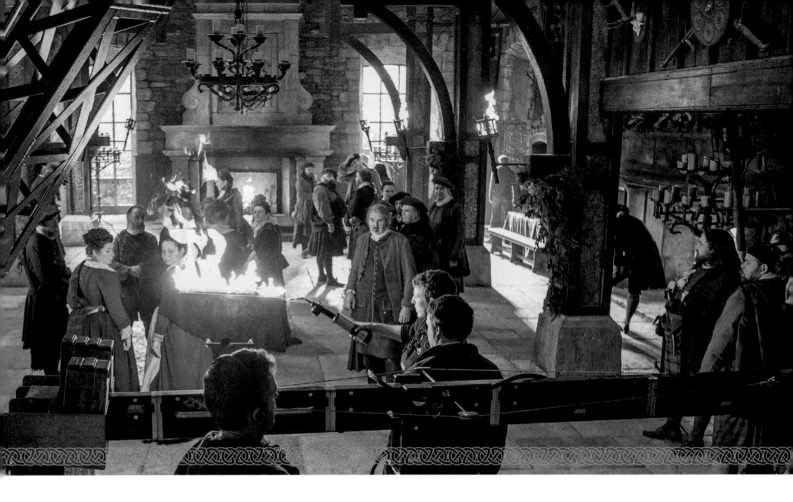

PRODUCTION DESIGN AND SET DECORATION: SEASON ONE

It takes a village to make a village...and a castle...and garrisons and Parisian apartments. The entire re-creation of eighteenth-century Scotland and Paris on *Outlander* is the work of production designer Jon Gary Steele (*American History X, Cruel Intentions*) and his vast art department team, including set decorator

Gina Cromwell, prop buyer Sue Graham, and a long list of other designers, carpenters, painters, and artisans.

Outlander first fell into Steele's lap many years ago in book form, when his longtime friend and collaborator Terry Dresbach demanded he read the series so they could discuss how they would re-

create the books visually. "In America they don't really do that many period things, especially back when we first started," he explains. "And it's really hard to get a period piece if you've never done one. Terry and I used to talk about how we wanted to do a period piece."

Cut to *Outlander* in development with Ron Moore, who commissioned a "look book" from Dresbach, who then enlisted Steele to help her. "We spent several weeks gathering images as a digital book. . . . Ron loved it and took it to Sony.

"Then a few months later Ron says, '*Outlander* is going to happen and I want you to go with me on a [location] scout,'" Steele explains. "We looked at lots of castles and amazing places. Then we really started a month or so later. We flew over to Scotland, and they found this old factory and turned it into stages. The whole production was going to be under this one big roof."

Steele put together his almost entirely UK staff, including a con-

struction team, plasterers (to create faux stonework), floor pavers, and more. "I had never done any of this, but of course we researched the hell out of it," he says. "We had tons of books, and every surface was covered with research on the walls. Actually, we had rolling walls covered for each major set and the direction that we wanted to take it. We rolled into the meetings and talked to Ron and the directors."

Steele remembers that Moore's mandate was that everything needed to look, and feel, real. "Scotland

year one was very down and dirty," Steele details. "We're basically showing the utilitarian-ness of the whole thing. But most of the locations are historical monuments, so they don't want you to build a fire in the fireplace. They don't want you to have a torch, for sure, on the wall. I was talking to Ron and said, 'We need fire everywhere. We need sconces with flames. We need fireplaces burning, because that's the way it really worked.'" The solution was to build all of the major interiors on their soundstages.

"We built the Great Hall, Claire's apothecary, Colum's room, and Claire's bedroom," Steele says, ticking off the list. "One of my favorites is the little set for Geillis's, which was very witchy-poo," he laughs. "They called it her still room, but it is basically her upstairs attic space. It is a big A-frame, and all the walls were covered in giant paintings of Renaissance tarot

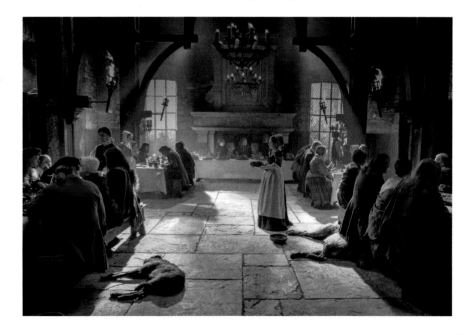

cards, hand-painted by one of our scenic artists. There are twenty four-foot-tall tarot cards scattered across the beams."

For Castle Leoch, Doune Castle was dressed for exterior photography, but the interiors were all sets. "We made a cast of some of the stones on the castle, which would become the stone of the interior hallways, the walls, and the fireplaces," Steele reveals. "The Great Hall alone had three giant fireplaces; you could basically walk into one and kind of walk into the other two small ones. It was a very utilitarian space. They ate there, had functions there, musical events, and they had beatings. It was almost like a town hall but it was in this great big space, so there was no upholstered furniture."

While season one kept Steele and his crew too busy to come up for air, Steele says the scope and detail of what they accomplished

made it worthwhile on the screen. "To be truthful, it is really fun, because you do not have time to get bored!"

◁ Set Decoration

Once Jon Gary Steele designed the idea for a set, set decorator Gina Cromwell and prop buyer Sue Graham went to work. The pair, who had worked in the same capacity on

Downton Abbey, left the nineteenth century to jump back in time to *Outlander*'s eighteenth century.

Because of the Scottish shooting location, Cromwell's biggest concern was where they would acquire or rent furniture and props. "We were four hundred miles away from London, and that's where there are big resources at prop companies," she explains. "We're quite used to being able to nip in and out

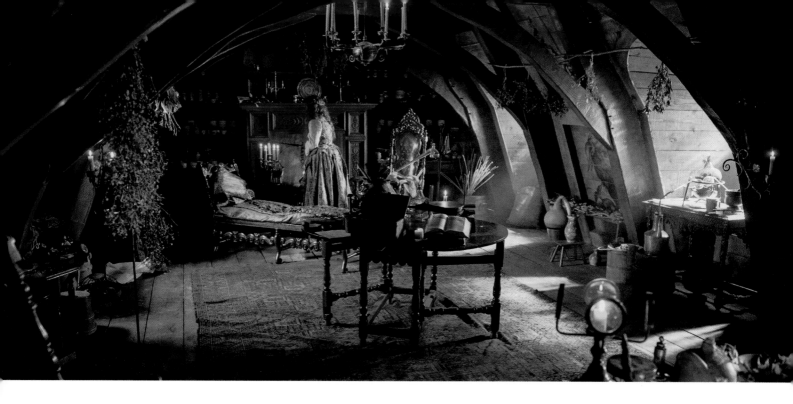

of those, but we couldn't do that anymore. So we had to start building up our own base here and also start to manufacture a lot of our own props, so that we would always have our own personal prop store for the show on hand whenever we needed it."

The pair also decided to focus on seventeenth-century furniture from the Jacobean era, so that the sets would have a lived-in look,

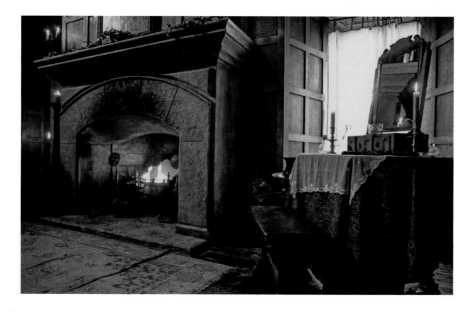

with older pieces to anchor the ancestry of the location. "It's not impossible to buy seventeenth-century furniture, as it's still around and not really heavily priced. We've been quite lucky to buy quite a few genuine pieces," Graham says.

Following Steele's lead to dress every set, Cromwell says, they had to learn his style, which is deeply rooted in architecture. "He likes to show a set that's got a lot of depth to it, going through different niches and alcoves," she explains. "He spends an awful lot of time thinking about how the colors are going to work. How we work with him developed from that, in that we have to see what he's doing with a set to make sure our furnishings work there."

As a team, Cromwell says, they were always battling the darkness that was inherent in the era. "Initially it was quite challenging to find furnishings and colors that don't look dead in some of the sets," she admits. "So we were buying props that had a bit of carving on them. Carved highlights in the back of a shot at least give texture. And we used quite a lot of painted backdrops, which it seems in Scotland is quite a tradition. [They] give a mottled coloring in the background, which certainly gives it a nice richness as well."

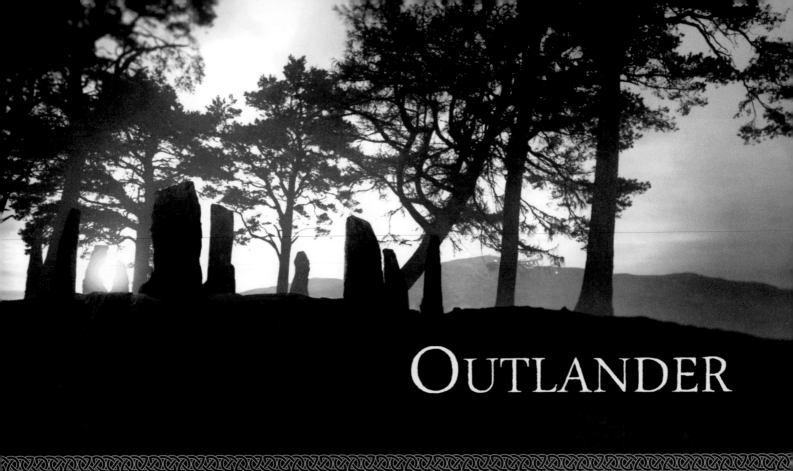

OUTLANDER

THEME SONG AND TITLES

"Sing me a song of a lass that is gone . . ."

Those haunting lines seem tailor-made to reflect the peculiar journey of Claire Beauchamp Randall—and so they should, given how much consideration was given to blending history, music, and fiction in crafting the perfect theme song for *Outlander*.

The tune fans recognize from composer Bear McCreary's series theme song is based on the traditional Scottish folk song known as "The Skye Boat Song." Formally collected by the late 1800s, the original lyrics are about the escape of Bonnie Prince Charlie after the Battle of Culloden. However, the words of the song been have changed many times over the years. In fact, the lyrics sung in the opening sequence of the show are actually a tweaked version of Robert Louis Stevenson's poem "Sing Me a Song of a Lad that Is Gone."

How this version of the song came to start each episode of *Outlander* is its own story, which begins

with Ron Moore considering who would be the best match to score the series. Composer Bear McCreary and Moore worked together on *Battlestar Galactica* and *Caprica*, and both have since gone on to new projects. McCreary, in particular, now scores more than three TV series at any given time (plus film work), so as Moore tells it, he assumed Bear wouldn't be available to take on *Outlander* as well.

But then Moore's high school–age son cited McCreary as one of the most influential artists in his life in a college application, and Moore couldn't help sending it along to McCreary. With the essay he included a short note, saying that he was executive-producing *Outlander* and asking if McCreary had any interest in scoring it. "He shot this email right back saying, *I am a Jacobite fanatic*," Moore says with remembered shock. "He said, *I did my thesis on the Jacobites and the music of the era! Here is an accordion piece I recorded for fun.* Attached to the email was an audio clip of 'The Skye Boat Song,' which I had never heard before. I said

right away, that is going to be our main title song."

McCreary says that attachment was never intended to be used in the series. "I just wanted to send him my favorite folk song, and it was something that I had recorded several times over the years," he explains. "It was just a song that meant a lot to me."

What came next was finding the right opening titles for *Outlander*. Moore says several companies that specialize in creating main title sequences pitched him and Maril Davis many different concepts. "There was everything from animated graphics and morphing to all kinds of symbolism and mystical stuff," he remembers. "It was interesting to see what everyone's take

was conceptually. But [the company] Imaginary Forces pitched some beautiful artwork with the concept of using half of people's faces, feet running through the forest, more-abstract imagery that I responded to immediately," Moore explains. "They came in and shot some stuff specifically with certain kinds of lenses, lighting and visual-effects work, creating the first draft. We just kept playing with it, and 'The Skye Boat Song' was something that I kept holding on to as being the song.

"It was interesting because the people here in Scotland were not in love with that [choice]," Moore reveals. "Among the cast too, if you ask Sam, Graham, and others what they think of it, they will still kind of

23

shrug and crinkle their nose a little bit, because to them this is sort of a nursery rhyme song. To me, I had never heard it," he laughs. "Americans were like, 'This is a beautiful song!' Yet they roll their eyes and call it a bit 'twee,' as they say. There was a moment where I took a deep breath and I was like, 'Is this a huge mistake?' But then I was so attached to it, I just said, 'Screw it! I love it and I'm going to do it anyway.'"

Using "The Skye Boat Song" as the theme's melodic base, McCreary suggested Robert Louis Stevenson's poem as replacement lyrics. "The Stevenson lyric feels more appropriate to Claire," McCreary says of his thinking. "The lyrics are a little more intimate. For our first version, we did the lyrics exactly as Stevenson wrote them—*Sing me a song of a lad that is gone*—and it was Ron's idea to change it to 'lass,' which I was initially nervous about," the composer laughs. "We are talking about a *very* famous song with lyrics by one of Scotland's most important authors. But the change kept the tone of the show, and it's sung in a haunting female voice. It opens without any

fanfare, just on a voice. Something about that was very compelling, and in fact, Ron and Starz and Sony all fell in love with it pretty fast."

And as for that lone voice, it belongs to vocalist Raya Yarbrough, who also sang for the *Battlestar Galactica* theme song and is married to Bear McCreary. "At the earliest stages, I wasn't really intending to have a vocal," McCreary says. "My first sketch was instrumental, and I think it was after that that I experimented with adding the vocal. I wasn't even sure that Raya would be the final singer," he adds. "I just had her come in to try it out to see what it would sound like, and she ended up being the final singer. She did a remarkable job." He explains that he and Raya also took notes from Moore, Starz, and Sony about making the song more intimate at the beginning and building to something bigger. "[Raya] feels to me like the voice of Claire, not in the literal sense, but she's really an interesting combination of all the things we wanted the main title to do. It is catchy and memorable, because, hey, I'm borrowing from one of the

catchiest songs ever written. Consider that box checked," McCreary laughs. "It also feels appropriate to Claire."

◈ Changes in Season Two

Unlike most television shows with a fixed theme song, *Outlander* has been very fluid with its main theme from the start. "In every single episode, the main title ends in a different way," McCreary says. "The episode title card is unique to every episode, so I'm always changing the main title [song]. It's something I've always wanted to do, but I find that most producers and networks are very hesitant to embrace the idea. But this is actually Ron's idea," he continues. "I was thrilled that he was open to it and Starz was open to it, Sony was open to it, so it seems like it shouldn't be a big deal, but it really is. It's not often in television that this happens."

For season two, the changes are immediate: Some of the main theme's lyrics are sung in French by Yarbrough, accompanied by Baroque instrumentation. "I started in

RONALD D. MOORE
Executive Producer

Co-Executive Producer
MARIL DAVIS

an extreme place," McCreary admits. "I did an entirely French version where we rerecorded all the dialogue and I used entirely French instrumentation as our starting point. We walked that direction back after getting some feedback from the network and the studio, which I totally agree with, that it was such an extreme difference that it felt like a different show—in a bad way," McCreary laughs. "Now what you have is this interesting combination of both of these music languages, where some of it's in English and the climax is in French. You have some French Baroque instrumentation, but you also have Scottish instrumentation in a more reserved variation."

For the visuals, Ron Moore asked the in-house team to create new French motifs to reflect the first half of season two. "The first season is very strongly about Claire, a woman of the twentieth century, Frank, the man she left behind, and then being in Scotland with the Scots," Moore explains. "A big chunk of the second season has nothing to do with any of those elements, so I thought thematically, let's hang on to some of the visuals from season one but let's also make the title sequence relevant to the second season." Hence, the additions of ornate carriages, lush costuming, makeup, and a serpent.

A third redesigned main title and theme debuts with episode 208, "The Fox's Lair," which Moore says eschews the French visuals in preparation for Prestonpans and Culloden. "There's more of an army sense in the third version," he explains. "There are Highlanders marching and there are Redcoats shooting."

For the theme, McCreary says, they returned to the Scottish instrumentation but with a martial approach. "We wanted something that would indicate that we were not returning to the same story," he details. "It's an arrangement that can almost be played by a marching bagpipe band. I pulled back on the harmonic progression and substantially on the orchestral presence. You don't get any orchestra until the very end, when I really bring up the snare drums and the pipes."

Score with Bear McCreary

If you're an aficionado of contemporary television scoring, then Emmy and ASCAP award-winning composer Bear McCreary is certainly on your radar. From *Battlestar Galactica* to *Black Sails*, *Agents of S.H.I.E.L.D.* to *The Walking Dead*, McCreary's numerous soundtracks run the gamut of genres, each uniquely augmenting the narrative it emotionally underscores.

Scoring as many as three television series at one time, McCreary admits he had no qualms adding *Outlander* to his list of current projects when Ron Moore reached out to him. "The guiding principle of my life and career over the last ten years is to never turn down an opportunity to do something amazing because I feel like I'm busy," he says. "I knew that this was a once-in-a-lifetime opportunity, so it didn't even occur to me to consider my time or how busy I am. I knew I had to be involved in *Outlander* from the moment I heard about it."

Outlander represents a truly special undertaking for McCreary,

as he was able to draw from his USC Thornton School of Music thesis on eighteenth-century Jacobite-era music to shape the series score.

With the era and native instruments of Scotland already cherished elements for McCreary to mine for the series, the composer says he was in the enviable position of having the research in his back pocket. "I got to untether my imagination and write with the kinds of sounds that I very, very rarely get to write with," McCreary explains. "Bagpipes, fiddle, pennywhistle, accordion, bodhran, Scottish snare drums, and then of course all of the melodies, the rhythms, and the lush harmonic language that are associated with Scottish music—I started thinking about that right away. I knew the players I wanted to work with. I knew the musical language I wanted to be communicating."

Once McCreary watched *Outlander*'s pilot episode, he connected the musical elements to the characters and emotional arc of the story. "I am a very visual musician," McCreary explains. "I was unable

to write original themes until I saw the first episode, but once I saw Claire and Frank, I was able to come up with a theme for them. When I saw Claire and Jamie, I was able to come up with a theme for them. From there, it all came very quickly, because it's just a musical language that's in my DNA. The inspiration was already there."

Different composers will, of course, approach a new score from a variety of different perspectives. Some like to create repeatable music cues for individual characters, craft easily identifiable themes, or even associate specific instruments with specific characters or places. McCreary considers melody the most important tool in his creative process. "I'm using music to communicate character, time period, and location all at the same time," he details. "So I don't like to associate a certain instrument with a certain person, only because we have so many characters on this show and so many beautiful, vibrant, instrumental colors, I would hate to only use one instrument on a certain character. Although

there is one exception to that: Frank."

He continues, "Frank's theme is played on a clarinet and that's not the most exotic instrument, and in fact that's the point. Frank's instrument is more classical. It's more twentieth century. It's something that we associate with the folk-song arrangements of Ralph Vaughan Williams and Benjamin Burrows, English composers who drew from British folk music. I wanted Frank to feel English. I wanted his theme in scenes with Claire to not feel Scottish, distinctly. What that means is then you have a color that you can bring back, and if you listen carefully, that clarinet shows up even when Claire is thinking about Frank. That's a very useful trick. Otherwise, with Scottish instrumentation and later with French instrumentation, I usually use all instruments at my disposal to communicate thematic material."

McCreary also says is he very selective about creating and using themes for a particular character. "I don't necessarily feel like every character deserves a theme," he ex-

CAITRIONA BALFE

SAM HEUGHAN

Based on the series of books written by
DIANA GABALDON

plains. "I actually think a show like *Outlander* would get ridiculously complex if I tried it that way. If anything, by scoring allegiances and arcs and relationships, it allows me to help guide you along what could be a very complicated story.

"For example, there is no Claire theme," he points out. "I score her context. However, I tend to think of the Claire and Jamie theme probably as her theme. It's used all throughout the show and I think it helps guide us on their arc, on their journey. You hear it in all these different permutations. You hear it from her perspective; you hear it from his perspective, which is a deeper, more baritone kind of setting, usually with low strings or a viola da gamba, which is sort of like a Baroque cello.

"Right now I have a Claire and Frank theme and I have a Claire and Jamie theme. I may come up with others," he suggests. "A love

triangle that's torn out of time is very much a driving narrative structure for the first two seasons, so I think in that regard, the themes are there to help you understand her motivations and her allegiances and her alliances with those two men."

One of the delights of working on *Outlander* for McCreary is that it allows him to delve deeply into the historical research that infuses everything he creates for the series. In particular, he says, season two became a rabbit hole of musical inspiration. "The amount of research that went into creating the music of Paris in the 1740s—I feel like I've earned an honorary doctorate in the French Baroque," he jokes. "But all of that is a way for me to get into the material, a way for me to get excited, inspired, and to find a musical language that I communicate in."

"Season two is a political thriller in the guise of a populous costume drama," McCreary says

of his take on the sophomore season. "I definitely leaned into the costume-drama aspect of it, partly because the visuals were so lush and Terry's costumes were so jaw-dropping. I really wanted to acknowledge that and take us into that world. I also used the harmonic and rhythmic language of the French Baroque music to create tension. And take notice that the underbelly of the score—the bodhran, the Scottish percussion, the small string ensemble—it's still there, because it's still Claire and Jamie. It's still part of that same story. It's an interesting dichotomy that I think creates a lot of tension, where you have this overlay of opulence and carefully researched French Baroque music, recording the composers of the day, but underneath is this pulsing, familiar Scottish color. It's really a combination that I don't know has ever happened before."

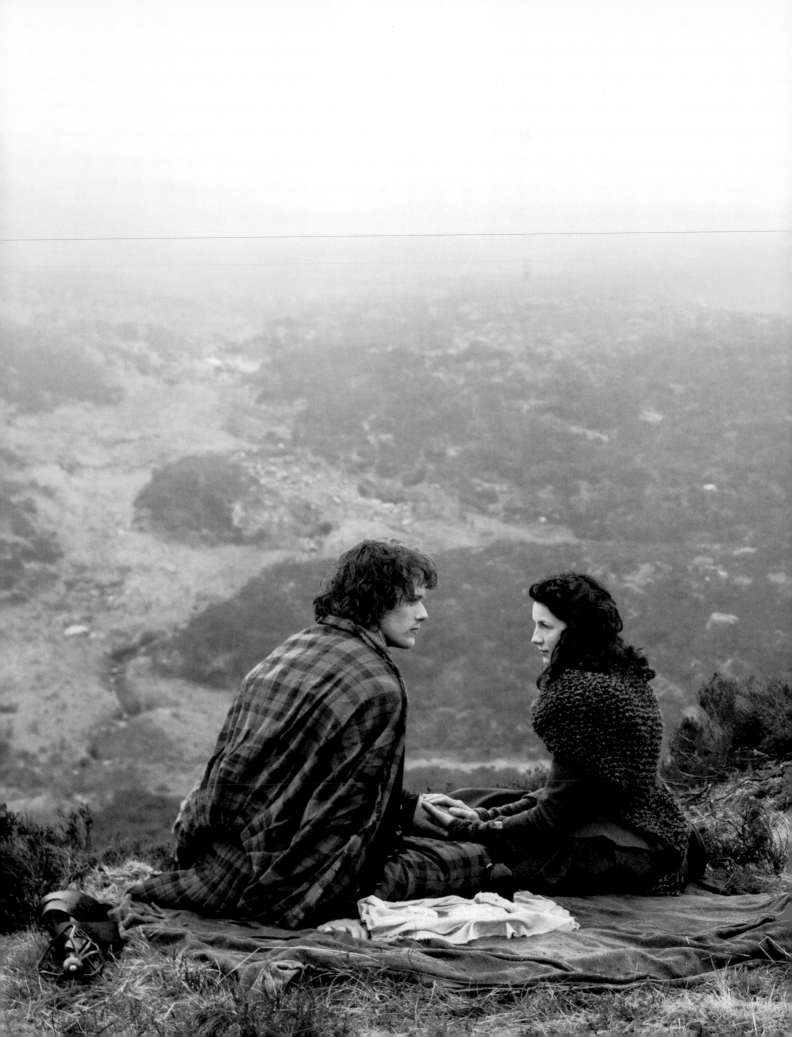

SEASON ONE

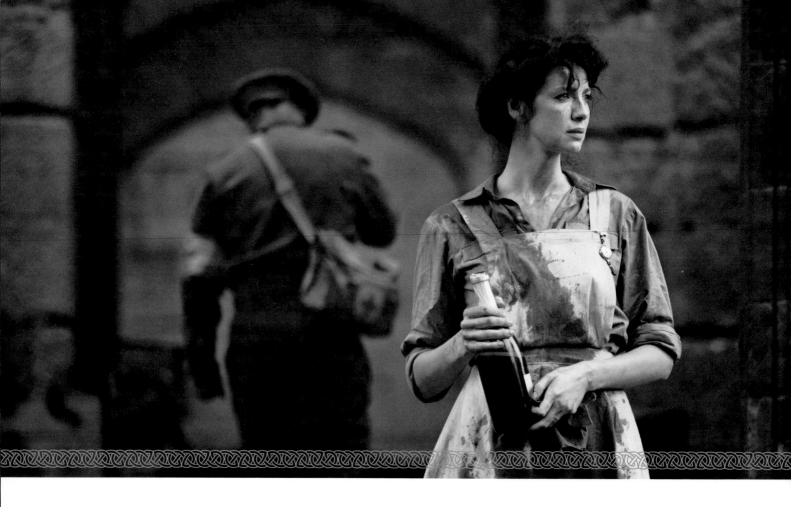

EPISODE 101: SASSENACH

WRITER: RONALD D. MOORE DIRECTOR: JOHN DAHL

From the moment Ron Moore first cracked the pages of *Outlander*, the novel, he began mentally sketching out how he'd translate major story moments into a pilot script. "I had thought through the opening moves of the show," Moore explains. "Start in World War II and then pick up Claire and Frank on their second honeymoon. Really establish them as a good couple and then she goes into the stones. Run into Jack. Meet Jamie and get out as they get to Cas-

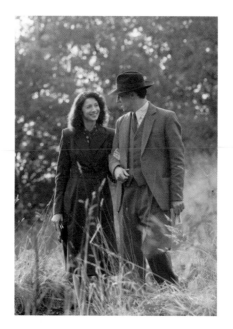

tle Leoch. I knew those were the basic building blocks of the pilot for a while."

But Moore reveals that keeping Claire's central perspective from the book, where she serves as narrator, in the series was not always part of the early architecture. "We were actually breaking stories and developing the first season without as much voiceover," Moore says. "We were not telling it completely from Claire's point of view." It was Starz CEO Chris Albrecht who became a

vocal advocate for maintaining the first-person narrative of the book.

"I thought that was a pretty bold idea," Moore recalls. "I have not seen a first-person-narrative show done like that in a long time. So we went back in and we rewrote the initial stories with that in mind and kept it as a more pure POV show. And it changed the whole tenor of the series.

"As [the pilot] developed, I then started to think of episodes one and two as a two-hour," Moore continues. "*Outlander* really doesn't start until the end of the second episode." There is so much to establish from the opening scenes of the book that a one-episode introduction to the series wasn't feasible.

The first episode, "Sassenach," is primarily meant to establish Claire in 1945, a British post–World War II combat nurse recon-

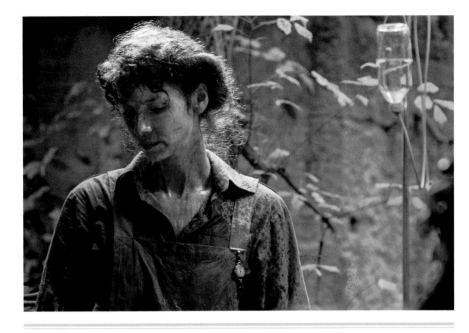

"There was an amazing booklet that was British World War II issue that showed all of the bandaging that [nurses] would have done. Those were Claire's base skills. I do have a strong stomach. The worst thing is how sticky the fake blood is."
—Caitriona Balfe on researching Claire's skills

necting with her husband, Frank, in Inverness, Scotland.

The first scene shot for the series is the opening sequence, which introduces Claire in gory combat surgery just minutes before the war comes to an end. The scene, which is not in the novel, was added to

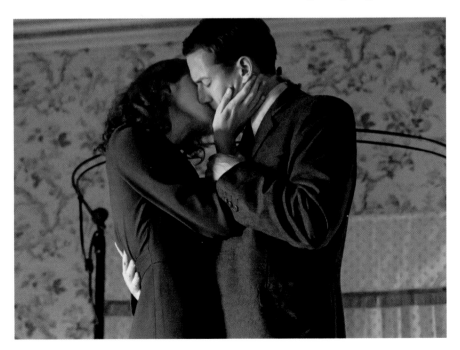

help ground the audience's sense of Claire's character. Director John Dahl, a lifelong friend of Terry Dresbach and a collaborator with Moore on *Battlestar Galactica*, was brought on to establish the look and tone of the series, so much of which is introduced in that scene.

"Ron said he didn't want it to be a period piece," Dahl remembers. "He wanted it to be handheld and gritty. We got David Higgs to be the cinematographer, who is fantastic. He really understood lighting and was very attuned to what the show could look like. We started looking at period films and references, and David said everything should be desaturated."

Filming at a dilapidated, roofless manor house, production de-

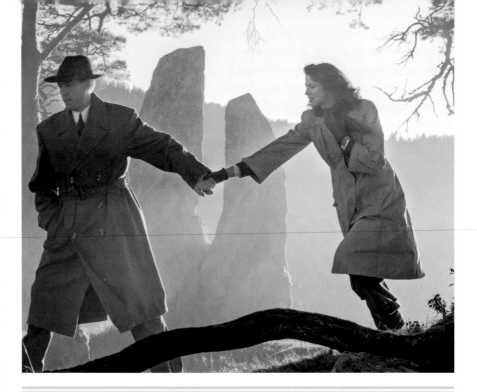

The famous Craigh na Dun standing stones pictured are actually foam set pieces.

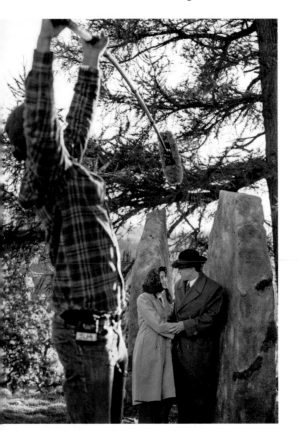

signer Jon Gary Steele turned it into a field hospital. "With the camera," Dahl explains, "we used a ninety-degree shutter that helped convey that gritty, desaturated look. We had tungsten bulbs, and I think we even figured out a way to get some smoke in the scene. We cast an actor who was an amputee, and then we put this plastic leg on him that was incredibly realistic-looking.

We're pumping blood and squirting it into Caitriona's face and then pooling blood on the floor. Then there was that great moment where she walks out and she realizes the war is over. I remember shooting that close-up of her with the sorrow that was on her face. We shot at maybe seventy-two frames a second, and it slowed that moment down. She just so beautifully cap-

> *"I remember when they were shooting the scene where Frank and Claire are jumping up and down on the bed. It wasn't written like that. It was written that she is jumping up and down on the bed to try to make him laugh. It was Tobias who said, 'Well, what if I got up there with her?' It was such a great instinct because it spoke volumes about Frank. He is not some stuffy guy who cannot connect and is closed off emotionally. It made a huge difference in the show."*
>
> —RON MOORE ON TOBIAS MENZIES

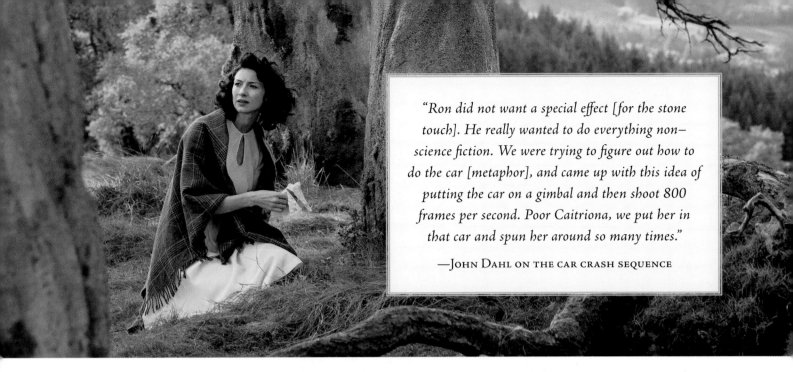

"Ron did not want a special effect [for the stone touch]. He really wanted to do everything non-science fiction. We were trying to figure out how to do the car [metaphor], and came up with this idea of putting the car on a gimbal and then shoot 800 frames per second. Poor Caitriona, we put her in that car and spun her around so many times."

—JOHN DAHL ON THE CAR CRASH SEQUENCE

tured that bittersweet moment." Claire aside, establishing the concept of the show required finding and staging their Craigh na Dun, Dahl says. But that task was not an easy one. "In Scotland, there are plantations and they've planted the trees in straight rows, so a forest doesn't look like a forest," Dahl explains. Locales near their stages were less than impressive, so the team traveled farther out and found their "magic" spot near Rannoch Moor, Perthshire. Steele's team created the twelve- to sixteen-feet-high standing stones from foam with a hard coating and carefully erected them on location so there was no impact on the ground, which used to host actual historic stones.

"For the scene where Frank and Claire go out there first thing in the morning, we filmed all the stuff at dark," Dahl reveals. "We actually had a gigantic light on a crane, and that's how we made our

sunrise come up. I feel like that one scene really helped us make it look more like rugged Scotland. I think it's one of the more beautiful sequences that I've gotten to film in the last few years."

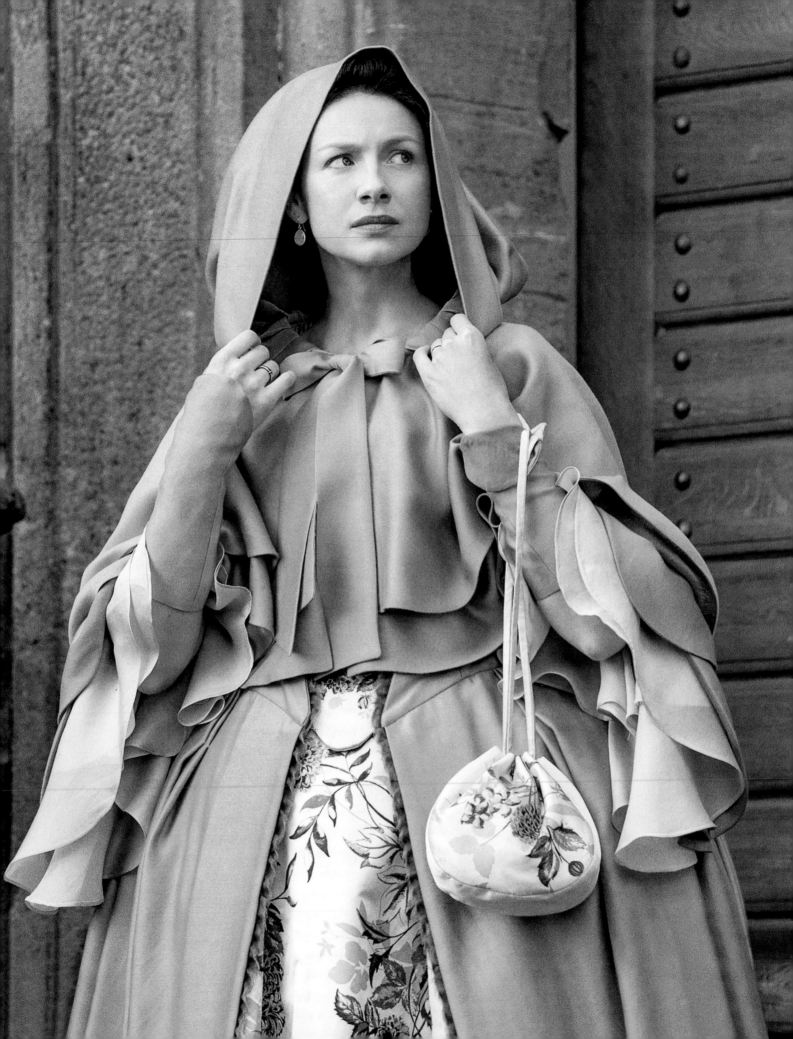

SPOTLIGHT:

CAITRIONA BALFE AS CLAIRE BEAUCHAMP RANDALL FRASER

Casting the right actor to fill a role, particularly one who has existed in the eyes and hearts of fans for over two decades, is a tricky endeavor. Sometimes the stars align, connecting performer to character instantaneously. In the case of *Outlander* protagonist Claire Randall Fraser (née Beauchamp), that character is a worldly woman trained as a combat nurse, beautiful, intelligent, and fiercely loyal—not to mention stubborn. What the producers of *Outlander* the television series needed to accomplish was marrying those fictional qualities to an actress who would also have to shoulder the real-world demands of appearing in almost every scene of the series, enduring the location and weather stresses, and creating one half of an epic romance for the ages.

After months and months of searching for their Claire, producers found her in Irish actress Caitriona Balfe. Balfe, who was asked to audition on tape (where the actor records the reading and sends it to producers to review later), remembers there wasn't much material to go from. "I got two scenes and a small breakdown. It was a very short description, that she's feisty and hot-headed." When the read went over well and she was subsequently asked to do a screen test, Balfe says, she really dove into the character. "I went straightaway and got the book and read it over the four days of Labor Day [2013]. I lay out by my friend's pool and just read."

Balfe says she connected with Claire due in part to her past as a model, a lifestyle that could frequently feel nomadic. Claire had a similarly unusual adolescence, traveling around the globe with her archaeologist uncle. "Claire always viewed herself as a very single entity, not being brought up with conventional ideas of where her place and station should be," Balfe conjectures. "In that sense, she does have a timelessness, and it has carried her through terrible situations because she always takes people at face value and always holds herself up as an equal to anyone she meets. In the 1700s, that causes quite a few problems, but that was definitely the strong-standing center point for her. Claire always reacts to things almost as a woman would from this time. I think that she is very advanced for her time."

Balfe also embraced Claire's profession as a World War II nurse by tapping into her personal ties. "My grandmother was a nurse in the Second World War, so that was an emotional link for me to Claire," the actress

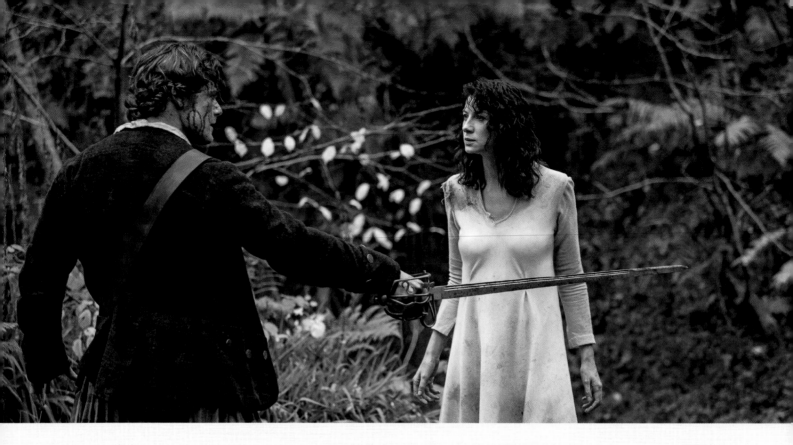

explains. "I did a lot of reading on nurses who served in World War II. What struck me about women of that time is that even though they were in horrific situations, they still had to live. They made the best of their time. There are great stories of being on ships and rescuing soldiers and nurses from sunken ships. It would be overcrowded, but they'd still have dances and get married in the spur of the moment, so that immediacy of life, I think Claire has a sense of that. Understanding Claire as the war nurse was such a great launching pad, because that gave me such a sense of her strength and her ability to endure so much."

The actress's deep understanding and embodiment of Claire earned her the part, which would become Balfe's first headlining role in television or film. Balfe admits that being cast was both exciting and nerve-inducing. "That first day [of shooting], I remember it so clearly," Balfe reminisces. "It really just felt so exciting. It's the very opening scene [of the series], and I remember walking through and there was so much life. We were in this ruin of an old manor house, and we had that field hospital set up. We had all the extras and it looked so amazing. The set was so incredible and it felt very seamless, in a way. I remember that cel-

ebration part of the scene where Claire walks out and drinks [from a bottle of] champagne. There was sort of an excitement in the air. I think there was also relief because I was so untested. The people above had taken a big chance on someone who did not really have a lot of [acting] credits. There wasn't the proven path of

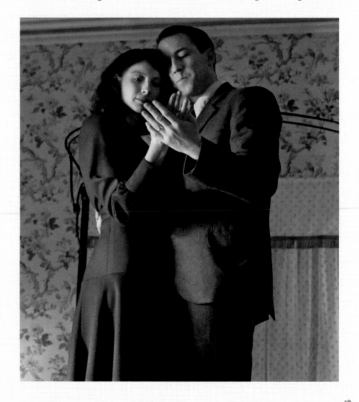

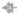

a lot of TV work. So I think everyone sighed a big sigh of relief after day one as they were like, 'Oh, she'll do.' Little did they know, I was just drawing on my boozy past," Balfe laughs.

Thrown right into the thick of the intense production rigors of *Outlander*'s first season, Balfe admits she had no time to contemplate, or anticipate, the all-encompassing demands of the series. "It sort of mirrored Claire's journey as well," Balfe explains. "It really came so fast and furious that it was just about getting through it. [Producer] Ira [Behr] and I always laugh about what he said in the room when I tested. He was like, 'For the first six episodes, you are going to be in every scene, every day.' Now I tell him, 'You didn't say that it was going to be for the ten *after* that as well,'" she laughs.

"It is a grueling schedule and it is quite tough, but I also relish that side of it. I love the days where we are out and running through the woods, or running over hills, or are on horseback and all of that. As long as the weather is dry, which is not very often." She smiles. "It

actually suits my personality to be outside and running around in the muck."

Balfe adds that all of that frantic activity served to further inform her portrayal, especially as Claire adapts to her new Highland lifestyle. "There is a sense that Claire can't relax, but what I really love about her is that even though she's in this really tense situation, where at any moment she could give herself away or be in trouble, she still can find space to build relationships and enjoy the life that is there."

Claire's ability to find joy in her out-of-time situation comes, of course, from her connection to James Fraser, as they form a bond of first friendship, then passion, and then love. Balfe says that, similarly, forming a connection with co-star Sam Heughan has been a big part of how much she's enjoyed the experience of working on the show. "We are really, really good friends," she says of their genuine rapport both on and off screen. "From day one at my test, when you meet him, he's just one of the most genuine, non-ego-y people. He's genuine and so supportive."

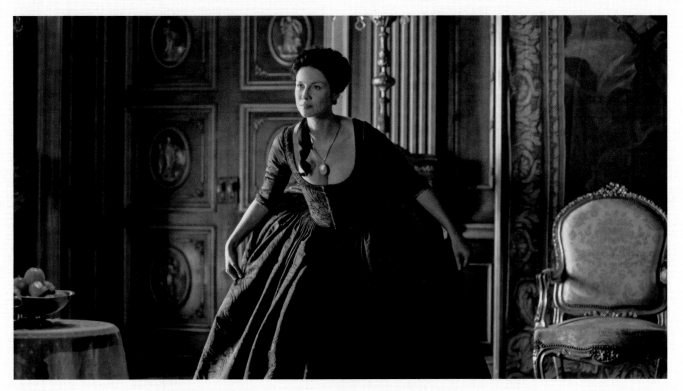

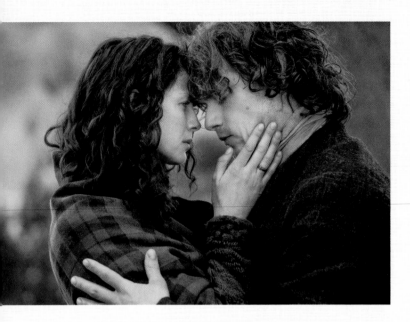

The actress says that their connection has been so important because, as actors, you need that kind of mutual respect and friendship to be able to be as intense and emotional as their respective roles call for.

"With those love scenes, I honestly think what helps me is that I don't really dwell too much on thinking about it beforehand," Balfe says. "Sometimes afterward, Sam and I will be like, 'What just happened? What did we do?' And then you're like, 'Oh God,'" she moans with mock embarrassment. "It helps that my character doesn't have any inhibitions, so you are playing that, and because of that, you don't have time to even think about your own insecurities. You focus on the scene at hand, and that helps. I think that if perhaps you were playing someone who was less forthright, that might seep into your own consciousness and you might not be as bullish about it."

With production on season one taking almost a year, Balfe remembers that time like a protected bubble, where cast and crew found the rhythms of the series together. When *Outlander* debuted in 2014 and quickly turned into a critical and international hit, Balfe says, it impacted how everything felt when they returned to work in April 2015.

"I was more aware of the pressure," the actress says candidly. "I actually had a moment where I had to say to myself, 'No, you can't think of this too much. You just have to get on with the job.'" However, the series' change

in narrative location, swapping the now-familiar Highlands for the majesty of the Parisian courts, added a disconcerting novelty to the early days of shooting. "Once [Claire] was in Paris, it felt like a very different show," Balfe explains. "It was Sam and I but a new cast. Regionally, it was so different, and the costumes were so different. It is so much more indoors, and it plays very much like a mental chess game for the first few episodes. Yet, in a way that is one of the beauties of the show, that it constantly feels fresh and you are with these great new characters and cast. But definitely in the beginning, for a moment, we were like, 'What are we doing?' It took an adjustment, because Sam and I are both so comfortable out in the wild. Season one felt almost easier, in a way, to just plow through and keep going. In season two, I think, Claire was contemplating her station in her life."

With Claire pregnant with Jamie's child and committed to changing history to avoid the downfall of the Highlander way of life, Balfe says season two starts off with a new sense of purpose. "Last season, everything we saw with Claire was so much more reactionary. She was really just dealing with the moment-to-moment of the events. In year two, maybe because of Faith [Claire's stillborn child], or maybe because of everything that happened at the end of season one, her armor is not as thick anymore. I think that as time can heal, time also brings things to the surface. What I enjoyed this season

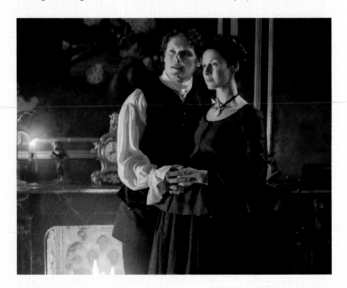

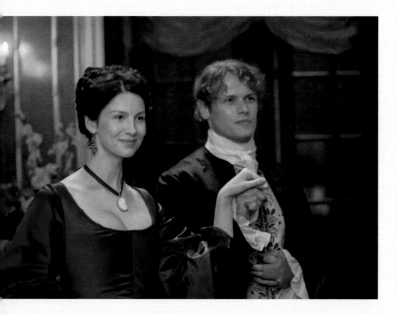

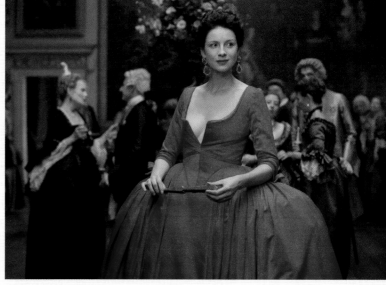

with her as a character is that [she] was allowed the space and the breath to let the events affect her."

At the end of season two, Balfe also got the opportunity to invent a new facet of Claire, one where she is twenty years more mature and shaped by motherhood and her constant loss of Jamie. Balfe relished the idea of exploring her character's mental and physical evolution as a woman in the 1960s. "It was so exciting to try and jump forward in someone's life," the actress says. "What does twenty years' experience do to change that person? What of you will remain the same? What will change? How do you carry yourself? How do you talk?

"I played around a little with her voice. I felt like maybe there would be a slight deepening of it. Obvi-

ously, we changed her hair. I wanted there to be a certain physicality that changed slightly. She's a doctor now, and she has to have this air of confidence and authority. She is a formidable woman, in a way, but she's also someone that has lived with disappointment and loss for twenty years. That has to have an effect."

The second-season finale, "Dragonfly in Amber," also reveals Claire's maternal side, through her complicated relationship with her now-adult daughter, Brianna. Balfe says she only had a short window working with actress Sophie Skelton, but it gave her a potent taste of the new avenues she'll get to explore with Claire. "It is such a difficult one, because you don't want to do this broad stroke of them having a difficult relationship. Yes, there is distance between them because, for twenty years, to have lived with someone, there would have to be beautiful points, high points, fun and laughter—then also distance or misunderstandings or disappointments. There's so much love there, but then it comes with all this baggage and guilt."

By season's end, Claire is once again a woman in transition, as she faces new life-changing decisions that will impact not only her own life but the lives of her daughter and Jamie Fraser as well. For Balfe, finding Claire in that space is not unexpected, because Claire Beauchamp Randall Fraser is all about transformation. "She is the same woman," Balfe muses, "but so much has changed and she is so different at the same time."

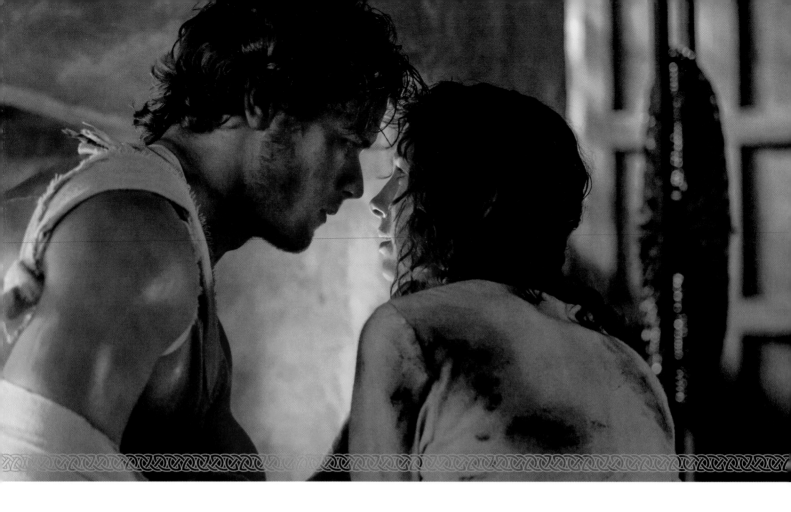

EPISODE 102: CASTLE LEOCH

WRITER: RONALD D. MOORE 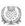 DIRECTOR: JOHN DAHL

With Claire the focus of "Sassenach," the second hour of the series was all about introducing the Highland culture—and the character of Jamie Fraser, played, of course, by Sam Heughan—to the audience. "Castle Leoch" establishes the dark and imposing castle as the epicenter of Clan MacKenzie. At the ruling seat and home of Colum MacKenzie (Gary Lewis), Claire finds herself forced to adapt to her new situation and the intense hierarchy within the castle walls. A still-healing Jamie becomes Claire's first advocate and friend, in a hostile environment.

"In the second episode, once we started getting into the Castle Leoch stuff with Jamie, that's where he really began to shine," Ron Moore says of unveiling Jamie as a character on the show. "You really saw the chemistry between [Claire and Jamie], like in the scene before the fire in Castle Leoch, when she is dressing his wound and he's talking about Jack, or the stable scenes."

For director John Dahl, "Castle Leoch" allowed him to establish the world of the Highlanders at its peak of wealth and formality, fleshing out the people who served the laird and his extended family. Native Scottish actors Gary Lewis, Graham McTavish, and Sam Heughan participated in a Highlander boot camp with the rest of their clan castmates, which Dahl says bonded the men and set the tone

for the first two episodes. "They were all so excited to be working on this show that's set in Scotland and in this period," he explains. "They just embraced it. They were learning their Gaelic and they were so into it. They'd all come to the set, do a couple of takes, maybe get a note here or there, but they would just nail it."

As for capturing the interior aesthetic of the castle, Dahl says the mandate from Moore was, make it dirty. "It's always filthy but lit beautifully," the director laughs.

The soot came honestly too, as Dahl says the producers wanted Jon Gary Steele's sets lit with real candles to create an authentic gloom. "They were double wicked, because [DP] David Higgs was a little concerned about the luminance coming out of them. I don't know how many hundreds of can-dles were up on the chandeliers. They were on a pulley system, so you can lower them down, replace them, then light them, and then roll them back up. If we were going to stop for a long period of time, we'd bring them down and blow them out. I think we went through hundreds of candles the first day we shot in that grand ballroom, because double-wicked candles burn twice as fast as a regular wicked candle. And every now and then one of the extras would feel some hot wax going down the back of their neck."

> "[Jamie's flogging] establishes the relationship with Black Jack Randall and also his sister, Jenny. It was my first day and I think I was more concerned about the fight, trying to remember all the moves. I basically have to fight off two guards. It was good fun. And then we got into the scene with Tobias, who got carried away. There were two takes that he managed to hit me on every [lash], and it was quite amusing. I said, 'That's pretty good, actually. That really hurt.' I didn't have to do any acting. I think that was just a sign of things to come, that we could really push each other and go to the limits of what an actor is allowed to do or not allowed to do. It was a very strong standoff between Jamie and Black Jack, setting that relationship up for each of them."
>
> —Sam Heughan

"We were filming that scene where [Mrs. Fitz] dresses Claire, and people were like, 'Do you need any help with that?' When Annette [Badland, who plays Mrs. Fitz] starts singing, that's because the silence went on for so long that Annette improvised humming and singing while she did it. The silence was so painful. They cut it down to that really short clip, but the whole thing took forever and everybody was just dying. I'm like, you've all learned how long it takes to get dressed in the eighteenth century. It was a great scene."

—TERRY DRESBACH

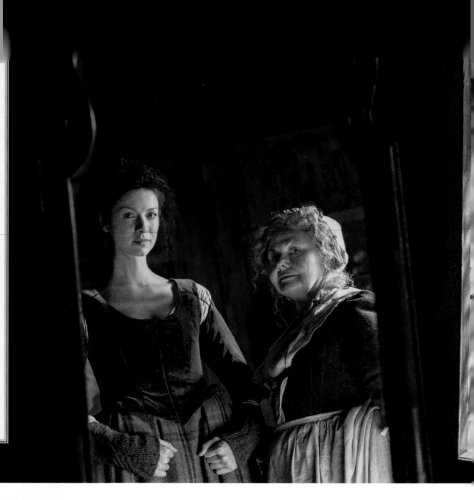

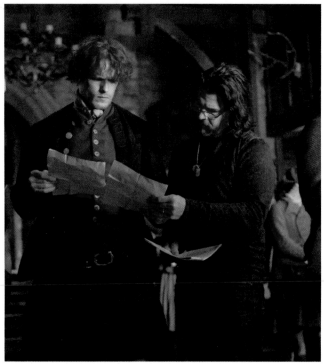

Sam Heughan as Jamie Fraser getting notes from Ron Moore (right).

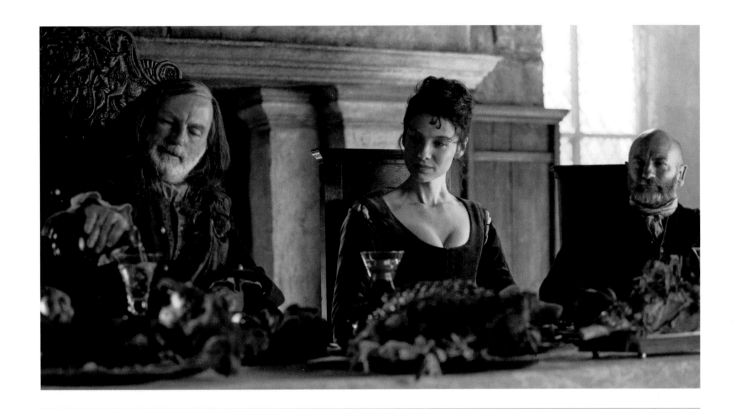

"In the feast scene, Colum really wants to present to Claire the sophistication, the good food, the good glasses, the good wine, their knowledge of history. He seems to like Claire, but he is also trying to gather information from Claire. He's also telling her something about himself and the MacKenzies."

—GARY LEWIS ON THE DINNER SCENE WITH CLAIRE

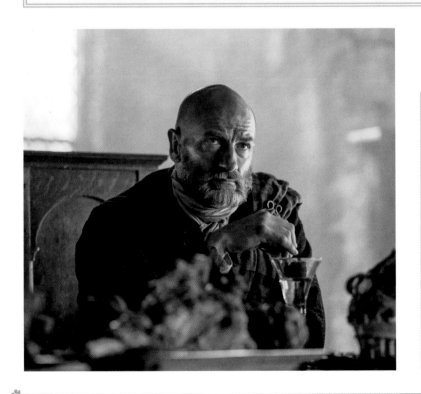

"The end of the episode, where Claire's being told, 'You're staying and you're not leaving,' Colum leaves her and walks up the stairs. I'm waiting at the top of the stairs and we both stand in the doorway and I very deliberately shut the door on her. We made that very deliberate choice as a sort of homage to the very end of The Godfather, when Michael Corleone shuts the door on Diane Keaton."

—GRAHAM MCTAVISH

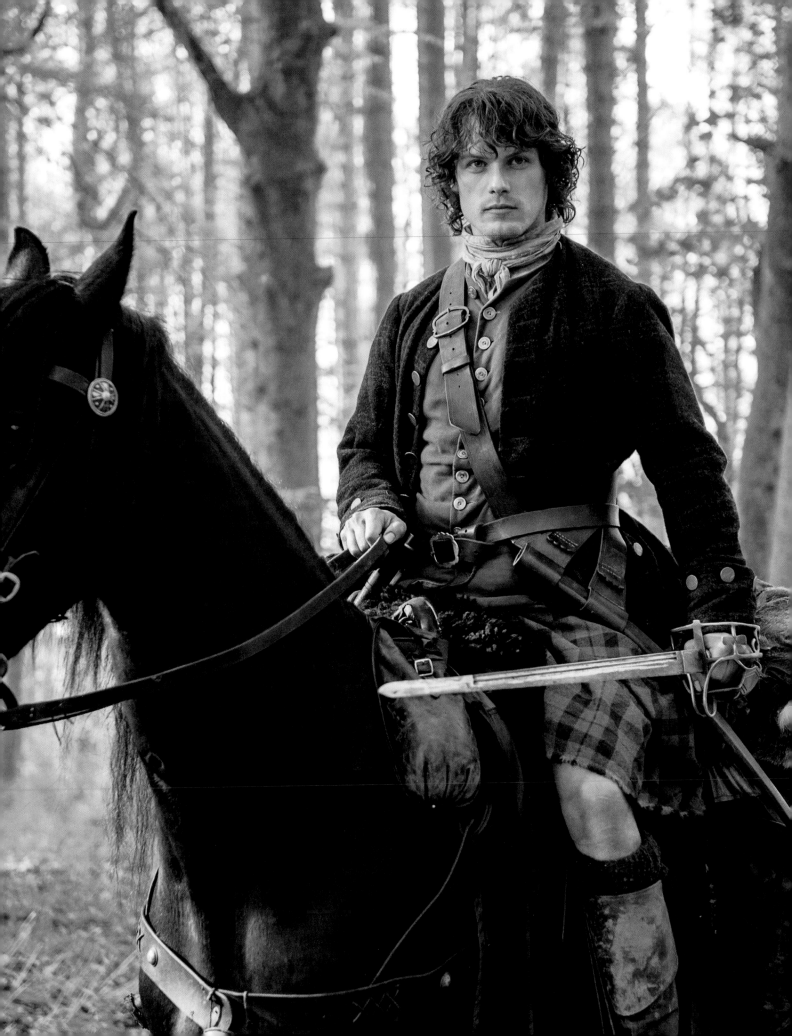

SPOTLIGHT:

SAM HEUGHAN AS JAMES ALEXANDER MALCOLM MACKENZIE FRASER

For more than twenty years, James Alexander Malcolm MacKenzie Fraser has endured as one of contemporary fiction's most beloved male characters. Handsome, brawny, charming, sexy, and loyal, to name just a few of his positive attributes, Jamie's proverbial shoes were always going to be impossible for any mortal man to fill . . . until they weren't.

When *Outlander* the television series entered its casting phase, everyone, from Diana Gabaldon to producers to fans, assumed finding the "right" Jamie Fraser was going to be a long slog through piles of unworthy headshots and audition tapes. But Scottish actor Sam Heughan arrived early in the process and, to everyone's shock, quickly owned the part in all of the producers' eyes.

"When I found out I got the part, I was over the moon," Sam Heughan says. He knew that trying to embody what for many people was the perfect man was never going to be possible, so he focused instead on creating a Jamie tied to the reality of his time and experiences. "I remember reading Diana's graphic novel [*The Exile*], which was a great way to understand Jamie's journey before we meet him in the show," the actor says. "He has just arrived back from France and is an outlaw. He's fallen in with Dougal and the other MacKenzies,

but they're not to be trusted either. Even going back to [Castle] Leoch is not the best place for Jamie, so he's not sleeping in the castle. He's sleeping outdoors in the stables, because he can't be seen. He is someone that is on the run and keeping himself shrouded."

Jamie's sense of isolation became one of the cornerstones of Heughan's interpretation of the character. To stay alive, he has to stay independent, relying on only one true ally: Murtagh FitzGibbons Fraser. "Early on, myself and Duncan [Lacroix] were always very aware of where each other was in relation to the other MacKen-

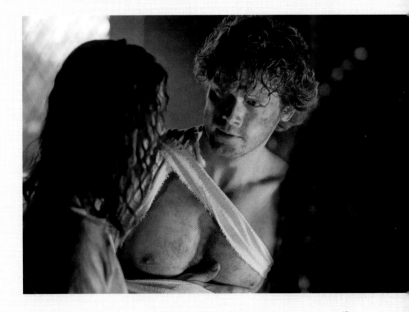

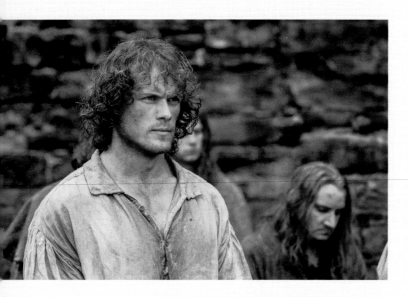

Our Gaelic coach, Àdhamh Ó Broin, really gave me an understanding of where the Gaels came from. I realized that the more I read into it, the more I found it a fascinating language that is very descriptive. I loved looking at the geography of Scotland and finding the [location] names and then finding out what they actually meant. So Jamie is a Gaelic speaker first and foremost; that was his first language. I try to keep it, and maintain it, throughout the seasons, as I think it gives [him] an element of honesty."

Heughan's immersion into the language also opened the actor up to a deeper understanding of his native country's clan culture. "We looked at the history of Clan Fraser," he explains. "They've got French roots, so that was quite interesting to look at their motto [*Je suis prest*] and their general geography. I was also really interested to learn about all the different clans and the way they interacted with each other and also fought with each other. We realized that it was never easy. They were constantly warring with each other and forming alliances and then falling out with them."

zies," Heughan reveals. "What we said from the start is that they are obviously family and they are the only two people that they can really trust. At a moment's notice they might need to escape together, or have each other's back, so there's a level of trust that is wonderful."

Adding to their connection was the decision to have Heughan embracing the Gaelic language to speak with Murtagh. "I think that was definitely the way in for me to Jamie," Heughan says. "Obviously coming from Scotland, I had seen it around and heard people talk it but didn't really understand where it came from.

Jamie's personal history, the cultural context, and the character's relative isolation make for a man yearning for connection, when fate literally drops Claire

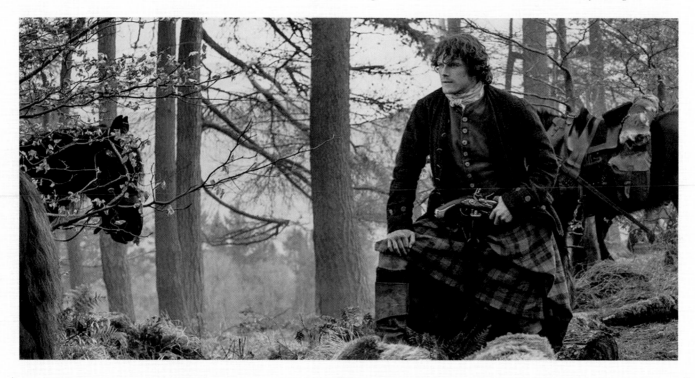

Beauchamp Randall into his path in "Sassenach." "The moment he sees her, I think, is the moment he falls for her," Heughan says. "I tried to play it in that moment, and I think you can see it," the actor continues. But after that, "he guards himself a little bit, because she could disappear at any point. I think Jamie can be quite outgoing and very expressive in his love when he is finally with Claire. But before that, I wanted him to maintain this front of capable Highlander.

"The men then would not talk about their feelings," he chuckles. "Life at that point was very dangerous and very short. He had to look out for himself, protect himself, and I think that initial [distance] is where it stems from."

Aside from his relationship with Claire, Jamie's actions in season one are largely driven by his interactions with Black Jack Randall. That first season outlines their violent history and then brings them together once more for a horrific dark passage of the soul in Wentworth Prison.

"I remember building up to it, thinking, *Can I do this?*" he says. "As an actor, you're not even sure if you can go there or if it scares you to go there."

It took about a week and a half to film the torture

sequence. "With all the prosthetics and makeup involved, we were doing four hours of prosthetics in the morning before shooting," he explains. "I'm coming in at four A.M., and then, obviously, a couple of hours at night to take it off. And then in between takes, I couldn't just go off on my own to sit and relax. I would have to go into the makeup room and get all of the back prosthetics touched up. There's no break in that. They were long, long days," he remembers.

"In the evening, there was the process of taking off all the makeup and prosthetics and having a shower," he recalls. "That was kind of the way to release it all and get rid of it. Everyone would leave the studio and I would stay there and do a quick workout in the gym, just to do something. I was staying in a little bed-and-breakfast right next door to the studio because we were in so early in the morning, so I was living this strange little life. I think that helped, living in this little bubble. It felt very much like being in this prison cell and that was my little world for that week and a half.

"In the real darkness of it, in between takes of some pretty heady stuff, I do remember [director] Anna Foerster coming up to me and saying, 'Let it go now. Just go and relax. We got it.' That was such a relief when it was over," he says. Heughan says he's grateful to get the opportunity to play such intense content. "When you're dealing with such big, emotional darkness, it's great to be able to take yourself there. In TV, you don't always

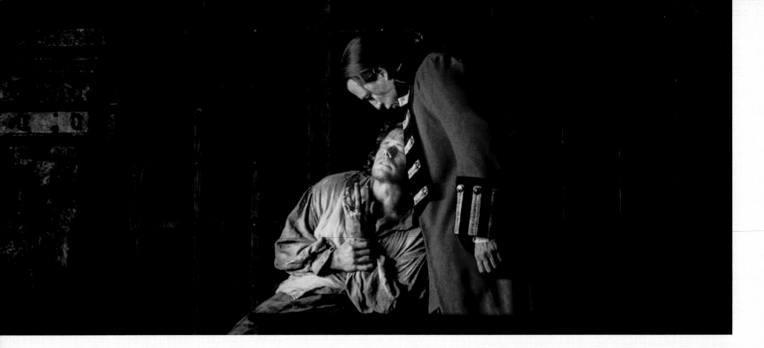

get to do that, so it's nice to be given the opportunity to really stretch yourself."

Though Jamie escapes that cell, the repercussions of his assault are very much present in the first half of season two, as Claire and Jamie endeavor to change history by subverting Prince Charlie's rebellion. Heughan says there was a heaviness that existed underneath the gilded Parisian salons. "Myself and Caitriona both felt when we first came back to season two that it was quite unsettling, because the characters that we knew so well were not being themselves," he explains. "He's a very honorable man but, I guess, he learns to be deceitful. And then, he is still obviously not addressing the trauma that happened to him. He has brushed it under the carpet, not thinking about it and throwing himself into this mission."

It takes Claire and Jamie bridging the chasm together, as well as the news that Black Jack Randall is alive, for Jamie to find himself again. "He was a shadow of himself in the first half of the [second] season, not being in control of his own destiny," Heughan muses. "When he finds out Randall is alive, it's like he is reborn. He can be in control and take charge. I really wanted that to be the moment that we see Jamie become himself again. It's a buoyant kind of happiness. He knows Randall is alive, so he can now take his vengeance."

Once the narrative returned to Scotland, Heughan says, the hours felt like pressure cookers for the charac-

ters. "Every action has a real consequence," he says. "There are a lot of promises made, and he does things that he says he won't do. It does feel that they are being strangled by time, because there is this finite point, which is the Battle of Culloden. It is really life and death."

But Culloden turns out to be inescapable, and that realization forces Jamie to make the most soul-shattering choice of his life, to save his wife and child by sending Claire back through the stones. In Heughan's last scene of the season, he chose to play the goodbye at Craigh na Dun without desperation. "At that point, there's a calm to him," he says. "Jamie knows that this is it, and this is what needs to happen now. The fact is that he is resigned and he knows his fate. He knows what needs to happen and that he needs to guide her gently, out of love and out of protecting her."

EPISODE 103: THE WAY OUT

WRITER: ANNE KENNEY DIRECTOR: BRIAN KELLY

This episode expands the world of eighteenth-century Scotland for Claire as she begins to see the realities of her new situation. Homesick and trying to find hope for survival and adaptation, Claire discovers that her modern knowledge and beliefs can set her at odds with her new hosts.

The episode opens with a flashback to a moment between Claire and Frank as he sends her off to the front, which writer Anne Kenney

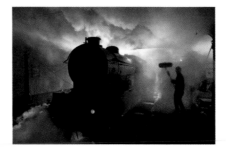

explains was meant to remind audiences of the bond between the two and reiterate the emotional stakes for Claire, though it was originally scripted as part of episode 104. "We really did want to humanize Frank more," she details. "From the jump,

Jamie is so handsome and charming and there's such great chemistry with Claire that we really needed, and wanted, the audience to also be rooting for Frank and Claire."

Back in Castle Leoch, Claire connects with Mrs. Fitz and tries to reach out and confess her true origins, a moment that may have surprised loyal fans of the books. "The thing that's nice about what we've done, and Diana's so supportive of it, is that there are times when we make another choice that Claire

50

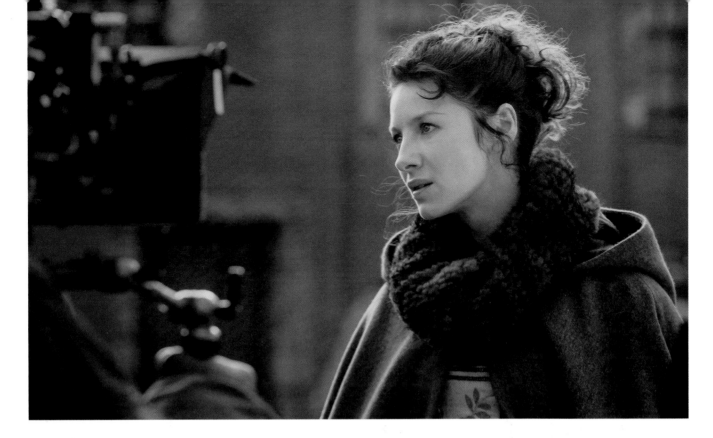

could've made and explore it a little bit," Kenney says of the scene. "We thought, it's a legitimate choice that, in that situation where Claire's so freaked out, you might test the water. She imagines what would happen and then takes that to a logical conclusion and realizes, *Oh no. I can't tell* anybody."

This realization sets the stage for the primary narrative of the episode, which sees local children coming down with a fever that the residents fear is caused by evil spirits. "We wanted to take an opportunity, early in the series, to show the difference between the twentieth century and the eighteenth century," Kenney explains. "[The sickness] was a way that we could do it. That story line was the result of a lot of detective work, because you want to show that superstitions are generally based in some reality. I was

going to our technical advisers and saying, 'This is what I need to have happen. Is there anything that fits?'" Kenney says the advisers provided the poison-plant scenario, which would have made the children sick but may have been beyond the community's understanding of the scientific cause, which would have led them to explain it with the idea of the devil's influence.

Director Brian Kelly says the heightened stakes of the illness allowed him to bring into relief the idea that "Claire is coming to this as a relatively emancipated individual. Even in terms of culture in 1945, she's pretty forward thinking and independently spirited. Then she's thrown back in time to a superstitious dark age."

The character of Father Bain (Tim McInnerny) ends up personifying that mentality that Claire

would have seen as backward thinking, and Kelly says he was particularly pleased with how McInnerny brought him to life. "Father Bain could have been a really two-dimensional character, but Tim managed to flesh him out while looking for some degree of humanity. Regardless of how Claire feels about that and how a modern audi-

> "We went through all kinds of crazy permutations of how Claire was going to save [Thomas]. At one point somebody suggested she do a tracheotomy with a straw from a basket, which I just wanted to shoot myself in the head at that point. Luckily, we didn't go down that road."
>
> —ANNE KENNEY

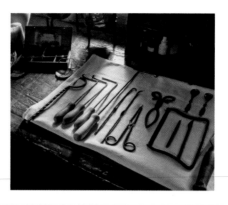

For Lotte Verbeek, the set for Geillis's space helped add to her understanding of her character. "It was great to walk into the set that was my space, my room. Plus, John Sessions [Arthur] was just fantastic to work with. I've never really done actual comedy. But that's also one thing I like about Geillis; there's space for that. I enjoyed that comic tone."

ence would dismiss a superstition, he has to believe it and take control in order to be the voice of authority, the voice of the church that, at the time, was second to the state in divine form. In a lesser actor's hand it could have been arch, two-dimensional, and unbelievable, but Tim bypassed that brilliantly."

At the Black Kirk—the deserted monastery where the boys were playing before falling ill—Claire and Jamie meet to suss out the situation, a conversation that serves a dual purpose. As Kenney explains, "The whole scene is about [Claire] getting closer to Jamie. He's telling her about his background: the idea that he's a Highlander but a well-educated Highlander, and, yes, he's still a little superstitious too." Kelly adds, "On my part, it was a conscious foreshadowing of the flirting that was going on between them. I like the fact that they were obviously teenagers up there."

Later, Claire also meets Geillis Duncan and gets to see her lush loft, crammed with herbs and tonics. "Of course, we knew that Geillis was also from the future," Kenney says. "But she thinks there's something off about Claire and she's not quite sure what it is. When she says, 'Come downstairs and tell me all your secrets,' she's wondering about Claire. She has a suspicion that she might actually be another time traveler."

"I never thought [Jamie] was [kissing] Laoghaire [Nell Hudson] to make Claire jealous at all, because at that point, as he says later, 'I was lost from the moment I saw you,' but he doesn't think that she's really a viable person for him. Also, Jamie is a twenty-two-year-old guy who's a little randy. I think if Claire hadn't come [around], he probably would have ended up with Laoghaire."

—ANNE KENNEY ON JAMIE'S MOTIVATIONS

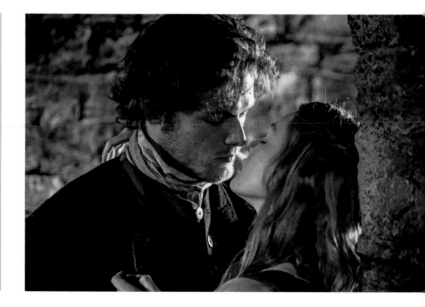

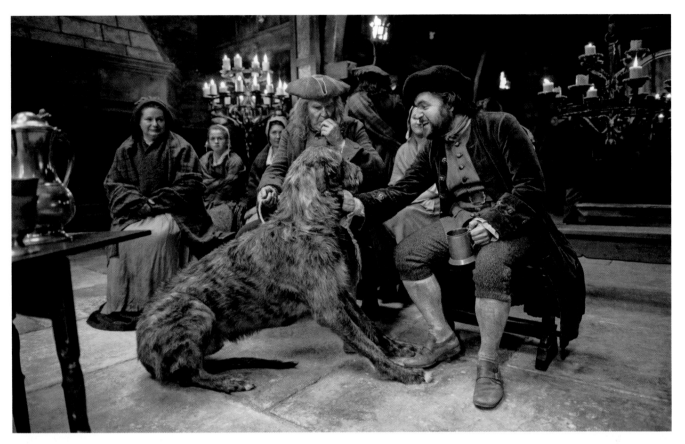

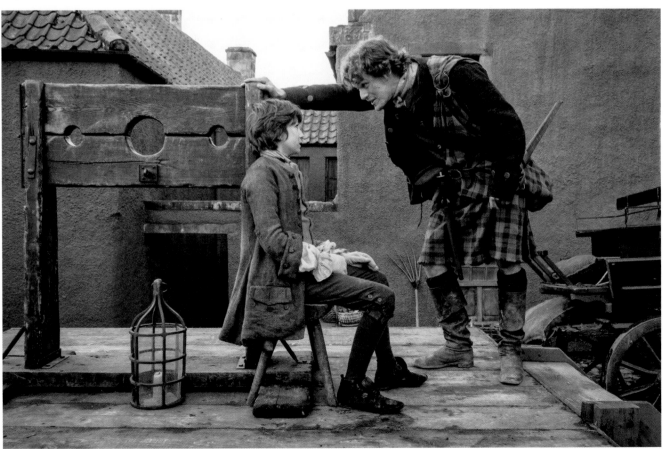

SPOTLIGHT:

TOBIAS MENZIES AS FRANK RANDALL AND JONATHAN "BLACK JACK" RANDALL

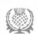

It's a rare achievement for one actor to play two such distinct characters that some audiences believe them to be played by separate actors. But British actor Tobias Menzies, who has spent the better part of two years bewitching audiences with his portrayals of Frank Randall and Jonathan "Black Jack" Randall, has been able to give each an incredibly distinct life onscreen. The former is the loving, erudite husband of Claire Beauchamp Randall in 1945, while the latter is the depraved British officer with a penchant for sadism. That audiences don't boo or wince every time Frank merely appears is no small thing, and keep-

ing the two distinct was a guiding principle in how Menzies approached the roles.

"It sounds odd, but I actually didn't spend a huge amount of time thinking of them as a pair, really. I approached them both independently," Menzies explains. "I just trusted that if I played the situations and the character, what they'd been through would play through, and that would do the work. And I felt like the writing was different enough for the two of them."

A very familiar face in British television and theater circles, Menzies came up for the role via casting director Suzanne Smith. Reading as both men, Menzies made

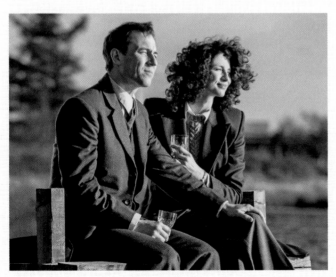

an immediate impression on the producers and sat down soon after to discuss the intricacies, and subtle connections, between the men with executive producer Ron Moore.

"He too was interested in the similarities between Jack and Frank," Menzies remembers. "Obviously they're both men who have been through wars, although wars separated by a couple hundred years. I think both Jack and Frank are men who are formed by those experiences, arguably, but they come to different conclusions. I think Frank is no less affected by his war experience."

With his characters' motivations established, Menzies started his preparation in earnest. "I was keen not to rely on anything too physical to differentiate them," the actor says ardently. "It could have been a very easy route with Jack, I suppose. He might have lent himself to something a bit more ostentatious and prop-ridden, maybe. But it certainly wasn't something that I was particularly interested in. I wanted him to be real and three-dimensional, even though he is obviously an out-and-out villain. I was trying to give as much shape to that as possible."

Instead, Menzies worked to distinguish them in much subtler ways. "We were aiming for the difference being in the eyes," he says. Playing Frank, Menzies softened his face and countenance, especially when looking at Claire. "I think making him more flesh and blood

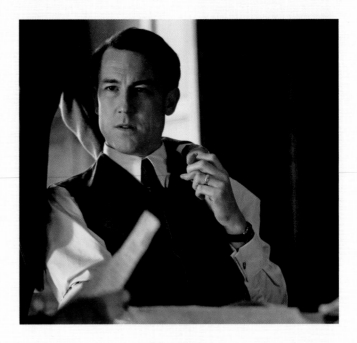

than he is in the books gives him more complexity," the actor says. "It creates some genuine drama really for Claire, in the choice to stay with Jamie. That was a complicated and sort of muscle-y decision, rather than Frank being an irrelevance. That's why we all wanted to turn the heat up on Frank and make that relationship hotter and more meaningful. I think it then raises the stakes for Claire."

When it came time to develop Black Jack, Menzies says the process took longer. "He definitely was the one I had to think about more carefully," he says with consideration. "Obviously, Frank is a lot closer to me and Jack is the stretch."

The actor says Black Jack finally appeared "partly through some conversation with the writers, a little bit of interaction with Diana, and then my gut feeling." Determining his psychology was key. "I quite firmly was much more interested in [Black Jack] as an investigation of a sadist rather than particularly concentrating on the idea that he's in love with Jamie. It's not that he has huge bravado and is very drawn to Jamie in a straightforward erotic homosexual sense. I wanted to make it slightly odder than that, to make it that Jamie became this sort of conundrum that the sadist in Jack wanted to unpick. He met this man who, in a way, was everything that maybe Jack wasn't or Jack had lost. That,

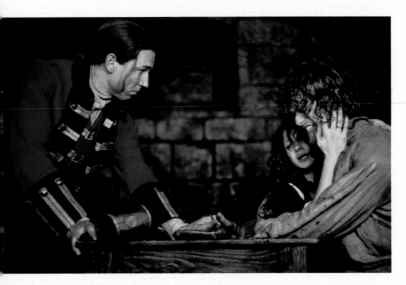

to me, felt like the emotions were therefore darker and more complicated, richer and potentially stronger than just straightforward lust. If he was doing all of those things just for a turn-on, that makes him irredeemable, really. Whereas if he's coming out of his own damage from what he's experienced in war, that for me felt like it was a more interesting route through."

Asked his thoughts on whether Black Jack's dark impulses are first uncorked by Jamie, Menzies says no. "I think his sadism has expressed itself in the past," he says with assurance. "Lallybroch, I think, is a relatively minor chapter in that story. He goes to this place, the guy kicks off, and he does what he would normally do, which is partly military procedure."

Menzies posits that Randall's obsession with Jamie begins with a scene that happens entirely offscreen. "I think the penny drops in the thing that we don't see, which is the previous flogging, where he sees that Jamie hasn't been broken and then he takes on the second flogging himself. He is unable to break him again, and from then on, he realizes he has met, in a way, his match. That's where the fire starts, I think. And I always wanted there to be a huge amount of respect for Jamie [from Randall]. As a human being, he recognizes nobility, in a way."

The actor says the same can be said for how Ran-

dall views Claire. "It's not just unpleasant behavior," Menzies says of Randall's aggressive actions toward her. "It's coming out of a curiosity and excitement. There's an energy there. She gives good game, and she can come back at you. There's an aestheticism about him, and I think that everything that Claire is is pleasurable to him. He appreciates her wit, her physicality, and her beauty. He is not immune to them and appreciates them, even while he's going about unpicking it."

In season two, Menzies revives the character to plague the Frasers once more, but he was determined to present Randall in a different light. "My feeling was I didn't want him to be quite so confident in the second season," Menzies explains. "Due to the very extensive injuries as a result of the cattle, he physically has been reduced. And probably the fallout from what happened at Wentworth and the breach—I'd imagine just in terms of the military hierarchy, maybe the book was thrown at him.

"So when we first see Black Jack in 'Untimely Resurrection,' he's in foreign enemy territory, actually," he continues. "I think at the time Britain was at war with France. My provocation was, we should see someone who has some hairline cracks in the confidence as a result. My instinct was to meet someone changed, as much as possible, by what happened."

That lays the groundwork for the heated duel between Randall and Jamie in "Best Laid Schemes . . ."

after the discovery of Fergus's assault. "That duel is driven by Jamie's anger more than Jack's, I think," the actor says. "Jack's taken what he wanted from Jamie, but he recognizes that he has to honor the challenge. Again, I think going in with that idea that he's slightly less Teflon, there's more apprehension and less feeling of invincibility going into that fight than maybe he would have had a few years before."

Death is averted for both men with the arrival of the gendarmes, which opens the door for the conclusion of Claire's own arc with Black Jack in "The Hail Mary." The terminal condition of Jack's brother, Alex, affords the audience one more opportunity to be surprised by the character, seeing him express love and devotion toward his sibling. "Jack's brother represents the only sacred thing in him, really, and it is an anomaly," Menzies explains. "His brother sees good in him, and that does odd, uncomfortable things to Jack, but yet he tries to be that person for his brother. I think it harks back to who he was prior to his experiences in the army."

When Claire and Randall commiserate over Jack marrying Mary Hawkins to ensure that Alex's child is raised well, Menzies says, he looked at that as an unexpected truce. "You could almost go as far as to say that maybe if you asked Jack, he might even describe them as friends," he offers. "It's very odd, but he feels a very

deep connection with [Claire and Jamie] because of what they've experienced. There's that line in Wentworth where he goes, 'We will remember this moment for the rest of our lives.' I think that is true, and that is a weird bond. That's why he feels able to confess and seek Claire's help with his brother, because there's a level of understanding between them, and when he says, 'I can't marry the girl,' she will understand that. Essentially, Jack doesn't trust himself with the girl."

Jack's last violent outpouring of grief over his brother is the last Claire, Jamie, and the audience may ever see of Black Jack Randall, as his date with destiny beckons on Culloden Moor. Menzies assumes that Alex's death represents "the loss of some final kind of plank to anything good within him." Whether or not he's satisfied with that ending is "a hard question to answer," Menzies admits. "I think it's a curiosity of the books and, in a way, this season that Jack does sort of disappear from the story, after having been such a strong presence in the first book. And he's a wonderful baddie that Diana's written, but she doesn't really utilize him hugely from there on out. I think it's a good [exit], but it's also a question of, what do you do after Wentworth, in terms of where do you take that story? I think it was a conundrum for the writers."

In the meantime, Menzies looks forward to further exploring Claire and Frank's twenty years of marriage in Boston. "I think that could be interesting," he says. "There's a real profundity about what they find between them, for all its flaws and deeply compromised nature."

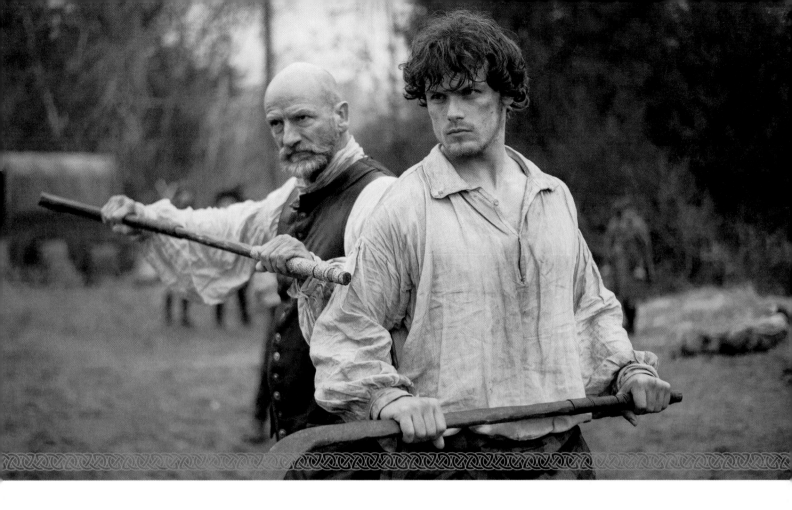

EPISODE 104: THE GATHERING

WRITER: MATTHEW B. ROBERTS DIRECTOR: BRIAN KELLY

Scottish culture—its hierarchy and its politics—takes center stage in this episode, as the MacKenzie families arrive to show their annual fealty to Colum at Castle Leoch. Written by Matthew B. Roberts, "The Gathering" featured a lot of new faces, dynamics, and cultural proceedings (like boar hunting), all of which Claire has to understand and adapt to quickly.

"It was one of those stories that had a lot of work to do," Roberts

> "Jamie, in a lot of ways, represents Dougal as a young man. He sees himself in Jamie. At the same time, he sees the threat that Jamie embodies. That's what I always had to try and walk that line between, those two feelings."
>
> —GRAHAM MCTAVISH

says. "There's certain episodes that can linger and just be more lyrical,

so to speak, but 'The Gathering' had to be a workhorse. It had to explain a lot of stuff, like the dynamics of the clan system."

Aiding that visually was director Brian Kelly. "There's just a lot going on behind the scenes and then a lot of learning who these people are and what they mean to each other," Kelly says of the challenge of bringing to life the inner workings of Clan MacKenzie. "There's the Gathering formality and then also the loss of somebody

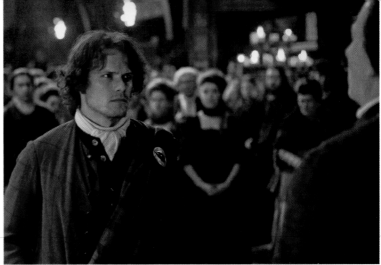

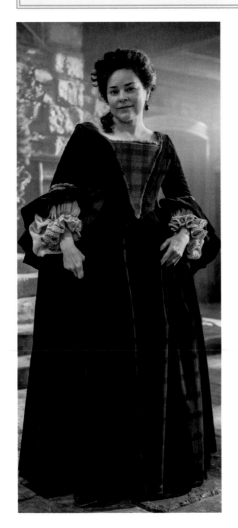

[Geordie] in the day-to-day, which is part of their life. It all helps flesh out how they treat each other and the importance of what their life means."

To get Claire—and viewers—up to speed without lengthy, tedious explanations, Roberts says, he used a writer's trick for combining background with action. "Dur- ing the Gathering speech, where Colum says it all in Gaelic, Murtagh is interpreting and basically outlining what's going on in regards to how Jamie had to remain in hiding and who he is. I thought it was a clever way of getting out the exposition in a way as something else is going on around it."

Filming the oath ceremony uti-

"Dougal's got a touch of the peacock about him. I think he's quite vain. He's not shy about bringing out a nice little outfit to show off. He was dressing to impress. You know, Terry used to refer to [my costume] as my Darth Vader outfit. I think he's a little kinder than Lord Vader, but he's very much making a statement of power with that outfit."

—GRAHAM MCTAVISH ON DOUGAL

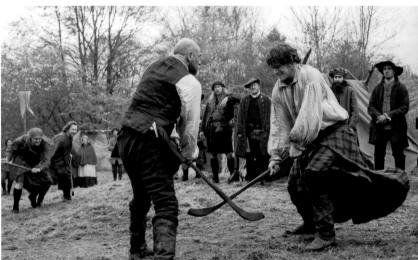

"For the stickball game, they were real shinty players. They had been standing around all day and looking at these lily-livered TV folk. It got a bit physical but in the best possible sense. In the end, Jamie and Dougal were having a face-off. I took one of the small cameras myself and was shooting it. One of my camera assistants turned to me and she said they were like two stags, and that's exactly what we wanted."

—BRIAN KELLY

> "One of my favorite scenes that I have written is the one where Claire puts a sedative in the wine.
> She and Angus are having a conversation about it, and the way Stephen Walters
> and Caitriona played it, I couldn't have been more pleased."
>
> —MATTHEW B. ROBERTS

lized the massive Great Hall set created by Jon Gary Steele and his team, which was filled to the brim with cast, crew, extras, and special guests. "It was pretty daunting, I have to say," Kelly remembers. "In terms of physical space, we rehearsed for a couple of days with all the background artists. I think that was the right thing to have done,

because we got them to rehearse dances, their reactions to stuff, and how everyone would part when

people would walk through. That made a big, big difference. We didn't really have to think about them, so then I could throw all my resources and energy toward the cast, as we had almost every member of the cast on the set that day. Plus Ron was there and Diana as well—no pressure!"

SPOTLIGHT:

GARY LEWIS AS COLUM MACKENZIE

Actors all have their different entry points that allow them to tap into the soul of a character. For some it may be an accent, or a costume, maybe even a particular line of dialogue. For Gary Lewis, the window into the soul of Colum MacKenzie, chieftain of Clan MacKenzie and Castle Leoch, was the man's library.

As he was reading Gabaldon's novel to get to know the character, Lewis says, Colum's love of books piqued his interest immediately. "It posed a question," the native Glaswegian shares. "What books were around in the 1740s in Scotland, and what books would have been available to somebody like Colum? Now, that opens up a lot, because you get a good idea that he's a *very* thoughtful man," the actor emphasizes with his Scottish brogue. "He considers things carefully because he's trying to see a bigger picture. He considers tactics and strategy and political matters. So I pictured there

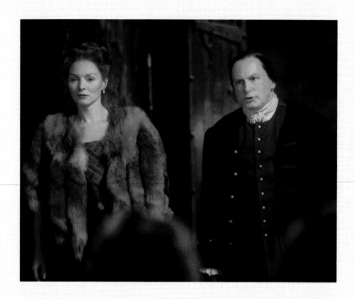

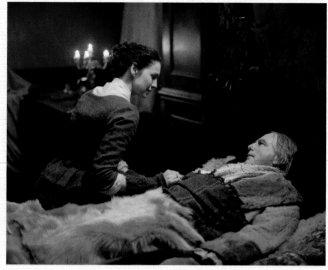

being a copy of Machiavelli's *The Prince* somewhere in those bookshelves."

Lewis contends that Colum would have read the book for its political strategy. "Mayhap he was like a Highland Machiavelli, although I didn't quite grasp him as being that," the actor muses. "There's more than one side to Colum. He wasn't just a horrific dictator but there was a softer side to him as well. He actually, really cared for people, but because of the circumstances in which he lived, he had to make very harsh decisions."

Lewis says peeling back the layers of Colum over two seasons was a fascinating endeavor, since he's a

character who possesses a keen intellect inside a compromised body. From his initial costume fittings, Lewis worked with costume designer Terry Dresbach to help him portray the symptoms of Colum's Toulouse-Lautrec Syndrome. "Terry was very helpful, because she made me a pair of shoes to emphasize it," he reveals. "They were wedged to emphasize that gait."

Lewis also researched how else the malady would affect his day-to-day. "What does it cost you to have this disability?" the actor asks. "How does it affect your breathing, your speech, how the pain would maybe greaten your temper? I work with the physicality in relation to the pain itself and also what it costs

him to subdue this pain with so much alcohol and then trying to hang on to his hat in terms of his mental abilities.

"I pictured him being absolutely exhausted after some of these encounters," Lewis divulges. "He never shows it until he's able to surrender quite visibly in front of Claire. He can surrender and feel the life draining from him. But for everybody else, I think, he puts a great effort into taking care of business exactly in the moment.

"Colum plays the cards he's been dealt, with his disability, with the political and the military situation with the family. Dougal sees himself as an ace, but for Colum, a lot of the time, he's the joker or a two of spades," Lewis laughs.

Luckily, Lewis's relationship with frequent scene partner Graham McTavish was far easier to navigate than the one between their characters. The old pub mates developed an offscreen rivalry that fueled their onscreen chemistry. "When I'm sitting with my wife [played by Aislín McGuckin], he would mutter away about [how] when he fathered Hamish [Roddy Gilkison] it wasn't a ten-minute affair, as he was in there all night. I can't tell you my retorts, I'm afraid."

As Colum's arc comes to a close in "The Hail Mary," Lewis says it was all about taking care of business before he goes. "He still has the games that he plays, but he's already crossed the Rubicon deep inside," the actor explains. "He's made the decision. The only emotional [moment] is with Claire, because he's saying goodbye to her, as well as to life. When she gives him the potion, then he knows that this is his way out."

It's said that all actors yearn for a good death, and Lewis says he's thankful for Colum's happy death. But that doesn't take away the sadness of leaving the *Outlander* company. "It didn't hit me until I left the set," he remembers. "I did the last scene and then I had to go and pack up. It was only when I was in the car heading away, I thought, *Oh my God!* Colum was a delight, you know, and a smart, smart man."

SPOTLIGHT:

Graham McTavish as Dougal MacKenzie

For actor Graham McTavish, getting cast as Dougal MacKenzie in *Outlander* wasn't just another role to add to his already very impressive résumé. It was a chance for the actor to go back home.

The Glasgow native has worked all over the world, from Los Angeles to New Zealand, with his career, but shooting in Scotland was a rare treat. "Scotland's the place where I not only spent a great deal of time grow-ing up with my family but also where I really learned to be an actor, I suppose," McTavish says. "I went to uni-versity in London, where I did acting, but subsequent to that it was Scotland that I moved to to learn the craft through the experience of actually doing theater."

Despite a varied career doing voiceover work, tele-vision, and films (most recently as Dwalin in *The Hobbit* films), the character of Dougal MacKenzie represented

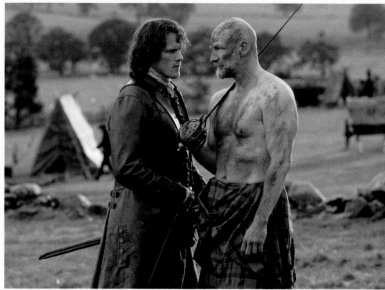

a unique opportunity for McTavish to sink his teeth into a robust, flawed, deeply patriotic Scot. "My goal, really, was to make him a well-rounded character and a multilayered and complicated character."

Dougal certainly ticked those boxes over two seasons, and McTavish says he always kept the character's obsession at the center of all his actions. "His overarching super-objective is the restoration of the Stuart monarchy," the actor says simply. "He hates the British because they are an occupying force, occupying his country against the will of the people of that country. He would've been a child when it happened, and this was utterly devastating to Scotland. To Dougal, it was almost an obscenity that the Hanoverians were on the throne and that the British were in Scotland."

Keeping that as Dougal's North Star created a through line for the actor and helped define the relationship between the MacKenzie brothers. McTavish compares the clan dynamics to modern-day politicians or the Mafia. "Dougal and Colum are a form of Mafia, and there's the power struggle within that. We very much echoed that."

McTavish says the fraught relationship between Dougal and Colum was so compelling because it was so relatable. "It reflects relationships that you have with people that are close to you," the actor says. "It certainly brought to mind my own sense of regret in regard to my own father. Not that we weren't close—we were—but

my father was a very working-class Norwegian man. I never doubted that he loved me, but there were things that I never got to tell him, say to him, or ask him before he died, and that, I think, really resonated with me."

McTavish says the MacKenzie brothers' final farewell in "The Hail Mary" amplified that sense of regret. "When I was doing that scene, I felt that need to tell someone the truth about how you feel, and then for that to be denied to [Dougal] is just devastating. To be honest, if he hadn't been killed in the next episode, I think Dougal would've just fallen to pieces down the road. He would've seen Culloden through, but I think after that he would've been a shadow of his former self."

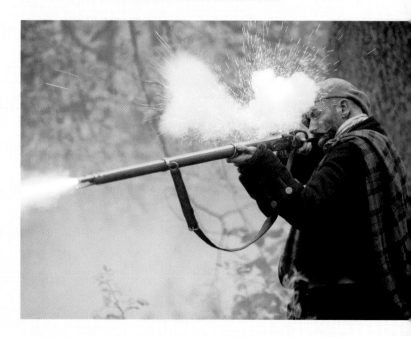

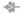

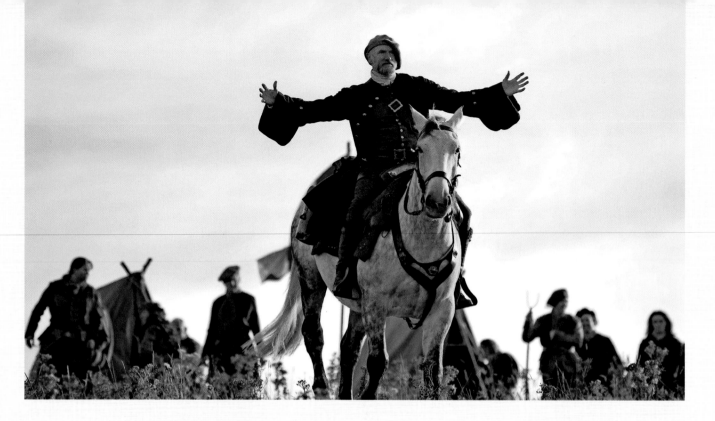

It's an unexpected end for Dougal, dying at the hands of his own nephew and his wife, but McTavish says the journey to that moment was very rich to play. "The relationship he has with Jamie, especially in the second season, I found particularly interesting, with their growing closeness, trust, and respect. Dougal's looking at Jamie and seeing him become a real man and a leader. It was wonderful and so poignant that all of that is just taken away from him. When you have given your trust and love to somebody, to have it taken away from you is just the worst thing.

"It was a great opportunity for me to introduce my children to Scotland," the actor says of his time on the series. "They're young and were able to come live with me and my wife in Edinburgh and really experience Scotland. *Outlander* gave me that, which is something that I'm very grateful for."

EPISODE 105: RENT

WRITER: TONI GRAPHIA DIRECTOR: BRIAN KELLY

Under duress, Claire joins the MacKenzie rent-gathering expedition for a long journey into the Highlands. For writer Toni Graphia, "Rent" started out as a writing assignment she admits to having had hesitations about. "I was a little bit intimidated to write that episode," she says. "It was more of a 'boy' episode, as it was on the road, it had a lot of Gaelic, and it was a lot of po-

litical machinations. But in the book, there was a sentence that said something like, *Claire wanders through the village and has tea with*

the village ladies. I thought, *That's where I'm interested. I want to follow Claire and see what she does, so that's where I was able to take that episode and make it mine.*"

As can often happen on set, the episode evolved from Graphia's script due to the realities of filming on location. "When I first wrote it, the opening was going to be on Claire skinny-dipping in a loch," she reveals. "Then

all of a sudden you hear this Gaelic yelling, and these naked Highlanders cannonball off the cliffs and crash into the water all around her. But when Ron got over there to start filming, one of his first phone calls was to me saying, 'We're not going to be able to do skinny-dipping, because it's freezing here,'" she laughs. "The opening that you see now, which is also beautiful and I'm proud of, is Claire reciting [John Donne] poetry by the lake."

Director Brian Kelly was able to frame that recitation in a gorgeous landscape that set a new standard for the series. "From the very opening, you can see this is somewhere new and different. We'd been worried about Castle Leoch only being in the woods, so this was actually a chance for us to go to the Highlands proper, which is so beautiful.

"The whole episode was very much informed by my childhood desire to make a western," Kelly

continues. "On horseback, you go through different environments, and being on the open road gives us a chance to play a little bit with moving the camera. For a scene where Ned [Bill Paterson] and Claire are chatting as they ride on horseback, we got a rig built, swinging a crane off the back of a pickup truck to follow them."

More important, Kelly says, the tantalizing open spaces serve to discourage Claire. "Her means of escape, she can see it wherever she goes," he explains. "She knows if she

turns this way or that way, it could be the way out, but quite honestly, where does she want to go? It's all frustrating for her to be presented with a means of escape but not be able to exercise it."

Graphia's attraction to the idea of Claire wandering through the village led to the wool-waulking party scene, one of the most memorable moments of the episode. But that scene also evolved from the original script. "The first scene that I wrote was that she goes into a house where the village ladies are hanging out. They have whisky together and Claire teaches them to play poker." But Diana Gabaldon read the script and noted that women of that time would not have downtime, Graphia explains. "Maril Davis had the idea, because she had read forward into book two, that there's a reference to Jenny doing wool-waulking."

Brian Kelly says he was charmed by the realism of the sequence. "To just urinate in a bucket and then start working with it!" he enthuses. "Well, that's what you have to do. It grounds it into historical accuracy and is a window into a life that most viewers wouldn't know. Plus, Caitriona does that slight awkwardness when she just sat down and joined in so well. It was really touching."

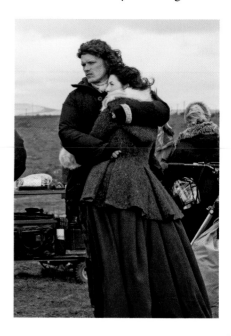

SPOTLIGHT:

GRANT O'ROURKE AS RUPERT MACKENZIE

Before *Outlander* relocated him to the Highlands of Scotland, Grant O'Rourke spent most of his professional life tromping the boards in theaters across the United Kingdom. As Rupert MacKenzie, one of Dougal MacKenzie's most loyal enforcers, O'Rourke has brought new life to a Highlander who was a minor character in the original novels.

Paired by writer Ira Behr, actors Stephen Walters's Angus Mhor and O'Rourke's Rupert MacKenzie became the "lovable knuckleheads" in the writers' room,

because of their ability to lighten the tone of the script when needed. It's a role that O'Rourke says he happily assumed, drawing on past comedic experience onstage and in television.

The actor says he got the role so quickly that he wasn't initially sure what the producers wanted from him. "I made a self-tape, sent it off, and I never met anyone at all," O'Rourke says. "They offered it to me about a month later, which I don't think will ever happen again in my career," he laughs.

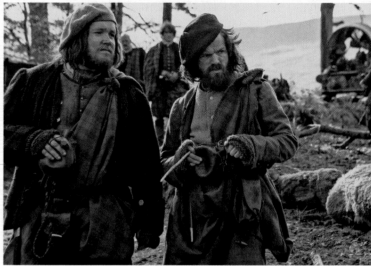

O'Rourke says he looked to the books to help him prepare but didn't find a lot about Rupert. "The only thing I could find out about the character was that he was fat and he had a beard, so I've got that nailed," the actor quips. "But there is quite a Scottish sense of humor with him, dispelling attention and keeping everybody's feet on the ground by making jokes. It's not about being a wisecrack or him wanting people to like him. It is almost about defusing moments and disconnecting yourself from anything too grave and dangerous. I know a lot of people like that, who are very quick to take the piss out of you, frankly. But they'll be the first to stand on your side if anybody else did, so that was a leaping-off point for me."

Often in the thick of the rough location shoots, O'Rourke was indoctrinated quickly into the physical-ity of the show, on the pilot. "When Jamie passes out, I had already been on the horses for about four or five hours in total at that point," he reveals. "We all had to dismount very quickly and go and tend to Jamie. I dismounted a bit too quickly and bent my finger right back and injured it for about three months.

"It was a happy kind of happenstance," he continues with a laugh. "My finger was sore, so all of the Highlanders went to pick up Jamie and move him and I didn't. I just hung back. It kind of made sense for the character, because Rupert, you'll notice, never picks *anybody* up. I realized that he sees himself as more of the delegator."

That element of trying to shirk their labor became a comedic riff between Rupert and Angus and helped solidify the chemistry between the pair. "Our relation-

"*I was one of the first [Highlanders] that insisted on dressing myself. You have people from wardrobe come in and help you with the kilt and everything at the start. I was very keen to just get rid of them so I could do it myself. Everything that Rupert wears is a decision that I have made at some point and a decision that I was prepared to make every day for practicality.*"

—GRANT O'ROURKE

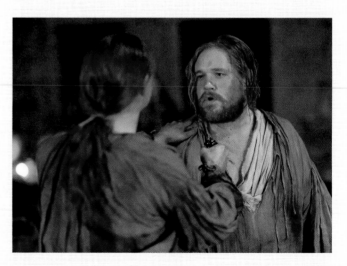

ship was developed over the course of the whole season, because we were always together," O'Rourke says of working with Walters. "Inevitably in between takes we stood together and chatted. I think the chemistry had a lot to do with Stephen, who is warm, friendly, and open. We were constantly standing next to each other, so we managed to create a relationship just because Stephen is such a great guy. He is very good with people, and I am not," he laughs. "So I've always compared Rupert and Angus to R2-D2 and C-3PO. Rupert complains a lot about Angus, and there is a disdain because he sees himself as quite elevated. Angus is like R2-D2, because you can't understand a word he says. He's much more aggressive."

After an extended break, the pair returned in the second half of *Outlander*'s second season. O'Rourke says the narrative felt a lot more "tense," but the company did not. "We were all so pleased to see each other

again," he says. "We just picked up the old routine. I think there was an element of learning to enjoy it a bit more. Obviously as an actor you don't know, this may be your final run."

Such was the case for Walters's Angus, whose death creates a surprise twist at the end of "Prestonpans." O'Rourke admits he was gutted to hear he was losing his scene partner. He remembers the shoot day as "quite respectful" in general. "An actor's death is a sacred thing," he says somberly. "I was lying on the bed, and Rupert kind of half wakes up and hears after [Angus] has fallen. It really hit me when Stephen started choking on the blood. It felt a bit real at that point, really."

As far as Rupert's reaction to the loss, O'Rourke says, "All I wanted from the scene was that when he goes over to pick up the sword and he goes back and sits, I wanted Rupert to be on his own. I wanted people to be able to see that he was now a single entity."

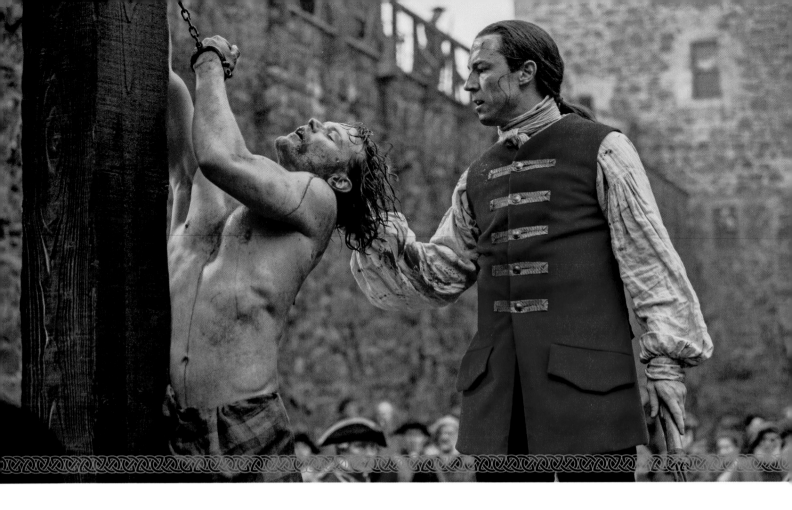

EPISODE 106: THE GARRISON COMMANDER

WRITER: IRA STEVEN BEHR DIRECTOR: BRIAN KELLY

From its conception in the writers' room, "The Garrison Commander" was always going to be a departure from the previous episodes in terms of structure. Writer Ira Steven Behr inherited the task of writing the episode due to a swap in the writer rotation, and he admits that the sudden change initially vexed him and left him unsure how to ap-

> "It was like a piece of theater. As an actor, to be given eight pages in a scene and just be told that we are going to do it in one long take is such a gift. You don't get those opportunities very often."
>
> —CAITRIONA BALFE ON THE INTERROGATION SCENE

proach the story line. It wasn't until Ron Moore suggested that he write it like a one-act play that he found his angle. Behr says the moment where Captain Randall pours the wine out the window helped him really "see" the man and his character to write him. "Besides being a sociopath, besides being dangerous and whatever else you want to call it, there's that real perverse, almost

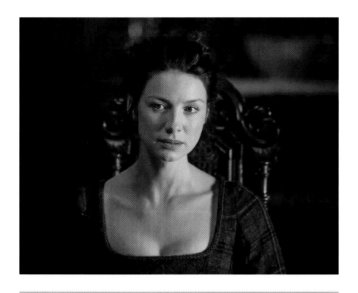

"For me, it was all about to what extent does Claire believe that there is a part of Frank within Black Jack at this point? And to what extent does she believe in his humanity? I think her experience as a nurse, having dealt with soldiers who would have experienced post-traumatic stress disorder, gives her an ability to hold a space for someone who is experiencing a struggle of conscience from these terrible experiences. I think that she walked into that [room] obviously very wary of Black Jack because of their previous encounter but that maybe she could understand that here was a man who had been affected by terrible atrocities of war and that maybe there was a way to reach him. Obviously, then she discovers there is not exactly a redeeming quality there. But it is a beautiful scene in that moment that you almost believe that she has reached him. She believes it so wholeheartedly."

—Caitriona Balfe on Claire's motivation with Captain Randall

"Before he understands that the two of them are linked, or connected, [Claire] has piqued his interest, partly because she's English. I think he believes, or suspects, her to be a spy in some way. My feeling, the more I worked on it, was that he was a collector, a connoisseur of the human condition. I think he's a very astute reader of people and he enjoys the chess of Claire. He again, in a different way, finds a very worthy opponent and he enjoys the chase. I think he would not see a contradiction, because the perversity in him is that he sees beauty in the punch as well."

—Tobias Menzies on Black Jack

infantile need to claim power," he says of Black Jack's character.

Behr constructed the majority of the episode as a two-hander—a play for two actors—in which the story is focused on Claire and Jack, alone in the upper loft. "I thought it was a tremendous opportunity to put our lead in jeopardy without ever having to resort to all the horrid clichés of, 'Is she going to be raped? Is she going to be hurt physically?' If you don't love Claire after this episode, if you don't respect Claire after this episode, then I don't know what else we could do."

Director Brian Kelly admits he was initially hesitant about how best to bring the episode to life. "I was incredibly daunted by it when I read it the first time. It felt like, that's going to get a bit dull for the audience, but in actual fact, to be completely honest, I was truly thinking, *How am I going to do this?* Unlike 'The Gathering,' there is nowhere to hide. This is just the two of them."

Kelly realized the best way to let the interrogation play out was to

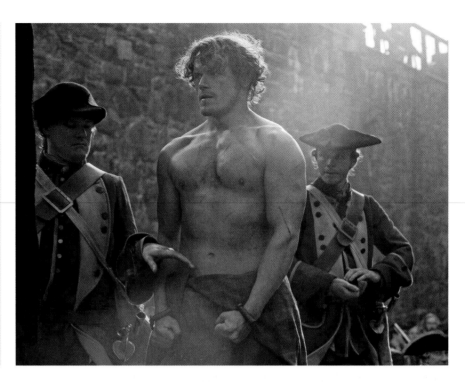

get out of the way of Balfe and Menzies and trust his actors. "We rehearsed for a couple of days where you get into the space, and we sat and moved around. Once I got all that in shape, it was standing back and letting them go on with it. It was just a delight and a privilege to watch them act, trying to create that environment where they felt comfortable. It was tough on them both because of the physicality.

One tends to concentrate more on what Claire considers, but Tobias has an awful lot to do here as well. He even has the ability to actually make you almost feel for that guy."

Within that conversation, the story flashes back to the public flogging that left Jamie's back permanently scarred. Kelly says he always intended to shoot the scene with no compromises and to pull back in the editing if needed. "Sam was fantastic, because it was absolutely freezing that day," he remembers. "Because of the schedule, we shot that a good five or six weeks before we shot the room with Cait and Tobias. Because of that, I thought, *I need as much as possible here* [to make that land]. Tobias gives good

psycho, let's be honest. The layers of obsession that Jack has with Jamie—he's consumed by it, and you see it in that scene. There was corn syrup on the stage and he slipped in that, but when it happened it was like, 'Wow, that's fantastic!' Then there's a point he turns to the crowd and tells them to be quiet, and that was an ad-lib from Tobias."

> "The last scene was informed a bit by screwball comedies. Cait picked up on that in the way she's pacing around. It was the idea that she should be painted into a corner with absolutely no way out, then to put it in such a beautiful environment as well. That wasn't to do with making it feel romantic. It was the juxtaposition. It was what we were seeing and what she was feeling. Again, it was the notion that all that she had been through and the idea of escape was a hairbreadth away."
>
> —BRIAN KELLY ON CLAIRE'S REACTION TO BEING WED TO JAMIE

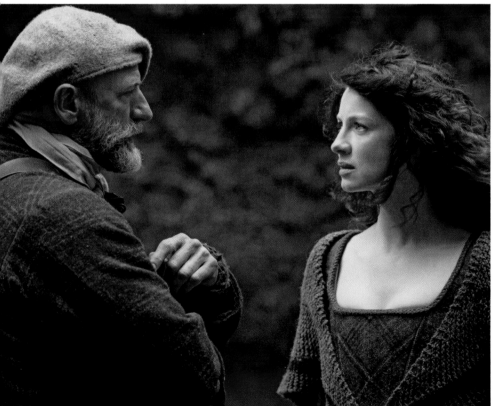

> "When I do, quite literally, rescue Claire from Black Jack, he establishes to his own satisfaction that she is trustworthy with the drinking of the spring, and he's on a threshold with her. Not that she's crossing the threshold with him. It's very much 'game on' for him, which is why the whole wedding is just so difficult for him to deal with."
>
> —GRAHAM MCTAVISH ON DOUGAL'S MINDSET REGARDING CLAIRE

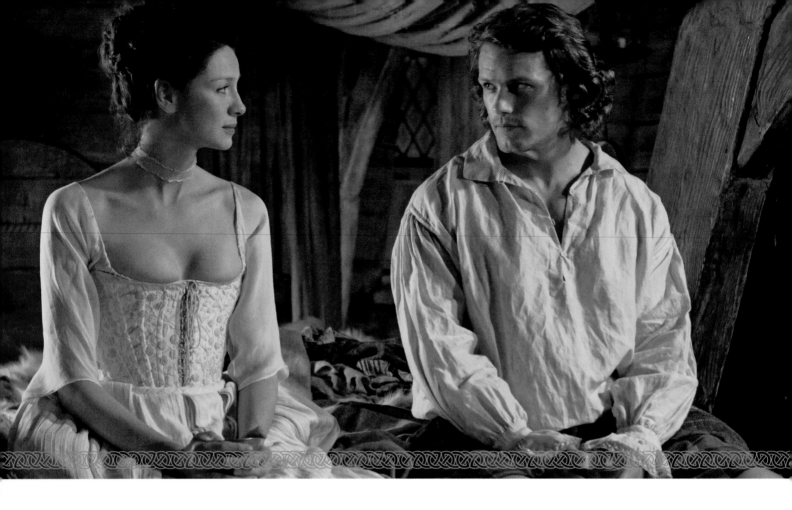

EPISODE 107: THE WEDDING

WRITER: ANNE KENNEY DIRECTOR: ANNA FOERSTER

I t's hard to exaggerate the importance of the wedding of Claire Beauchamp Randall to Jamie Fraser, both in the hearts and minds of fans and in terms of its significance as a defining moment for Gabaldon's *Outlander* novels. Series writer Anne Kenney says she was aware of the great consequence of—and, subsequently, expectations for—the episode that would contain that wedding, and that's what drew her to write epi-

sode 107. "When I walked in the door, I knew that's the episode I wanted to write," she says. "When it was getting assigned, I went flying across the room, and it was

funny because the guys were like, 'Oh my God, you can *have* that episode.'"

Kenney found herself paired with director Anna Foerster to bring the marriage to life on the screen. The two women agreed that they wanted to make sure the episode would chart a tremendous physical and emotional evolution for Claire and Jamie.

"At that point [in the writing], we were still only in Claire's point

of view," Kenney explains about their narrative structure. "We couldn't go out of her point of view. We had to devise a convention where we can see Ned getting the dress and Rupert and Angus with the ring. How would she know those things? We decided it was Jamie telling her these stories, which fit organically because we say Jamie's such a storyteller."

The wedding night also portrays the physical consummation of Claire and Jamie's mutual attraction, which at this point has teased fans across six episodes. Aside from the consummation being necessary to legally bind the marriage, it also carries intricate emotional repercussions for Jamie's and Claire's characters. "In terms of the sex, I think that the goal was we knew we were going to have them make love three times, and each one had to mean something different and, ultimately, move them to a new place in their relationship," Kenney explains. "The first needed to be first-time awkward sex, so we added in stuff like where she

"The moment in the stable when Jamie seeks Murtagh's blessing before he gets married was a great moment, where he gets his blessing in a roundabout way. Murtagh also reveals a little bit about Jamie's mother and about his love for her. I don't actually think he says much, apart from that she is a bonnie lass or something, but you can see that Jamie really needs Murtagh's blessing before he can continue with this. Going back to the Gaelic, I like to call him athair baisti, which is 'godfather.' It just feels like this special bond."

—SAM HEUGHAN ON JAMIE'S CONNECTION TO MURTAGH

says, 'You're crushing me.' The second one, Ron kept referring to it as the playful 'Wow, *this* is how this works' time. Then the third one we decided was the love lovemaking, when they got to a different place."

When it came time to shoot,

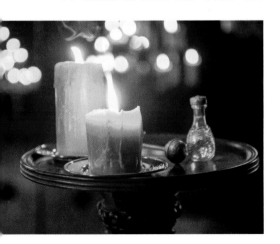

"I actually filmed [the scene where Rupert and Angus interrupt the bridal suite] two days after I had done a thirty-mile kilt walk for charity. I was in so much pain that I was almost in tears putting on my boots that day. It took me about ten minutes to walk about a hundred yards to get a sandwich. But it was one of these days where you got to go in and have fun with a scene and play around with it. I was in a lot of pain, but hopefully you can't see that."

—GRANT O'ROURKE

Foerster was adamant about having a thorough rehearsal before the set was even built. "We talked through the scenes over and over," she explains. "What could happen here, what should happen here, where do they need to end up? He's clumsy in a way, and that doesn't just happen. We walked through it over and over again but without emotionally going there, without playing the scene."

The result was an episode that was enthusiastically received by critics and audiences for being both sensual and stridently feminist in its point of view. Foerster says she didn't set out intending to do something different from other love scenes on TV; rather, it came organically from the characters and

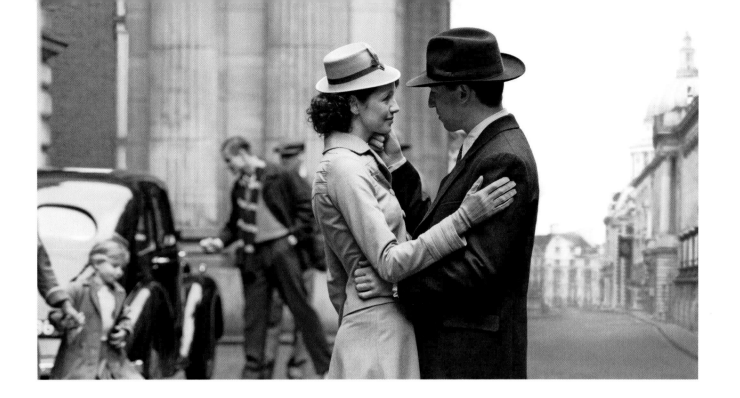

story. "It was really an important thing that with those three stages, we earned each one," she explains. "The way each was shot and blocked earned the next one, asking the audience to go there. So it was absolutely crucial to me to make sure that I stay with our characters, that I see what they see. I'm there with their emotions, with their expressions, with how they experience the thing. A lot of times sex scenes are created as a fantasy of men, in terms of you have that voyeuristic idea of that's how sex should look or this is how sex should be. It was

absolutely crucial for me that I had to make sure that every shot was true to their experience. Just as an

example, when they undress and Claire walks around Jamie, it's how she experiences his body for the first time. How she watches him, how she takes him in. It's funny because people point out in my episodes, and it's absolutely true, that I'm a huge fan of showing hands to explain certain things, like tracing the movement of the way Claire touches him. So basically their sexual or emotional relationship is anchored in the way those three sex scenes evolve and is laying the groundwork for whatever comes after as well."

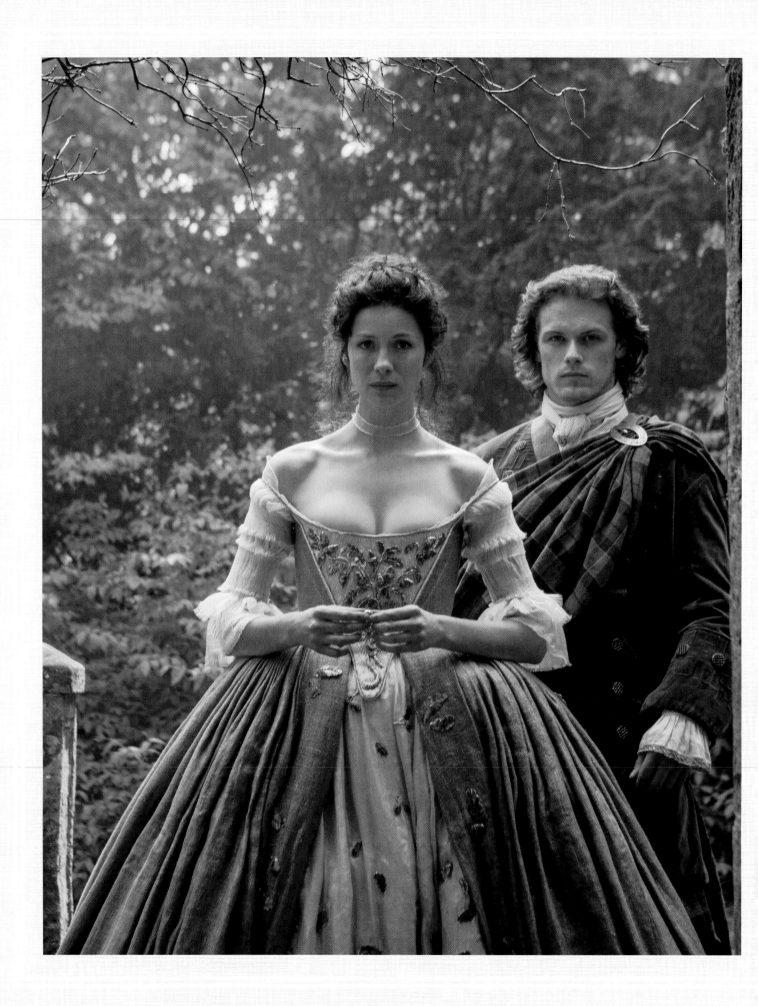

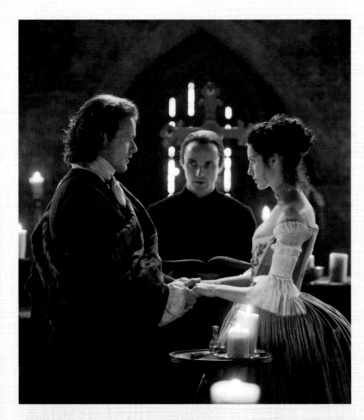

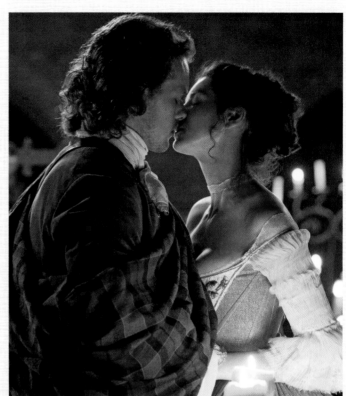

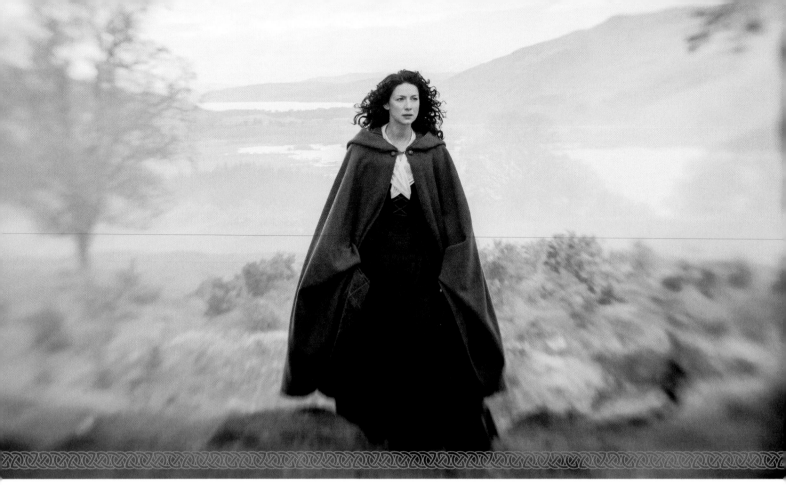

EPISODE 108: BOTH SIDES NOW

WRITER: RONALD D. MOORE DIRECTOR: ANNA FOERSTER

I n the early days of the show, when Ron and Maril initially mapped out all sixteen episodes, it was clear that Claire being rescued by Jamie from Black Jack at Fort William would be a riveting cliffhanger to set up the second half of the season. The question then became, what would be the events that could lead to that high-stakes moment?

"It was one of those moments in the writers' room where someone

said, 'We haven't seen a lot of Frank. What if we cut to Frank in the 1940s and see what he's been doing looking for Claire?'" Moore recalls. "Everybody went, 'Well, that's not really in the book. They never broke her point of view. Can we do that?' But we all kept talking and we started getting excited about it."

Moore continues, "I remember I had this idea of starting on the telephone ringing over black, and that would take us into that world.

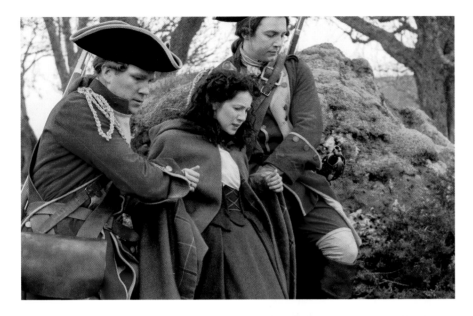

at the same time. Then everybody got excited. It was just one of those great moments in the writers' room where suddenly you're all riffing off each other and you really have this momentum that builds into something."

Anna Foerster was charged with bringing the excitement on the page to life on the screen. The romance of "The Wedding" sets up a little bubble of domestic happiness that's broken up quite dramatically

We start the story of what Frank's been doing as he's been searching for her. We talked about doing scenes at the Reverend Wakefield's [James Fleet], and somebody said, 'What if Mrs. Graham [Tracey Wilkinson] tells him about the stones?' Then someone else said, 'Then you know he would go out to the stones.' I thought we could start crosscutting between Claire at the end going up to Craigh na Dun and Frank going up to Craigh na Dun

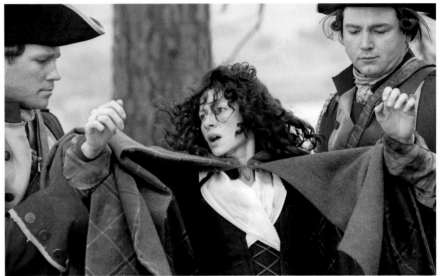

in this episode by the portrayal of Frank's anguish and the brutal attack on Claire.

Foerster says she was thrilled to start the episode with Frank in 1945 Inverness. "I think it was a genius decision to show more of him. I remember when I listened to the [audiobook of *Outlander*], I was asking myself all the time, 'What's Frank doing?' I was thinking about him. Suddenly, here comes the answer. It makes it so much more dra-

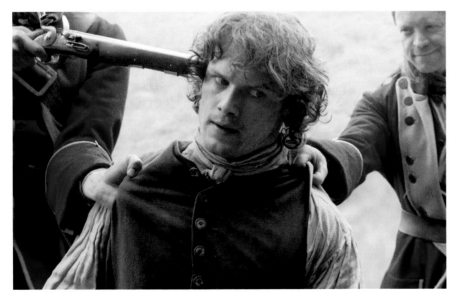

matic, because you see this is somebody who is really, really suffering over the loss. You see him in the police station and he's really upset."

Later in the episode, the honeymoon is over for Claire and Jamie when two Redcoat deserters capture them and attempt to rape her. Foerster says there were a lot of

key developments to set up with that one brutal scene. "One of them was really the aftermath, when she's walking on [the ridge] and she has the bloody hand," she details. "It took us a very long time to work out where we shot this, because it was very important for me that you can see her in the foreground while you have the rest of the scene unraveling in the background. That was visually how removed Claire is from them and their friends.

"Also, there is a technique used when the rape [attempt] happens that is almost a blur in her mind," Foerster continues. "I know some

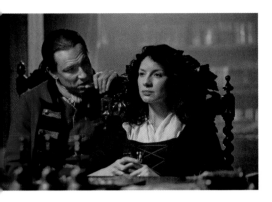

people like it, some people don't like it. It was very important to me that, again, we feel what she is experiencing, so that meant distorting the images a certain amount. The movements imply she can't quite fathom what's happening to her and what's going on, so that was an attempt to visualize that. It's like identifying yourself with Claire. This rape, or almost rape, is traumatic, but I feel the real trauma is the way she experiences it. I didn't want to have a situation where you step back and you say, 'That's really terrible.' I wanted to have a moment where you're in it and you say, 'Oh no.'"

For the intense scene where Claire escapes to the stones and then gets captured, Foerster worked hard to achieve what Moore and the writers conceived. "I personally spent a lot of time conceptualizing, storyboarding, and working out this whole thing at the stones, where they finally 'meet' each other. That was very highly, technically worked-out stuff. The way Frank walks around and moves, then looks up and there's the scream. It transitions to go from one world to the other by not cutting but by moving the camera across the stone. You end up in one time, seeing her being dragged away, and then you just track to the right, the same stone, and you are in the other time, seeing Frank walking away. That was fun to work those things out and plan them and then

"We had this moment where Claire needs to stab [a deserter], so there was this long discussion about how we were going to do it, because I wanted to [shoot] it in camera. We came up with a knife with a really strong magnet and put a metal plate in the back of the guy who's raping her. She could just punch that knife there and it stuck to it. That was helpful, because it wasn't like we had to cut and stop and put something on there and then restart again, which sometimes takes out the immediacy of it."

—ANNA FOERSTER

achieve them on a technical level. Actually, the scene used to be a lot longer and a lot more complex with more shots. It got shortened for the right reasons. It's exactly right now."

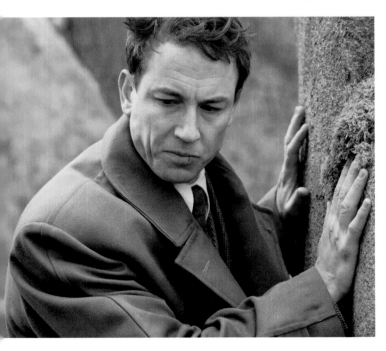

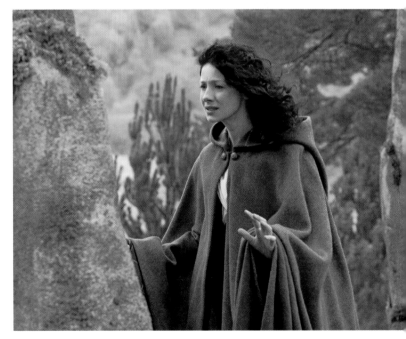

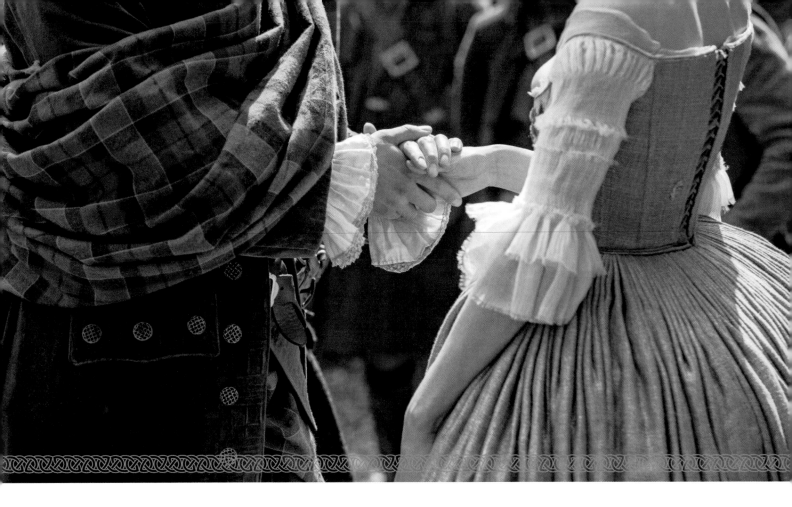

COSTUMES: SEASON ONE OVERVIEW

Can a job be fated? Some would say yes. Case in point: *Outlander* costume designer Terry Dresbach, whose adoration for the series long predates the television adaptation. Dresbach adored the books by Diana Gabaldon, and for twenty years the series remained her personal favorite, which she endlessly recommended to friends and peers.

But the idea of adapting the books for TV only crossed her mind as a passing recommendation to her new husband, Ron Moore, in the early 2000s. Dresbach remembers telling him, "'You need to make this into a movie or something,' then he'd go, 'Uh-huh,' because nine million people tell him those things each day," she says with a laugh.

Around 2005, the Emmy-winning costume designer retired from her field to raise their family, and thoughts of an *Outlander* show faded away until that fateful dinner almost a decade later where Ron, Maril, and Terry discussed the book again as viable material for adaptation. Based on Maril's and her enthusiasm, Dresbach says Moore finally read the books, which

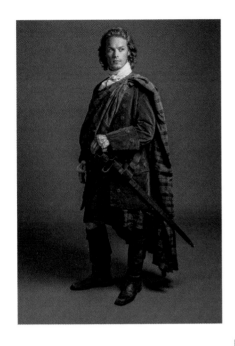

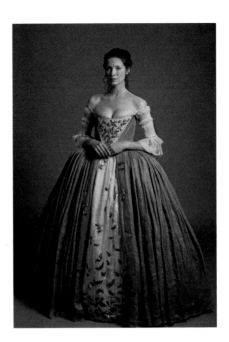

with this crazy momentum that pushed us all into it. It's kind of odd.

"But then moving forward to actually making it, I didn't want to do it," she admits. "I didn't want to make it. I was out of the business. I'd been out for ten years. So they went to other costume designers, and everybody kept turning it down because it was so big. Finally, Ron just turned to me and goes, 'You know you have to do this, right?' I said, 'Okay, I'll go for four months

is when he told her, "It's not a movie, it's a TV show."

Which brings us back to destined projects, which Dresbach says is how she thinks of her work on the show. "I look on [*Outlander*] as a very fated thing, because if you look at all of these people who came to it in different ways—me, Maril, Matt [Roberts], Ron—we all ended up

> "*Ron dictated that the only red he wanted [in season one] was the Redcoats, and I remember just kind of going, 'Why would the British Army pick red? It's so stupid. You cannot blend in.' Ron was the one who said, 'Yeah, but it's so intimidating to just impose red.'*"
>
> —TERRY DRESBACH

tumes for the first time, as Diana wrote them. I realized I hadn't ever really clocked any of them. I hadn't really noticed that there was a yellow dress here or that was an azure cape.

"It's funny going back in and looking at it from the design viewpoint," she continues. "I thought, *Wouldn't it be cool if I designed it exactly the way Diana wrote it! I*

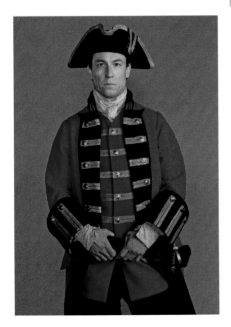

and get it going and then I'll leave.'" Dresbach pauses and laughs, adding, "Well, that was four years ago."

Once committed to the endeavor, Dresbach admits, she had to go back to the source material to approach it with new eyes. "I don't read with specifics in my head," she explains. "I read with tone and a sense of character and who people are. So when it came time to actually design it, I had to go back and reread all of them, because I needed to read the cos-

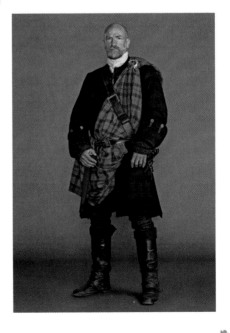

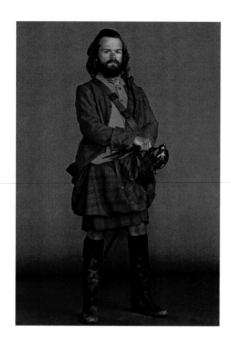

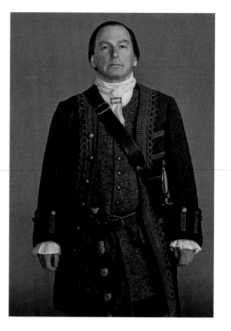

But Dresbach says her drawing board kept the book front and center out of necessity. "This has been a very novel experience for me because everything I've ever designed before has been based on a script," she explains. "Now I'm designing based on a book. Ron yells at me all the time, because he's says I don't really read the script as much as I should. He's right, I don't," she laughs. "A lot of that is because my design work has to be in place long before the scripts come out. There's no possible way they would be able to shoot. [Production] would have to wait for three months in between each episode for us to make all that stuff."

In order to anticipate the needs of the *Outlander* narrative, Dresbach and series production designer Jon Gary Steele set about making a "look book," or visual primer, of everything they might

drew it out and plotted it out, but it just wasn't going to work. Diana and I have talked about that, because you can write whatever you want and people make up their own pictures in their head. It's impressions, but when you actually commit it to a three-dimensional reality, it doesn't translate. Then you go back to the drawing board."

need to create for the show. "That was an incredibly informative process for both of us, because this look book was a couple of hundred pages. It was huge!" she enthuses. "It took us weeks and weeks and weeks. We basically put the entire first book in visuals. It really ended up being our design platform for the entire show. It wasn't specifics; it was like a picture book of *Out-*

"There's not a lot of evidence that anybody wore family tartans. There's a lot of debate back and forth about this. Essentially, it seems that the majority agree that family tartans were a very romantic invention of the Victorians. So I have to extrapolate. I go back to the plant dyes in whatever area you're in. If you're in the western part of Scotland, maybe these dyes are available, and if you're over on the eastern coast, maybe those dyes—something that would connect colors to certain areas and to certain places. Perhaps that's where the clan tartans grew from. Then I think that probably the MacKenzies, the MacDougals, and the whoever elses lived in that area might have all had tartans in a similar color range. We honored that because it is something that people love and identify with, so you don't just jettison that because maybe it isn't accurate."

—TERRY DRESBACH

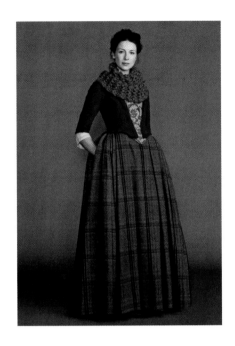

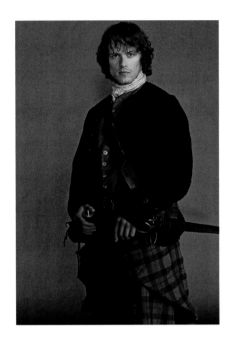

lander with the overarching look, the palette, the tone, the feel, and that was our jumping-off point when we got to do the actual show."

P re-production is one thing, but the realities of the project hit home once the series went into filming. For Dresbach, once she landed in Scotland she had a total of seven

weeks of prep before shooting started. She and Jon Gary Steele arrived at an empty building that they would have to turn into their creative hub, from scratch. "There were no sewing machines; there were no telephones. There were no hangers; there was nothing," she recalls. "And then there was the cold, terrifying realization that there were no rentals."

Rentals are the costumes that a production uses for a short duration and then returns to a costume house. In Los Angeles or other production hubs, they provide the bulk of a film or television show's costume requirements, especially period pieces. "Hollywood got out of the period film and television thing decades and decades ago," Dresbach explains. "That stock has been split up and sold, but now all of Holly-

wood is descended upon the UK and is making [period] TV like crazy. So you go to the rental houses and it's already tagged [for other shows]. The first season we rented whatever we could get our hands on, but it wasn't much and it was in pretty bad shape. We still had to

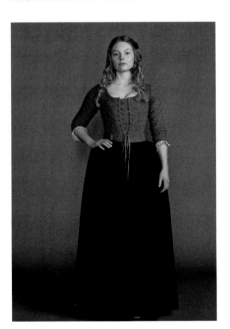

"We created five tartans, five patterns. We used the same dyes for all of them. We made a caste system with the tartans. Colors represented wealth. The more intense the color and the more color you had, the more money you have. Red dyes cost more than brown dyes, so we added in colors to create station. Our lowest on the economic rung is just a lighter brown with a darker brown weave going through it. Rupert wears that. The MacKenzie tartan, we added in a bright-blue thread that goes through it. The Outlander tartan, as we call it, is the one that Jamie wears all the time. It's beautiful shades of browns and blues that are woven together. We also brought in a little bit of red, because Jamie's mother married outside the clan, so I wanted to bring in a little bit of another color and because I knew that the tartans of Diana's world were a red plaid. I wanted to give a nod to and an acknowledgment of that, because I knew that the fans were going to be looking for that red."

—TERRY DRESBACH

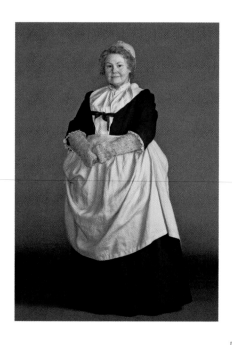

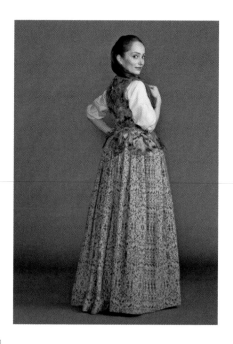

like *Game of Thrones* meant the local talent pool was mostly spoken for elsewhere. "You have to create crew," she explains. "You're bringing in local theater companies. You're bringing in people from Scottish Opera. You're bringing in kids who have just gotten out of school; a lot of our team is just out of college. You have a widely disparate group of experience. We probably have four or five people who have ever worked in film and television before, out of a crew. We were bud-

make tons and tons of clothes, and we absolutely were going to have to make all of the principals' costumes. Every single episode I'm going, 'You guys remember there's no rentals, right? There is no eighteenth-century Macy's!'"

To make those costumes, Dresbach also had to do some creative hiring, because productions

> *"I think subconsciously blues and browns were the palette for season one. Claire wears a lot of blues and browns. In the 1940s, they wore a lot of blue and brown. It's a very soft, beautiful, muted tone. I think that it was subliminal that I was living in these tones. I was living in this environment and that blue, that particular blue, like Claire's blue coat, is very similar to the blue in the* Outlander *tartan."*
>
> —TERRY DRESBACH

geted for a team of eight, and by the time we finished, we had twenty-five or thirty."

The average turnaround for one costume for a primary cast member (who often needs multiple copies due to the harsh location demands) is two to three weeks, which means Dresbach's team was on overdrive. "Season one, there

was no sleep," she says frankly. "There were no weekends, there was no nothing, because we were truly just one step ahead at all times of barely getting things to set in time, and sometimes not. Sometimes we would have to [say to production], 'You're going to have to change the schedule, because there's no way we're making all of this stuff in this amount of time.'" But the proof is on the screen—not only did it get done, it got done beautifully, and to Dresbach's exacting standards.

In terms of historical accuracy, Dresbach says, she did a great deal of research and due diligence, but in the end the images on the screen are an amalgamation of history, form, and function. "There's very little documentation about what was worn in Scotland," Dresbach explains. "After Culloden

and their cultural genocide, which is what happened with [England's] goal to erase a culture, it's so much more than just making laws. It's doing things like getting rid of kilts. You can't wear the tartan anymore. If you're trying to wipe out a culture, there go the books, there goes the music, there goes the national dress, there go the paintings, there goes the culture, and so there's very little out there.

"We then set this standard of wanting to not modernize and contemporize history," Dresbach continues. "I was jumping up and down, screaming about the eighteenth century being one of the sexiest, most fabulous periods of fashion ever, and there was no need to mess with it."

Dresbach married that mandate with contemporary Scottish environs to create her ultimate costume aesthetic. "I knew I was going to have to deal with the climate, and so that opened up the door to what modern people are wearing," she says of her inspirations. "There's almost no day that you walk down the street in Scotland where people aren't wearing a scarf around their neck. There's a lot of wool, and going backward doing research, looking at what the fabrics were [in history], we were able to access some of that. The wool would've kept them dry, so we draped everybody in these good, heavy, strong wools, and that's when we really started to go. When you start look-

> *"In my original 'look book,' I had sketches of Jamie wearing what is essentially a modern-day kilt; that was how little I knew. The minute you land [in Scotland] and you're sitting in the office, looking out the window, and it's freezing and it's pouring rain, you know if we dress them in the way that we're planning, they're all gonna die."*
>
> —Terry Dresbach

ing at the Scottish woolens, it's textile heaven. These things are unreal. Before you even get to the tartans, to the plaids, the richness of the weaves are so organic. There's a million colors blended in to make this one shade of brown. It is an incredibly rich palette, and the fabrics then turn around and connect directly into nature.

"The other thing I was able to research was dyes," she continues. "How did people create color? You

have to do that, because you're not going to the fabric store. So you start pinpointing it to the region where your story takes place. Now your colors are dictated by the [local] plants. You're putting together a puzzle. You put all that together and you end up with a palette, and then all of that interestingly enough matches the environment you're standing in and looking at every day. It felt right," she says with pride. "The first day that we had all our Highlanders onstage, somebody next to me kind of took a gasp of air and said, 'They look like they all just grew up out of the ground.' That's exactly what I wanted to do. When you look at them I wanted you to feel Scotland. When you look at Jamie's clothes or any of our Highlanders', they're all the textures and values and tones and colors that you see every day walking around Scotland. Every single one."

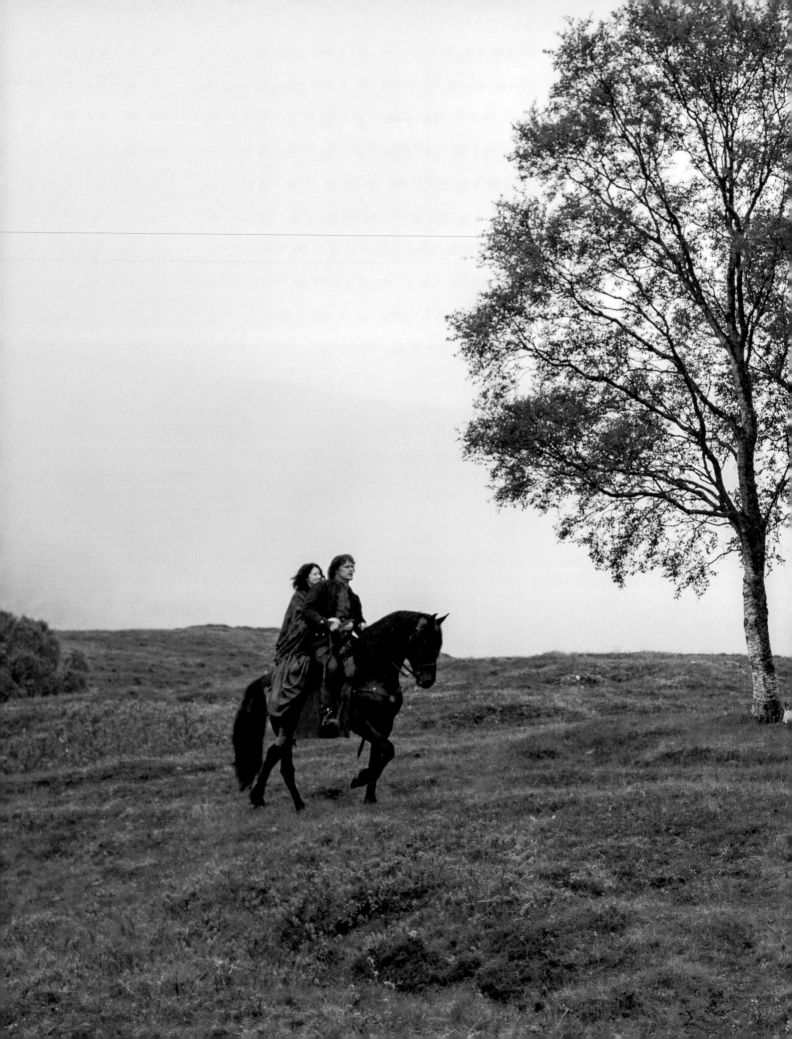

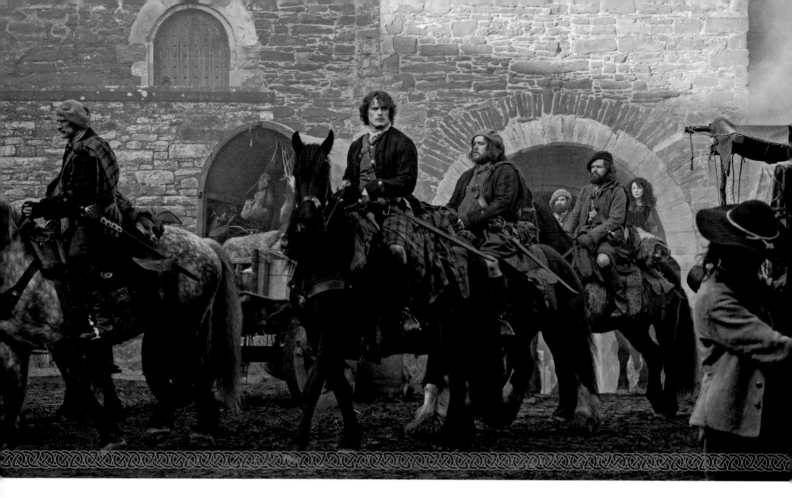

EPISODE 109: THE RECKONING

Writer: Matthew B. Roberts Director: Richard Clark

"The Reckoning" picks up exactly where "Both Sides Now" left off, with Jamie interrupting Black Jack's assault of Claire in Fort William. But the voiceover switches to Jamie's point of view, the first time in the series we see events from a perspective other than Claire's. Writer Matthew B. Roberts says the shift served two purposes: to expand the scope of the storytelling outside of just Claire

> "The whole bit where Laoghaire and Claire are walking through the woods together, where there's a little stream and the hills, we found it literally just on the other side of the dual carriageway a stone's throw from the studio. We looked forever for those woods, and they turned out to be fantastic."
>
> —Richard Clark

and to give actress Caitriona Balfe a necessary break. "Prior to that she was in every single scene," Roberts says. "We didn't really know about how difficult the shooting was going to be, so that's how we fixed it, and it really worked out.

"It's very emotional," Roberts says of the episode. "You have this rescue; you have the big argument by the ruins. Then you go into what we would like to call 'the spanking,' and then you go into the makeup

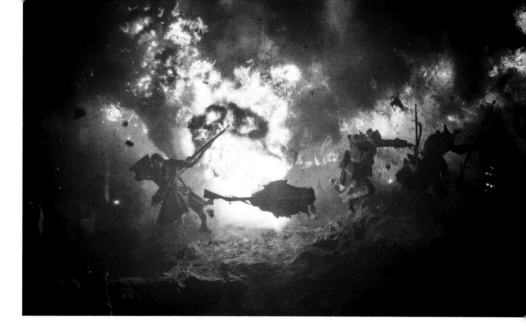

and the intense lovemaking, which is probably the longest lovemaking scene in the history of television."

It fell on director Richard Clark to create visual cohesion by grounding the episode in Jamie's energy and perspective. To start, the prison rescue was the biggest set piece the series had attempted to date. "It was filming in the middle of January on the east coast of Scotland, so it was brutal, and in the end, actually, quite a lot of it got cut out," the director recalls.

It was in fact Clark who shot the cliffhanger moment used to end episode 108 and start 109. The director says he learned during rehearsal to block out all of the movements of Jack's assault before shooting. "First of all, you've got a cat-and-mouse between Claire and Jack," he explains. "So how do you retain tension and how do you use physicality in their movement? At the end of ['Both Sides Now'], we put Claire seated in the chair, so she already assumes a position of power to start. Then we had Tobias walk round the back of her deliberately, to make her feel uncomfortable. Then Randall takes Claire, and

Jamie comes in and saves the day. Again it was working out how you get the tension, how you retain suspense, as that was about an eight-minute scene."

Right after the adrenaline rush of their escape, Jamie and Claire have a huge fight where their frustrations with each other erupt, fueled by the intensity of their deep caring for each other. "It's quite a long argument, where I was focus-

"At the castle where [Jamie and Claire] actually jumped off, there was no sea underneath it. I think it was eighty or ninety feet high, and as a stunt coordinator you think, We can do this. But it opens a whole can of worms about other things. So we did green screen in the studio of both Cait and Sam jumping off about four foot onto some mats. We got the initial jump with their faces. Then, when we were filming the ship with them going off over to France, the camera ran off with the actors, and we had a little second unit shooting them jumping off the harbor wall. We had the camera in the water and it looks really good."

—Dominic Preece

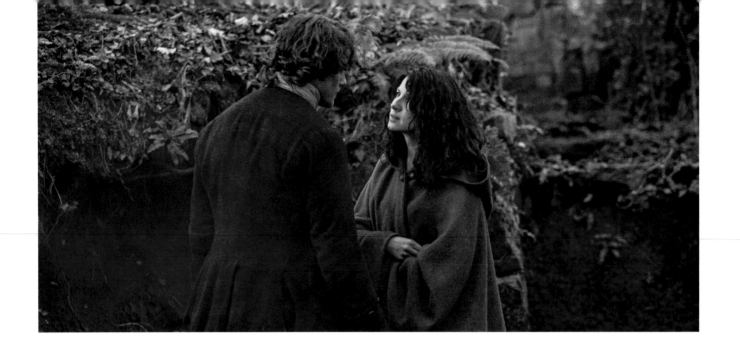

"*The fight down by the river after they rescue her is a huge moment, and it is such a great scene. You really see two people who are so fiercely passionate about each other and about life. That gives them the ability to get dirty in a fight. You see the kind of unattractive side of that passion, and they press each other's buttons so it gets really nasty. It laid down the rules of their relationship. Funnily enough, that was one of the scenes that I tested with Sam. It's sort of evolved slightly, but that was an original audition scene.*"

—CAITRIONA BALFE

ing on capturing physically him falling back and her coming down to him," Clark says. "He's trying to stand up and uphold this archetypal, expected position of a man in the face of this modern woman. Watching him actually collapse and admit and express a vulnerability at that point was a key piece of their relationship. I think at that point being heroic but then expressing that vulnerability was probably the thing that allowed her to see him. It twists beautifully when, in the next minute in the inn, he goes and gives her a whipping."

The spanking scene was not an easy one to plan and execute, since it essentially involves one of the show's main protagonists doing something that feels backward and unacceptable to a modern audience. Again, Clark says rehearsal was key in creating character balance. "For instance, I inserted her kicking him in the face," Clark says. "You wanted a sense of a defiance from her and a sense that she was giving as good as she got, basically. And it could have been played out on the bed, but I

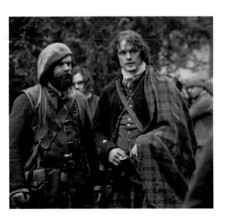

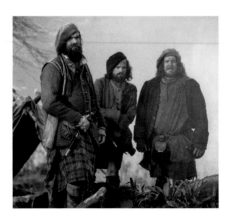

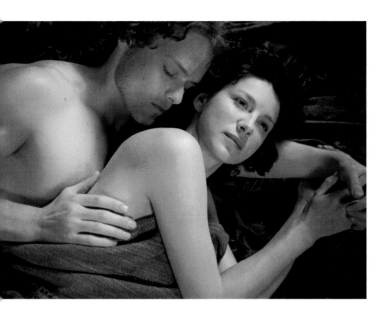

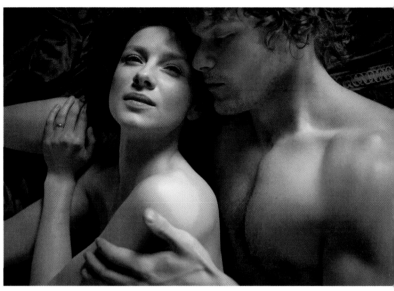

> "The spanking scene . . . that's a tough one as a woman of today to get your head around. I don't know if I fully got there, because you are trying to realize that he's a man of a certain time and it was permissible in that time. Even for a woman in the forties, it wasn't okay for her. But it still happens today, with women getting stoned to death in some countries in a much more horrific version of it. It's hard as a woman to be okay with that and finding a way of making it okay and forgiving the person afterward. I think we achieved it."
>
> —CAITRIONA BALFE

didn't want them on a bed. I wanted it to be messier than that. It's about him trying to start off in control and the whole thing falling out of his control."

It all culminates in a lusty, angry sex scene, which Clark reveals was actually Caitriona and Sam's first for the series. "This is before they'd shot the marriage," he

shares. "It was quite tricky, partly because [the characters] are quite raw and because this was the first really intimate scene that both the cast and the crew had done."

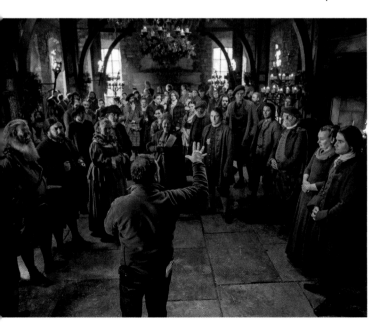

> "Regarding Laoghaire, this is 1743. For her to go find a love potion, for her to find an ill will, for her to do these things, that's her Facebooking about it or her putting on Twitter that this girl is a tart today. She feels like she's being bullied by Claire. In ['The Way Out'], Claire was like, 'Let's try to set you up,' so it's even more of a betrayal for this girl when [Jamie and Claire] hook up. When we got to ['The Reckoning'], Laoghaire was like, 'Wait a minute?' Jamie comes back from the road and she finds out he got fucking married!"
>
> —MATTHEW B. ROBERTS

EPISODE 110: BY THE PRICKING OF MY THUMBS

WRITER: IRA STEVEN BEHR DIRECTOR: RICHARD CLARK

With the threat of Randall hovering, "By the Pricking of My Thumbs" finds Jamie and Claire reaching out to the Duke of Sandringham (Simon Callow) as a potential ally. In exchange for his help, the debt-ridden aristocrat enlists Jamie to stand for him in a duel.

"I really got into the idea of the

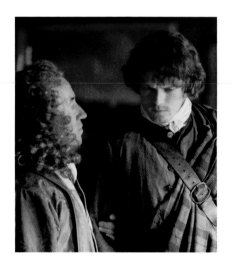

duel," writer Ira Behr says. "But I wanted it to be a brawl. I wanted it to be sloppy and kind of violent, not some Technicolor [version] of guys dueling. More like Richard Lester's *Three Musketeers*."

However, Behr remembers a specific rewrite request from director Richard Clark when it came down to opening the episode. "Richard, the director, goes, 'I'd like

to start the show with a sex scene. Can we do a sex scene? I just want to start it with a sensuous feeling.' So I wrote this very *specific* sex scene, which then became very popular [with fans], it seems. It was an act of oral kindness given by the male to the female and then interrupted with the female demanding, in a positive way, completion," Behr says with a smile. "It really just came out of me refusing to do another 'she's on top of him or he's on top of her' scene, plus I could make it part of the story, with Murtagh coming in."

Later in the episode, Behr got to introduce the very memorable and very witty duke, who is often named by Diana's readers as a favorite character.

"The thing that cracked that character for me was the opening line, where he's looking out the window and he goes, 'Scotland . . . it will have to do,'" Behr says.

Embodying the character was famed British thespian Simon Callow, who Clark describes as a "consummate professional" and who helped shift the tone of the episode. "You have an English guy that's suddenly appearing, so you can give

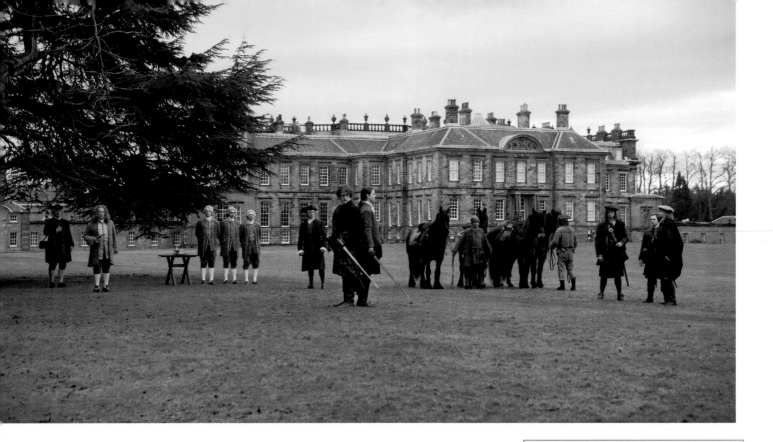

this a different feel and a different scale that says something historical about Englishness and the difference between the castle and the notion of Englishness.

"Simon was just glorious," Clark continues. "He stole the scenes and really found this rather exuberant character. Simon's scenes always felt like they played out well and that they fulfilled themselves."

And as for the crucial duel scene, Clark said, he made sure the sequence balanced danger and humor, especially when the duke runs away. "You needed a tension between the intimate and the grand, and it should have formal scale and grandeur. I went for very formal to start with, and then as it falls apart you get into more of a handheld fight," the director explains. "A messy, scrappy fight sort of thing. I hope that we managed to capture something of that across it."

> "I think Dougal's relationship with Geillis is a real match between the two of them. It's like a political alliance, really. I don't doubt that there was passion there. You know, I liken them to Lady Macbeth and Macbeth, in a way. That sort of passion they had for the cause."
>
> —GRAHAM MCTAVISH

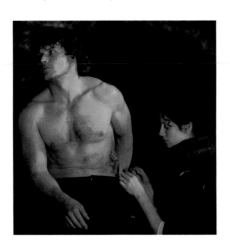

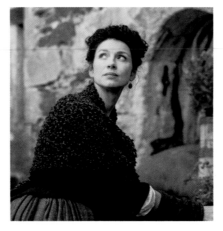

"In the script, Dougal was railing around and smashing stuff up [in Castle Leoch]. There wasn't any interaction with anybody else. I was concerned that that was going to start to feel slightly repetitive. I had this idea of what if they have three or four people around with shields, trying to corral him, trying to find an imaginative way to resolve a number of different things."

—RICHARD CLARK

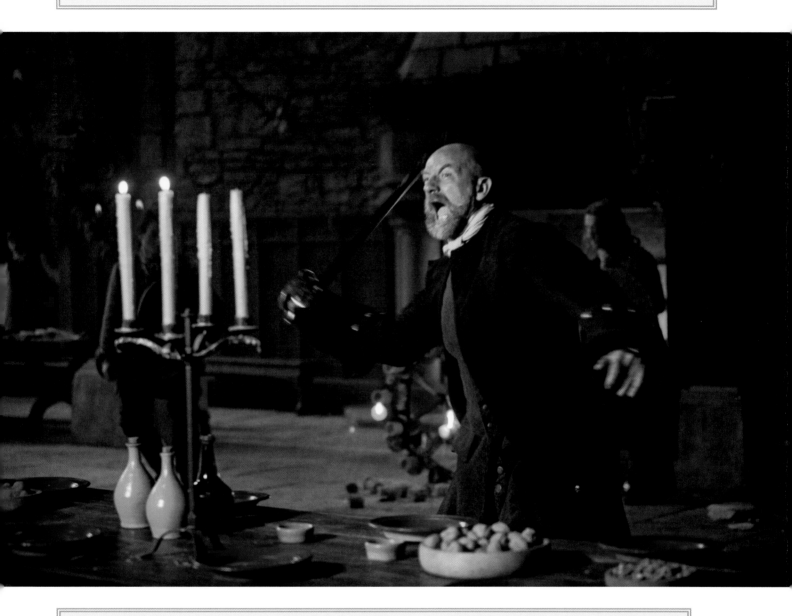

"Stephen [Walters] was such a joy to work with, because he's my kind of actor and the kind of actor that I try to be myself, who can just change and do things that are unexpected. Stephen did that in that scene to me. That's what I think it's about, reacting to the other person. When Stephen came in and he was doing his thing with the bottle and all the rest of it, that informed my reaction."

—GRAHAM MCTAVISH ON ANGUS LURING DOUGAL AWAY FROM THE WEAPONS

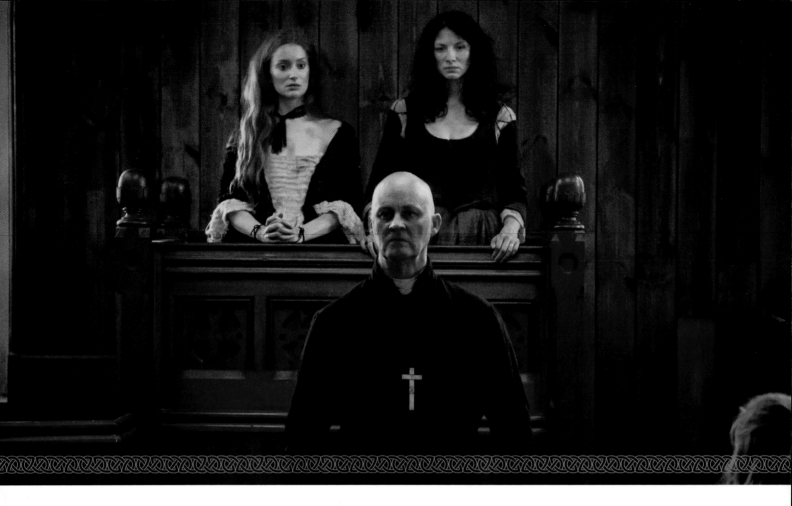

EPISODE 111: THE DEVIL'S MARK

WRITER: TONI GRAPHIA DIRECTOR: MIKE BARKER

A dynamic episode filled with unexpected revelations, "The Devil's Mark" distilled another major moment from the books—the point when Claire and Geillis are accused of witchcraft. Much as Anne Kenney claimed "The Wedding," writer Toni Graphia knew she wanted possession of telling this story.

"My absolute favorite part of the book was the witch trial," Graphia enthuses. "I would have

> "What I really liked about the witch trial is you get to see her true colors. You only get to see the core of her at the witch trial, and that was extra fun to play because all of a sudden you see sincerity and a passion that maybe you never would have expected [from her]."
>
> —LOTTE VERBEEK

swum to Scotland myself to write the witch trial, I loved it that much. I always called this episode a love story between Claire and Geillis as much as between her and Jamie. I like celebrating the friendship between them and showing that two women don't have to be similar to be friends, that circumstances make strange bedfellows. They didn't trust each other, yet when they're in trouble together they find a bond."

Ron Moore happily assigned

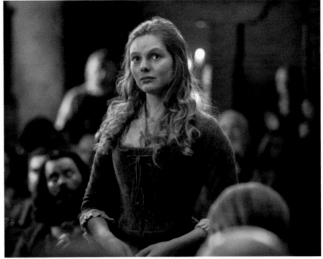

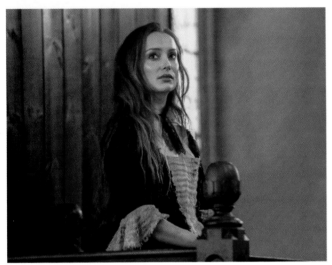

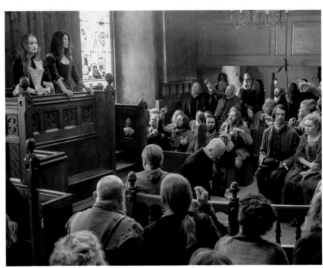

the episode to Graphia, but he had some logic concerns he wanted to be sure the episode addressed. "Ron kept bumping on the story, saying if they're spending two nights in the thieves' hole getting drunk, why aren't they talking about being from the future? We knew we had to save that big conversation for Jamie, but Ron was right in that if these two women thought they were going to die, and they're both from the

future, why didn't they have that conversation?" Graphia says. "The compromise was that they can talk, but it has to be at the courthouse, at the last moment, so they don't have time for a giant conversation. There's just a recognition of 'You're from the future!' It addresses Ron's [story] note, but it doesn't spoil the Jamie beat."

Graphia also reveals that many in the writers' room had reservations about having Claire's confes-sion in the same episode as the trial and subsequent escape, worry-ing that it was simply too much emotional punch for one episode. But "I felt they went together or-ganically," Graphia says. "In my mind, having that moment with Geillis is the catalyst for Claire to tell Jamie."

Director Mike Barker, tasked with seeing the episode through, says it was also one of his favorites and captures the true essence of Gabaldon's book. "It was a culmina-tion of time travel and the political intrigue. It was all of the characters coming together and exposing themselves in truth. The thing about having such a big concept is, in order to carry an audience through it, you have to believe in those small moments where two people are talking to each other and they're exposing themselves. It's those little tiny moments where it's rooted in reality that allows you to

travel through these really big concepts."

For Claire and Geillis, that was represented with their confinement in a dark pit. Barker says, "It was probably the hardest few days for me, working in that little cell, because everyone comes in there with ideas of what they think it should be and I was really clear that it needed to be smaller, not bigger."

Shot inside an old abandoned factory, it was a grueling episode for both cast and crew. "I brought in mist and I brought in spray and water. Cait was furious with me for introducing the rats, absolutely furious," Barker says. "But I have to say the girls are pretty extraordinary, because they literally wear nothing, they are tortured from the beginning of the day to the end of the day, and they never, ever, ever complained. Well, they complained about the rats, but apart from that they never complained."

For the other confession, where Claire finally tells Jamie the true story of how she came to be in eighteenth-century Scotland, Barker says it ended up being the toughest scene he's ever filmed in his entire career. "The truth of it is that it's just one woman on her own, saying something that's so ridiculous in the grand scheme of things, and she has to convince a man that it's actually for *real*. So it was tough for Caitriona because I kept doing it over and over and over again, because I had to *really* believe it. I kept [the scene] so simple because the whole thing rests on her performance. She must have done that scene twenty-five, maybe even thirty times. She actually did a perfectly good job quite early on, but it's about that tipping point where, when she said it, she really meant it. And that's where she got to in the end."

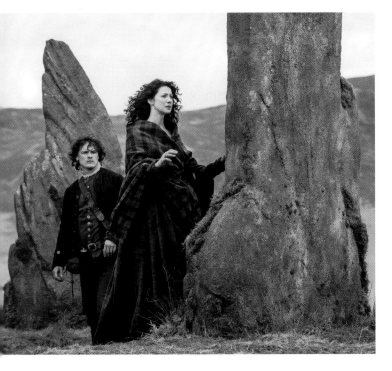

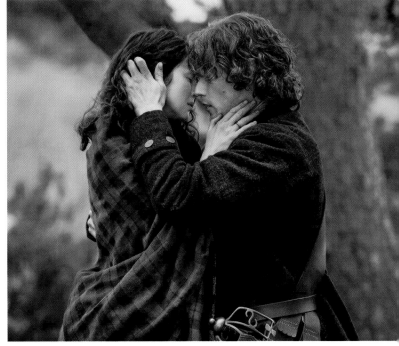

SPOTLIGHT:

LOTTE VERBEEK AS GEILLIS DUNCAN

Dutch actress Lotte Verbeek hasn't been in the acting game that long, but she's already made a name for herself playing enigmatic beauties who often know more than they're willing to share. There's something in her eyes and the impish curve of her smile that's beguiling and a little dangerous.

Hence the perfect fit of Verbeek to *Outlander's* Geillis Duncan, the red-haired firebrand who knows many a thing about keeping secrets. "I tend to like roles that are a little mysterious," the actress says with a smile. "As in real life, you don't get the full person at first glance, ever. There's always a story behind everybody. I think the characters that sometimes make an effort to cover that up, or present themselves in a different way, those characters are extra interesting."

Geillis certainly fits that description as a character, but interestingly enough, Verbeek initially auditioned to play Claire. Sometime later, Verbeek says, her agent came back with a request by the casting team for her to read for another part, Geillis Duncan.

"When I saw how Geillis is described as being Scottish, tall, blond, and green-eyed, I was like, 'Well,

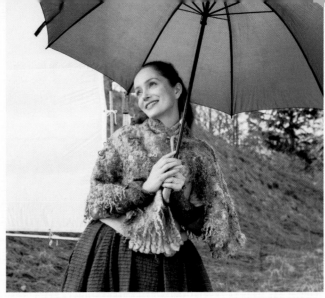

that's not me,'" she laughs. "But my agent encouraged me to just have a play with it, so I did. The first scene you actually see me in the first season, that was my audition piece."

The producers offered Verbeek the part, despite the fact that the multilingual actress was not fluent in the Scottish brogue. "English is not my first language," Verbeek explains, "and Scottish gets tricky even for Brits, so how would I be able to do it?" With the help of on-set dialect coach Carol Ann Crawford, Verbeek says, she was able to get a handle on the right dialect. "I was also lucky to have a friend whose wife is Scottish and happens to have a lovely voice and a lovely accent. I used her help too. Now every time I go back to Scotland, I get right back into it."

With accent and demeanor in place, Verbeek says, playing Geillis was a constant exercise in discovery. The actress sees her character as a rebel and outcast by choice. "She's an activist and she believes in what she believes in. She's willing to even die for it. In the sixties, she's kind of a rock star, and there's flyers and posters of her everywhere. But after she travels through time, she is a bit of an outcast, even though she's married well and she's in a nice house."

Isolated by her cause in the eighteenth century, Geillis sees Claire's arrival as an opportunity to genuinely connect again, Verbeek says. "You can sense that she really needs and wants a friend," she muses. "She's kind of lonely too in that world. Yet she's kind of cruel toward Claire. She's not necessarily just being nice, you know? She's toying around with her too. She knows more than Claire knows and she could have helped Claire more by being less concealing, but she doesn't. I kind of like that," she laughs.

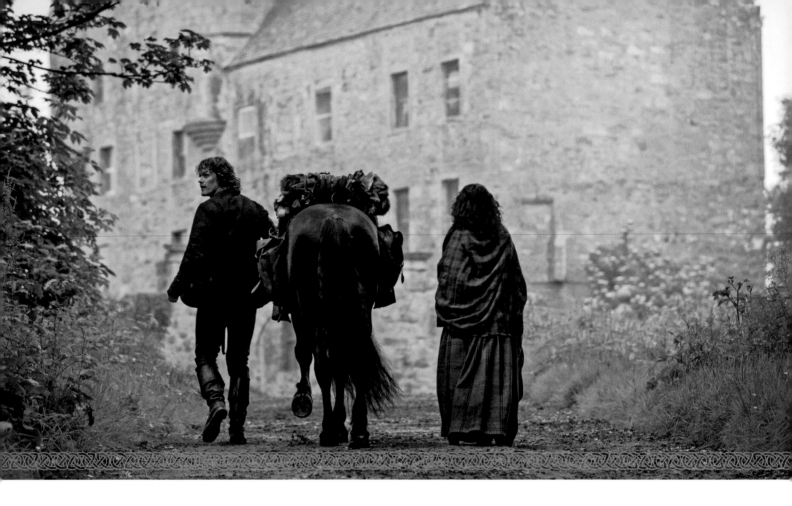

EPISODE 112: LALLYBROCH

WRITER: ANNE KENNEY 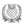 DIRECTOR: MIKE BARKER

The Fraser ancestral home takes center stage in "Lallybroch," as Jamie returns home with his new bride. Despite being the laird in name, Jamie's been on the run as a fugitive for some time, so his abrupt return disrupts the entire dynamic of the estate. "Any of us who go home have a tendency to regress," writer Anne Kenney says of the episode's central theme. "You're a different person with your family than you are with

> "Lallybroch is very important. We get to see his family side. Through that, we realize Jamie is maybe not as perfect as we thought. He has all this history and backstory that he maybe has not dealt with. He feels responsible and feels guilt for his sister, so it all sort of comes into play."
>
> —SAM HEUGHAN ON WHAT GOING HOME REVEALS ABOUT JAMIE

your friends and your spouse. What this became about was Jamie trying to figure out who he is in this place and how does Claire fit into all of it too. The honeymoon's over. Now we have to see who we are going to be to each other, and to the world, now that we're together."

To Jamie, Lallybroch represents his birthright, the legacy of his father and the responsibility of caring for the people who work his land. Director Mike Barker knew

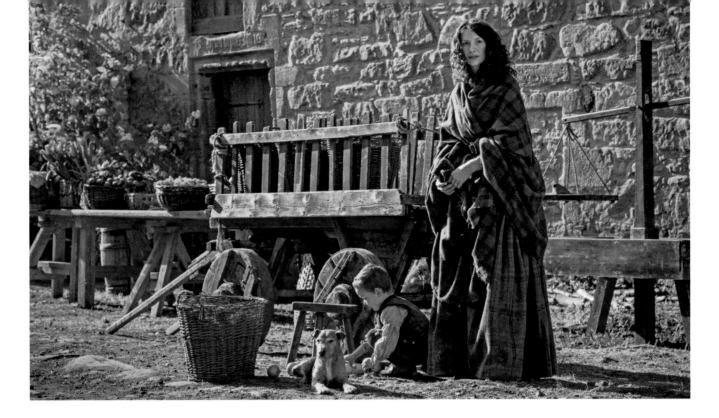

his visuals had to embody all of that emotional weight while exuding warmth. "I think it was really about creating a sense of familiarity about it," Barker says. "I imagined [the grounds] a bit like a big cozy sofa, where you sit in it and it feels like it's a real sofa."

However, in reality, Lallybroch as a location proved to be a challenge. "The house, Midhope Castle, was chosen in block one, and it's possibly the worst location that's ever been chosen for a film ever," Barker laughs. "It is diabolically bad. It faces the wrong direction to

the sun; it's constantly in the shade. You have to be really inventive about how you shoot it."

Another difficult aspect to the episode was Jenny revealing what happened to her when Jamie was arrested and she was left behind to deal with Black Jack Randall. "The

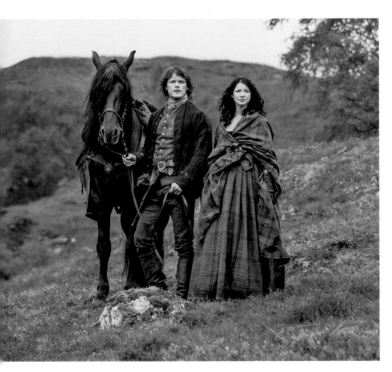

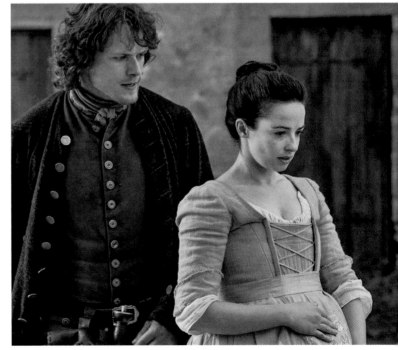

thing that was so difficult about that scene was that it involved a penis," Barker says candidly about the graphic portrayal of Randall's attempted assault on Jenny. "But Tobias was so unbelievably relaxed. Of course, the producers left it to me to go and speak to him [about the nudity]," Barker chuckles. "He was completely at ease.

"I found it quite harrowing, actually," Barker admits. "There's no fun in shooting scenes like that, because you are talking about violating someone. Even though Jenny's being incredibly strong and fighting back in the way that she could, it still doesn't get away from the fact that ultimately it's a rape, whether it happened or not. It's a very difficult thing, so I wanted to find a very simple, single image that was a violation without it actually being sex. That's where the thumb came

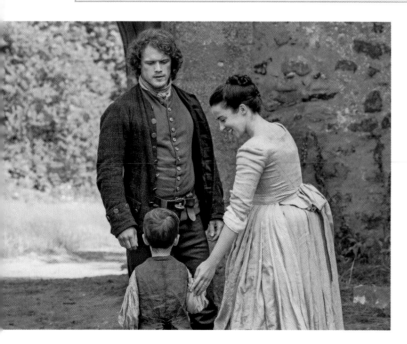

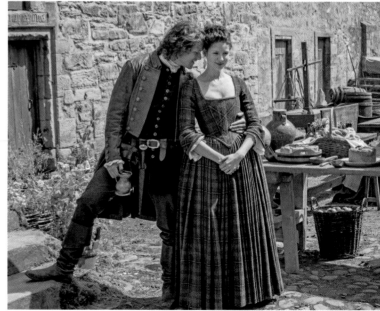

> "The nature of the power dynamic between Jenny and Ian [Steven Cree] is what fascinated us both, because Jenny obviously is very headstrong, very stubborn. Ian knows exactly how to soften her, to stay on her good side and manipulate her in the right way of true, complete love and affection. We discussed that a lot, just what it is that has drawn them together and what it is that works about that partnership so well."
>
> —LAURA DONNELLY ON JENNY AND IAN'S DYNAMIC

from," Barker says of Randall forcing his digit into Jenny's mouth. "It could have been sexy, but it was really, really frighteningly violating, I thought. It's all in her eyes."

Finding out that Jenny successfully humiliated Randall into leaving Lallybroch cemented the strength of the character for Jamie, Claire, and the audience. "Jenny is this idea that helps you also understand Jamie's attraction to Claire," Kenney explains. "Jenny is this very smart, independent woman. You can see where—and I think we all do that to a certain extent—you replicate your familial relationships. We see how much influence and respect Jamie has for her. So I think that's really interesting that she and Claire are birds of a feather."

Kenney says watching the Fraser siblings reorient around each other in the episode was very satisfying. "My favorite scene is in the graveyard with Jamie and Jenny at the end," she shares. "I loved writing it. They played it beautifully. I feel like it's so human when she confesses that on some level she blamed him for their father's death. When something horrible happens, you want to find somebody to blame. The fact that she did that, and once she saw [Jamie's] scars, she realized, what have I done? I just love that moment between the two of them."

EPISODE 113: THE WATCH

WRITER: TONI GRAPHIA DIRECTOR: METIN HÜSEYIN

The Lallybroch visit takes a dark turn in "The Watch," when Taran MacQuarrie (Douglas Henshall) and his band of local "protection" enforcers make an extended stop at the Frasers'.

"Ron and I always talked about how the whole point of 'The Watch' is inspired by *The Sopranos*, a show we both love," writer Toni Graphia reveals. "We wanted it to be, what would you do if the Mafia came in, took over your house, and Tony So-

> "The Watch is the sort of life Jamie could have had if he had not gotten married. He may have become one of these mercenaries, and actually it is quite an appealing life. If Jamie had maybe gone down a different path, he may have been someone very similar to MacQuarrie, and he may have had a similar sort of fate."
>
> —SAM HEUGHAN

prano sits at the head of the table? He just takes over. That was the pressure-cooker idea that we built this episode around."

The Watch itself is mentioned in Gabaldon's book but only peripherally. "She never does a whole [story] about them, so this episode is not in the book, really," Graphia explains. "We knew we had to split Lallybroch into two halves. In the book, the chapters that are in Lallybroch are very happy and not

much happens plot wise. This was our attempt to make an episode that had conflict yet still uses what Diana set up."

As Graphia was expanding the MacQuarrie character in her script, she says, the visual of a watch became her focal point. "I wanted Taran to have a watch as a spoils of war. When I was researching pocket watches, I came across a very real watch called a memento mori watch that was designed originally by Mary, Queen of Scots. It had a beautiful quote that roughly translated as 'Death visits with impartiality the castles of the rich and the cottages of the poor.' I thought, *That's a perfect metaphor for this episode.*"

Outside the MacQuarrie narrative, the episode also focuses on the bonding of Claire and Jenny. As Jenny goes into labor, Claire joins

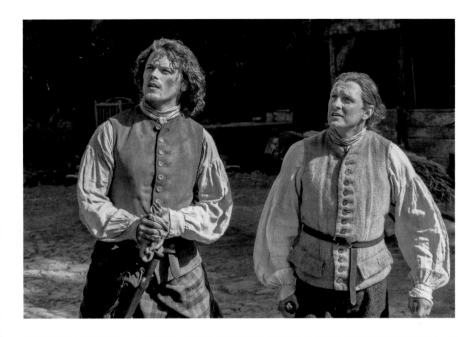

"You can't buy a watch and put it on TV, as it's copyrighted. You have to make one and design it yourself. We found out it was going to cost quite a bit of money. We didn't want to spend that much money on it, yet it was so crucial to the piece. David Brown, who is our wonderful, wonderful producer, agreed to the watch and allowed it to be made. I love the watch. We also shot it as the title card of the episode."

—TONI GRAPHIA ON MACQUARRIE'S WATCH

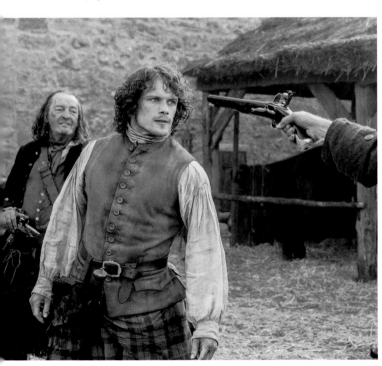

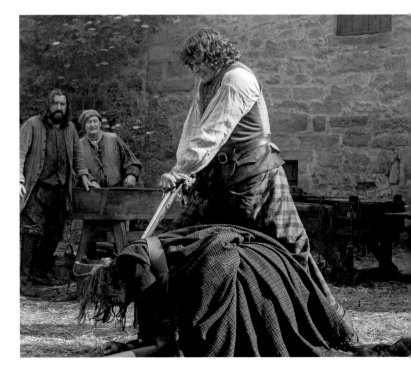

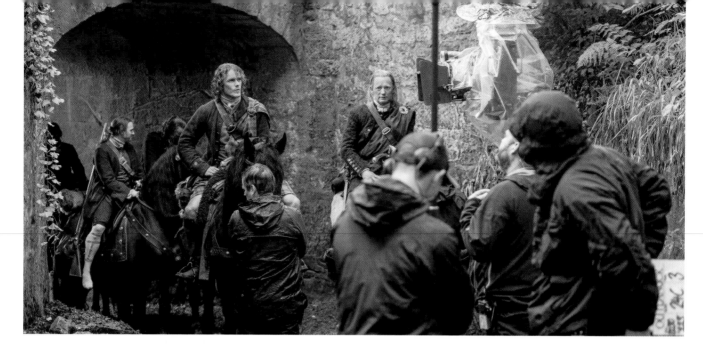

her in confinement, and the two speak very frankly about marriage, children, and the power of birth. "That speech Jenny says to Claire is word for word from the book," says Graphia. "It was one of my favorite things in the book and I wanted to honor that."

Director Metin Hüseyin reveals that he used his own personal life and writer Matt Roberts's background to help block Jenny's labor. "The birth was based on [my son's] birth," he says with a smile. "Both of our kids were born at home. My wife denies this, but what I remember is that she was so restless. And then Matt Roberts used to be a paramedic, so he's delivered a couple of kids in backs of trucks and things,

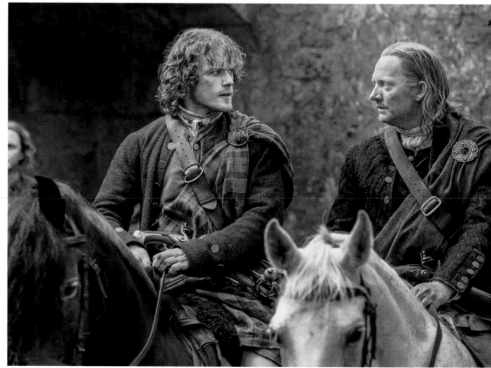

so weirdly we used our experiences. Cait and Laura were willing to go along with us," he chuckles. "I also thought that was some extraordinary writing. Diana's writing of Jenny's description of what it's like to have a baby inside her, that always brings a tear to my eye."

Graphia was pleased to create another moment of resonance for Claire and Jenny, when Jamie goes out with Ian and MacQuarrie for a raid. "When we have them sit on the steps and Jenny says, 'I've been where you are. I've been sitting on these steps looking for my brother to come home. He will come home,' she's reassuring her," Graphia says. "She gives Claire the bracelets and it's like saying, 'You're a part of the family now.' Then Claire hugs her and Jenny pulls back," she says. "I love that moment."

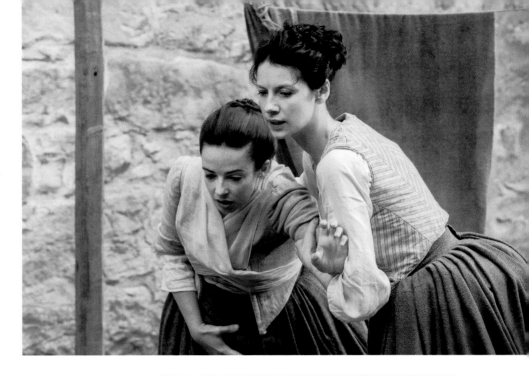

"Claire is using the conversation that she's having at that point to distract and to soothe Jenny, and it worked. I thought that it was just really beautifully adapted. It gave me a really different angle to think of Jenny as well. I really enjoyed that. It was one of my favorite scenes, actually, just this moment of very quiet reflection for both of them in the midst of something that is absolutely the height of drama."

—LAURA DONNELLY ON JENNY AND CLAIRE'S LABOR CONVERSATIONS

"When it came to Jenny's childbirth, I watched a lot of videos on how to deliver breech babies. Whether or not in the actual doing of the scene you use any of that, I feel that it's important just to inform yourself and to feel like you know what that process would be. What would it feel like to turn a breech baby inside the uterus? So watching YouTube is great. I don't know what actors did beforehand, because I use it so much."

—CAITRIONA BALFE

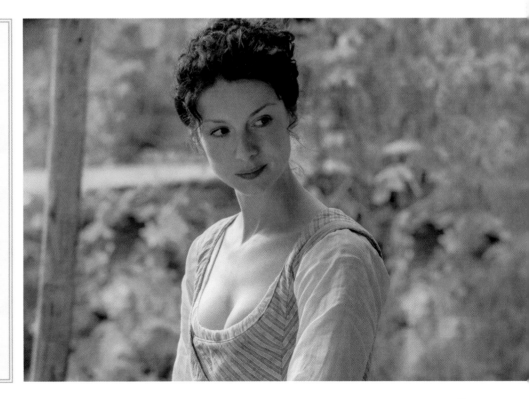

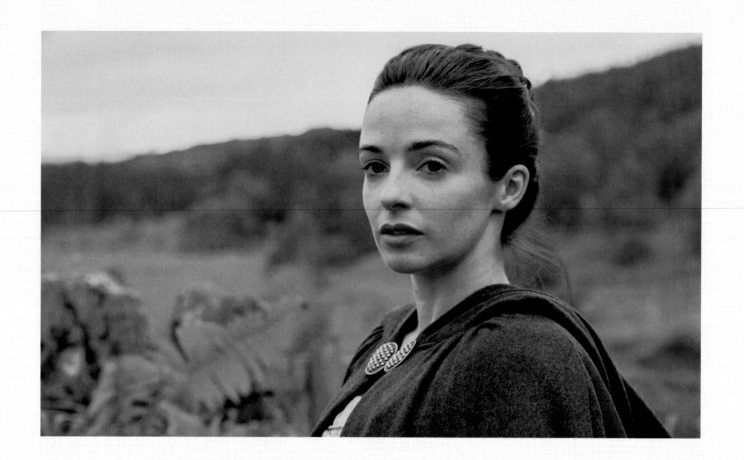

SPOTLIGHT:

LAURA DONNELLY AS
JANET "JENNY" FRASER MURRAY

Characters as resourceful, resilient, and deliciously stubborn as Jenny Fraser Murray don't come around often for actresses, which is why Laura Donnelly was so grateful to win the coveted part. Playing Jenny also came with the perk of reuniting (after a previous film project) once more with Sam Heughan as an acting partner, this time as the headstrong Fraser siblings.

Having also read for Claire, Donnelly says it be-

came clear when she did a chemistry read with Sam that she was more suited to playing the sisterly vibe of Jenny. Maril Davis agreed. Donnelly was cast and then quickly set about developing her character. The actress says a huge insight was finding out that Jenny's personality traits were influenced by Diana Gabaldon's own personality, so she used that and the script to flesh out her take on the feisty head of the household.

As a former resident of Scotland, Donnelly says she

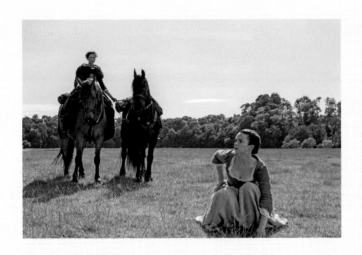

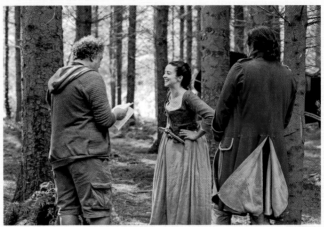

was able to easily access the accent, but she worked with dialect coach Carol Ann Crawford to tweak it toward more of a northern sound so "Sam and Ian [Steven Cree] and I would have similar accents and sound like we were from the same area." Donnelly says that in addition to Heughan she also knew Cree, who plays Jenny's husband, from previous experience, so the trio was able to draw on those prior relationships to create a quick rapport that translated onscreen. "Steven is such an easy guy to get along with, and he's very fun and very charming," she says warmly. "It's funny, because the dynamic between Sam, Cait, Steven, and myself all together has a similar timeline to it, in that me and Steven and Sam have known each other for a long time. We've all only come to know Cait through the job, so there's an underlying truth to the whole thing, which kind of helps."

Donnelly only appeared in "Castle Leoch" and didn't return until "Lallybroch." "That first scene was

Sam's first day on set," she remembers. "Everything was really just beginning, so to come back six months later to a well-oiled machine in full flow was remarkable."

Donnelly reveals that her return scene was in the episode-ending graveyard confrontation, where Jamie and Jenny have it out regarding their long-simmering regrets, blame, and guilt left unresolved since Jamie was arrested and their father died. "The challenge of that scene was that they both have to draw on four years that we haven't seen," Donnelly details. "It's a big opportunity for us as actors to create that path. From my point, Jenny is a very stoic character and she doesn't feel comfortable giving a lot away, so to have all of that bubbling under the surface but try to resist it coming out is a really wonderful thing to get to play." Its resolution also set the template for playing the Fraser siblings from that point forward in the series, which Donnelly says they continued to explore in season two.

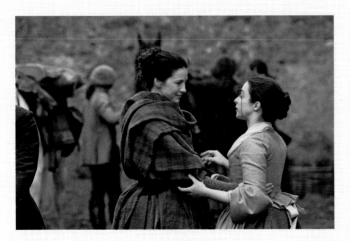

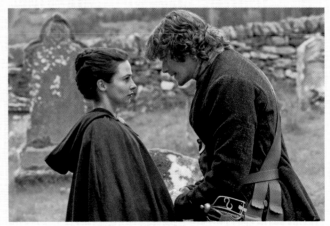

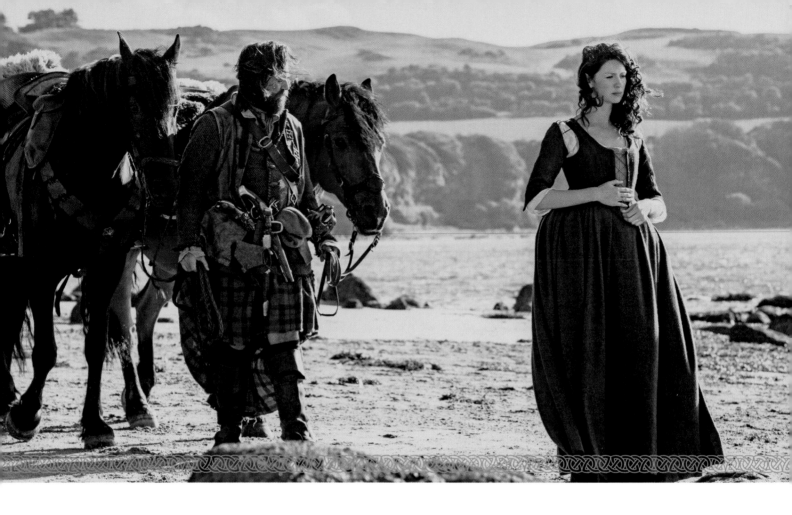

EPISODE 114: THE SEARCH

WRITER: MATTHEW B. ROBERTS DIRECTOR: METIN HÜSEYIN

When Ian returns to Lallybroch without Jamie, Claire and Jenny saddle up their horses to go on the road to find out what's become of him after the Redcoat ambush. "The Search" turns into an epic journey for Claire as she pursues her husband across the Highlands.

For writer Matthew B. Roberts, the episode became his most difficult script to break, because the search in the book is essentially treated as a passing aside. "It's maybe five paragraphs," Roberts explains. "It mentions that Claire sings, or Murtagh sings and dances, and then the gypsies relay the message. Boom! That's it," he laughs.

With a relatively blank canvas to explore how Claire tracks down Jamie, and plenty of character moments to explore along the way, Roberts broke down the script into three parts. "I did two buddy pictures and then a stage play. It had

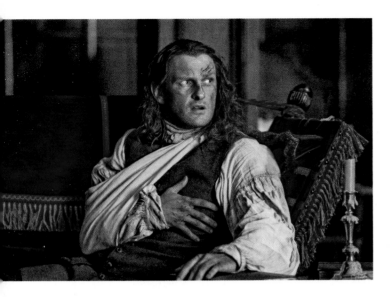

Jenny and Claire, Claire and Murtagh, and then Dougal and Claire at the end."

Roberts also wanted to give the entire endeavor a slight twist. "In the definition of 'search,' you go and look for something," he explains. "What I liked about this, and what I really wanted to hit on here, was you did the exact opposite. Murtagh even says, 'We're not going to find him; he's going to find us.'"

Director Metin Hüseyin knew he had to create a very cinematic setting so the sense of miles traveled and time passed would read

for the audience. Having Claire and Murtagh become an act in a traveling show helped the director hit his goals. "We knew we had to show the repetition of it all, and we knew we had to make it feel like they were crossing Scotland. Although we as a production couldn't cross Scotland and show all the different places that they may have been to," he says with a knowing laugh.

The opening block with Claire and Jenny, Hüseyin says, was defined by a sense of impulse. "Claire has an idea," he says. "'I'm going to go and find Jamie wherever he is,'

but she really doesn't have a clue. Jenny just leads the way until it reaches a point where they hijack the English soldier, and Claire finds out a big part of herself there, that she would have killed that guy if she'd had to."

Jenny then hands off Claire to her next guide, Murtagh. "When he arrives, they have to just get on with it," Hüseyin continues. "They seem to be unhappy with each other, but we find out that they're both blaming themselves and both feel like they failed [Jamie]. Then we go on this trip with them."

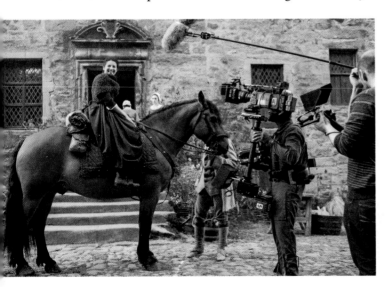

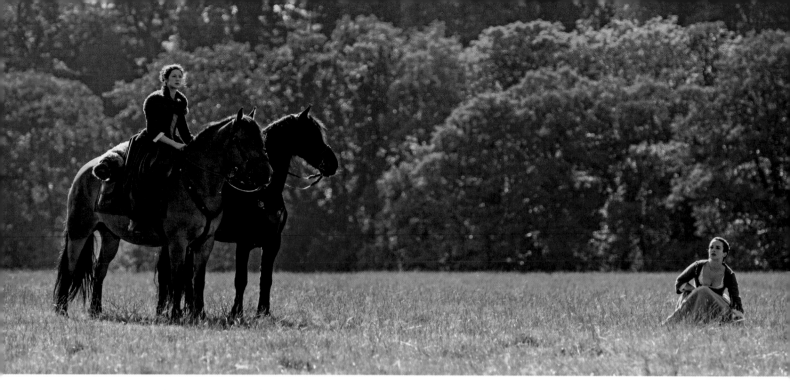

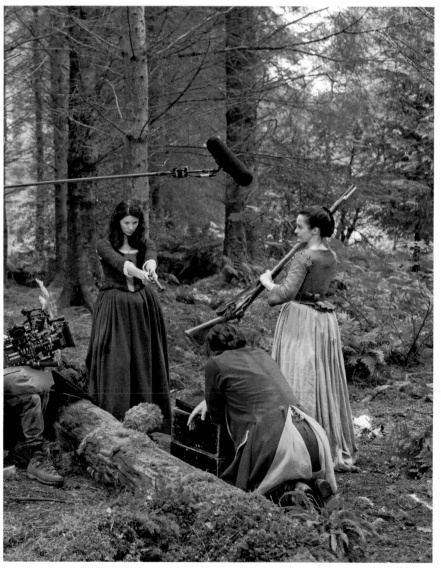

"The difference of having spent a couple of [weeks] in the sets of Lallybroch and then to suddenly be out in an absolutely different world on the back of a horse was wonderful. And when [Jenny and Claire] ambush the [soldier] and they both have the guns pointed, it was a real badass shot at that. I also like the scene where Claire's gathering wood and Jenny just reminds her that you'll do whatever it takes to protect somebody that you love. It's a moment where they find a mutual respect."

—LAURA DONNELLY ON JENNY AND CLAIRE'S ROAD TRIP TO TRACK JAMIE

Hüseyin adds, "I have to say that Duncan, who plays Murtagh, did a lot of training to dance badly. I think to dance badly you have to be able to dance well so that you know what you're doing. I thought he was fantastic in those scenes with his grumpy little face when people told him he was crap. It was very sweet."

With the journey leading to Jamie's whereabouts with Black Jack Randall in Wentworth Prison, Roberts says he appreciated that "The Search" allowed him to explore key characters before the explosive finale. "It was one of my most satisfying writing experiences, because I thought I was very true to the book," he muses. "And I thought that I was true to the characters. It worked out nicely in the end."

"The [prosthetic lactating breasts] did take some getting used to. We had a little rehearsal before and a camera test of the contraption to get a bit used to it. Overall, it was a bit of patting your head and rubbing your stomach at the same time. The idea was being as organic as possible in that moment. This is supposed to be something that Jenny is so comfortable with. If there is the slightest hint in my face, or my voice, that this wasn't something that was second nature, then it destroys the entire point of the scene. Claire is the one that's supposed to find it fascinating, or in any way surprising. I was so impressed with how it looked when I saw it on the screen. And it was a scene I was actually really proud to be part of, because I think that the whole principle was to show the reality of breasts, and breast-feeding, and the reality for mothers today. I think that it was a great thing to put on TV, and to show people that that's just reality."

—LAURA DONNELLY ON JENNY'S BREAST-FEEDING SCENE

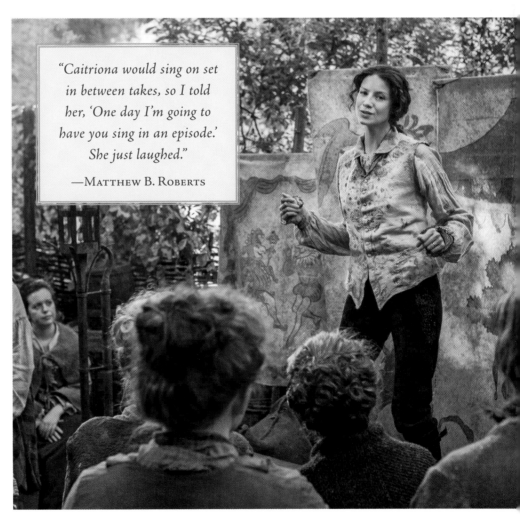

"Caitriona would sing on set in between takes, so I told her, 'One day I'm going to have you sing in an episode.' She just laughed."

—MATTHEW B. ROBERTS

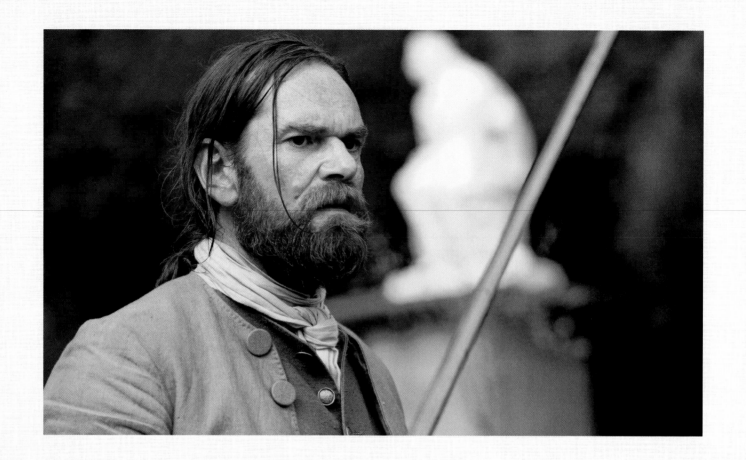

SPOTLIGHT:

DUNCAN LACROIX AS

MURTAGH FITZGIBBONS FRASER

As a wanted man, Jamie Fraser has always kept his circle of trust very small: Claire, Jenny, Ian, and arguably his most loyal ally, Murtagh FitzGibbons Fraser. When it came time to cast the TV-series version of Jamie's de facto godfather and lifelong protector, it (perhaps ironically) was British actor

Duncan Lacroix who ended up best embodying the Highland curmudgeon with a heart of gold.

Lacroix, a theater actor known for roles in *Vikings* and *Game of Thrones*, remembers that Murtagh was initially described in his audition notes as "dark and watchful" and always paying attention in the back-

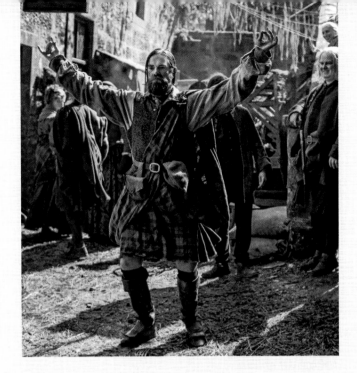

ground. "I think the word 'hawk' was also mentioned," he recalls. "There was just something about that character description that seemed like a comfortable fit for me. And I think my features tend to lend themselves to that kind of character as well," he chuckles.

While most actors relish a chatty character, Lacroix says Murtagh's economy with words appealed to him from the start. "The fact that he didn't speak much, or that when he did it was because he had something to say, I admired," the actor says. "That and his stubborn loyalty. Things are pretty black and white for Murtagh, and there is something very freeing about that. He's free from a lot of self-doubt and second-guessing."

Like Murtagh in the books, the character in the TV series always places himself where Jamie might have the most need of him. For Lacroix, that loyalty is the defining characteristic that binds the two men together. "I always felt that some of my best scenes are when Jamie and Murtagh are alone," the actor says. "It's the calm moments in the middle of a storm where both characters get to reflect on the madness that is going on around them. There is something very natural about the chemistry between us. But I like to think my best work is not just working opposite Sam but also the work I've done one-on-one with Cait," Lacroix adds. "They're both such wonderful actors, and that always brings out the best in me."

The rapport hasn't been lost on the writers, who have leaned into it more as the story progressed. "I remember chatting with Ira [Steven Behr] early on and found out that Murtagh was going to have a big part to play in season two," the actor says of his expanding arc. "It was a gradual process, and I think that as I was developing him, the writers had time to see what I was doing and develop that into the later episodes."

In season two, Murtagh in the series deviates from the books, as he is told about Claire's origins by Jamie and then enlisted as a co-conspirator in their plan to stop the Jacobite rebellion from France. While the character's footprint expands in the narrative, Lacroix says, Murtagh's reasons for helping haven't changed: protect Jamie in any way that he can.

"I think Murtagh is a pragmatist and isn't necessarily a Jacobite," Lacroix says of his character's agenda. "He would do anything to preserve the Highland way of life, and he clearly sees the Bonnie Prince as just another foreigner who knows nothing of what Highland life is really like."

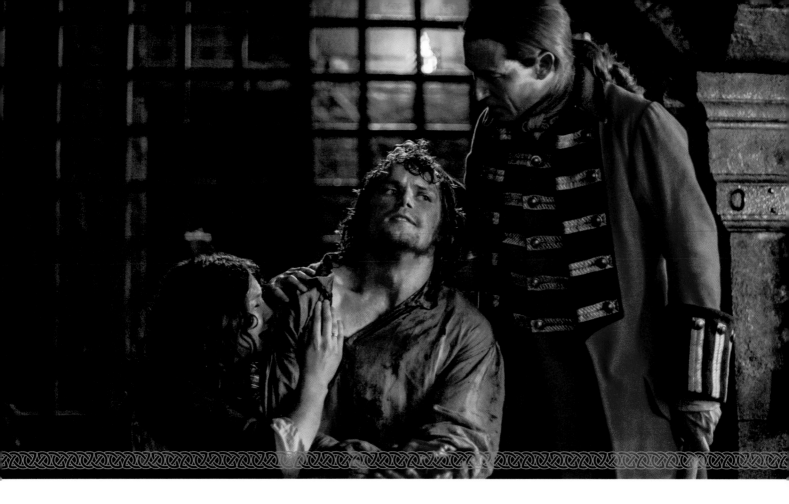

EPISODE 115: WENTWORTH PRISON

WRITER: IRA STEVEN BEHR DIRECTOR: ANNA FOERSTER

The writers' room always knew that the last two episodes of season one would be brutal to write and shoot. However, writer Ira Steven Behr took creative ownership of "Wentworth Prison" without hesitation. "Ron and I have had discussions." Behr smiles. "He gets Frank. I get Black Jack. I don't know what that means and I don't think anything should be read into that."

In fact, Behr says, the most complicated aspects of that script were in building up to the big res-

cue at the end of the episode. "The stuff that was hard to write—and it sounds so silly—was the cattle [scheme] at Sir Marcus MacRannoch's [Brian McCardie]," he explains. "That was actually a tougher scene, in terms of the writing, to get right. It was figuring out how to lean on Murtagh and Ellen [Fraser] and the jewelry. And what are the guys doing while they're sitting around? But I did know that I

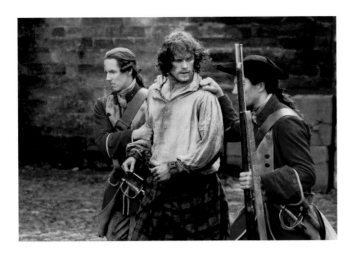

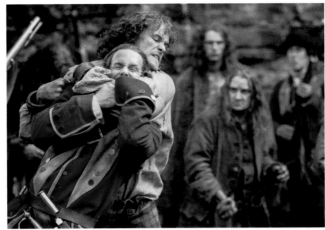

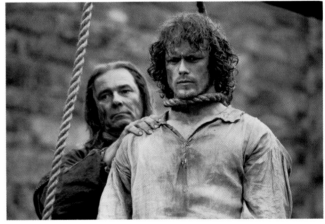

wanted it to be Murtagh who comes up with the [cattle break] idea, just because I felt if anyone still has a little bit of mystique of quietude around them, it's Murtagh.

"The other thing that was tough was the hangings at the beginning," Behr continues. "They were tough because I wanted them to be very, very unsettling." Director Anna Foerster followed Behr's lead and visualized the bleak hangings at the Wentworth gallows as Taran MacQuarrie and Jamie await their turns at the noose.

"What's important for the whole hanging scene is the idea that they realize there is no way out," she says of the duo's mindset in that moment. "The whole hanging stuff, it's excruciating and terrible. Even the first guy hanging, it takes a long time. They're suffering. The fact is you'd be standing there, staring at it. [Jamie] knows he's going to hang and he has all this unfinished business with Claire. All his thoughts are about Claire and the fact that he basically failed her. It was important to get this across, because when Randall shows up it's almost surreal for Jamie."

From there Foerster had to lead her cast and crew into the virtual bowels of hell as Randall starts his interrogation of Jamie, first with Claire in the room, and then just with the two men in "To Ransom a Man's Soul." Rehearsal again was

key, she explains. "It's really good if you have the mechanics worked out, as that allows the actors to then be really open for their acting, for their emotions. I think that was hugely successful in terms of allowing the actors to go there. As well for me—it allowed me to then concentrate on performances."

As to the intense period of shooting in the dungeon, Foerster reflects that it was a remarkable experience observing how it affected the whole crew. "At some point we were a little bit concerned: How will it be when we do all the tough stuff between Jamie and Randall? How will the crew react? Will it be awkward? It was really interesting what an immediate impact it had on the crew. They were all in it. It was affecting everybody. It was actually a very, very rewarding experience to see a whole team come together like that in this really, really awful place."

Foerster says she was keen to

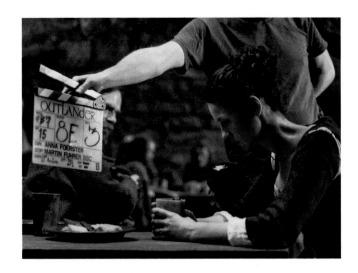

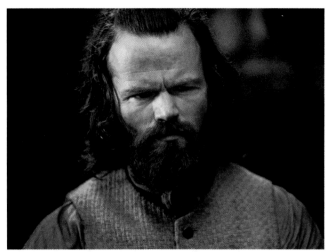

make sure she gave her actors what they needed to get through the scenes. "Sometimes actors need different things to deal," she explains. "Some of them do the scene and then they snap out of it and they joke around and it's funny. In the Randall–Jamie scenes, that wasn't the case. We were really stuck in that dungeon. There was no real escape. And I say this the most compassionate way I can: I definitely pushed those two people. I know I had a conversation with both of them at some point, and it feels weird to have a conversation like this, but I said, 'Look, we're going to be in this and it's going to be terrible. I will continue pushing, but you have to let me know when it reaches a pain level that is not supportable anymore.' I think that almost gave them a challenge. It's funny, it was almost like it had the opposite effect. I truly pushed them and they were embracing it."

> "Black Jack can take anything, but the only moment he's shaken is when she tells him the day of his death. That gets to him a little bit. It doesn't really change anything. It doesn't change what he does. He was not walking that way to say, 'Look, watch out. There's a hole over there.' She was going into that hole whether she mentioned that or not."
>
> —IRA STEVEN BEHR ON JACK THROWING CLAIRE
> OUT OF THE PRISON

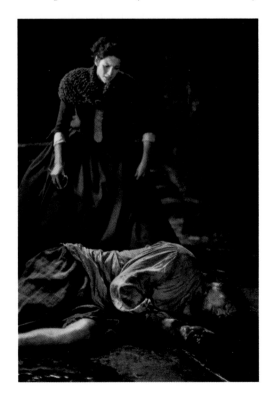

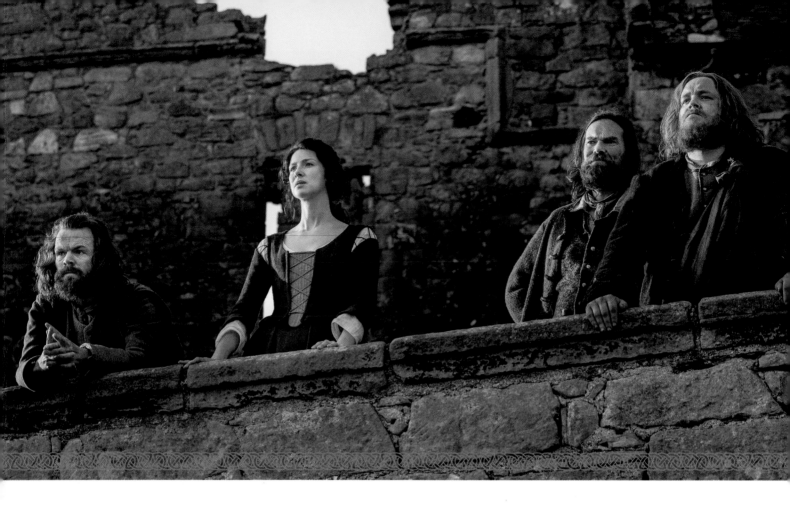

EPISODE 116: TO RANSOM A MAN'S SOUL

WRITERS: IRA STEVEN BEHR AND RONALD D. MOORE ⚜ DIRECTOR: ANNA FOERSTER

Telling Diana Gabaldon's *Outlander* story authentically meant the production was always going to have to reproduce the harrowing rape and torture of Jamie by Black Jack Randall in Wentworth Prison. But reading it and portraying it are very different experiences, and deciding just how graphic the series was going to go with it ultimately rested on Ron Moore's shoulders.

"Starz from the very beginning embraced it," Moore says of his creative parameters. "They were totally down with doing the end just as it was in the book. They pride themselves on being a premium cable channel that is not afraid of this kind of subject material. There was no restraint at all. It was just about finding the right balance and the right tone of doing the scenes. The crucial stuff was in the structure of [the episode] in that they rescue Jamie and then we're going to tell a flashback tale. Claire is trying to reach and understand Jamie, and then he is withholding. Yet we the audience

are going to go back with him into the cell."

It is typical for most showrunners to write the first and last episodes of their seasons. Moore always knew "To Ransom a Man's Soul" was coming but was assured by longtime collaborator Ira Steven Behr that he could choose not to write it if he wanted. Moore dove in but admits he hit a creative wall quickly. "It doesn't happen very often, but I got to a place where I was struggling with it," he shares. "I kept working at the scenes and I just couldn't grab it. I had pages of stuff, but I just knew that it wasn't working. It was meandering around with lots of long speeches that didn't quite move or touch you. So I called up Ira and said, 'I need help. Let's do this one as a team.' He had done such a great job with [episode 115], so he took the lead on those scenes with

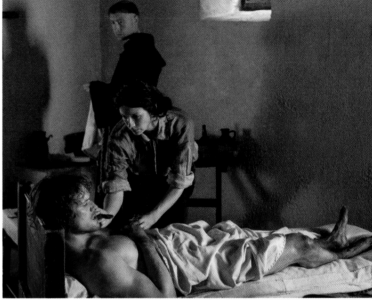

"I was very keen to make [the torture] very forensic so that it wasn't emotionally incontinent. The violence was not coming out of a thuggishness or a brutishness; there was a precision, an accuracy, and an intelligence behind it. It is an almost loving but profound investigation of Jamie and what Jamie is made of emotionally and psychologically. Through that Wentworth sequence, [Jack] comes to understand that Jamie is built upon Claire and the idea of Claire. That's why you come to the end where he almost personifies Claire and gets him to say her name. I think what he's trying to do is, if he poisons the idea of Claire, or who Claire is for Jamie, that will unravel him."

—TOBIAS MENZIES ON PLAYING JACK'S
MINDSET REGARDING JAMIE

"I love the moments when Murtagh and Jamie are alone and they speak out to each other in Gaelic. It feels like a private language where they can really open up to each other. In the monastery, basically Jamie is asking Murtagh to kill him. It was great to be able to really act something quite dramatic where people won't understand every word. They get the gist. What I wanted to do in that solo moment of telling Murtagh everything, it felt important to me that it be in Gaelic."

—SAM HEUGHAN

Jack and Jamie and really brought it into focus. Then I could help riff on it. It became much more of a collaboration between the two of us, and that is what really made the episode finally come together."

In tackling the most graphic material, Behr says, "The one thing I was firm on was, we can't make this smaller than it is. We can't TV this up. This is not about 'feel good'

television at this stage of the game," says Behr passionately.

Moore continues, "It had to be about the relationship between Jack and Jamie, in specific terms: Jack's obsession with Jamie. It was figuring out the dynamics of it and then letting the actors rehearse. Watching what they bring to it and having long conversations with them and the director to keep mining the material. What's Jack Randall's obses-

sion with this young man about? What is he willing to do to him? And what does he want?"

Uniquely for Foerster, Moore, and Behr, what Randall does to Jamie forced them to consider how the audience would process Jamie's choices. "You have a really strong hero in Jamie," Foerster explains. "You need to make sure that you, as the audience, are not questioning him as a character. I think we

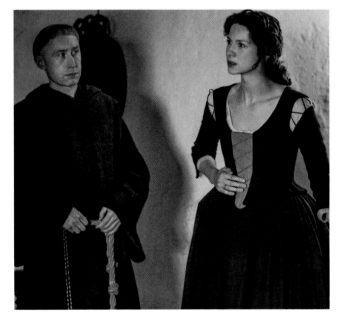

all were trying to work on that. First from the script, then the way it was blocked and the way it was shot."

When Jamie succumbs to Randall's twisted psychological warfare, Foerster explains, "It becomes clear that even if it's Jamie's choice, it is almost an altered mindset when and how this happened. You have to show the depth of the brainwashing to actually justify what Jamie is doing in a way that, as the audience, you still believe in him as a hero."

Later, in the monastery, Jamie is so broken by Randall that it takes a desperate Claire to help pull him back to the world of the living. For that emotionally devastating scene, Foerster says they used a special lens to simulate a window into Jamie's mind. "When he looks up and into Randall's eyes when it's really Claire, we're trying to get into his head again to see what he sees and what he experiences. When they throw each other off the bed and

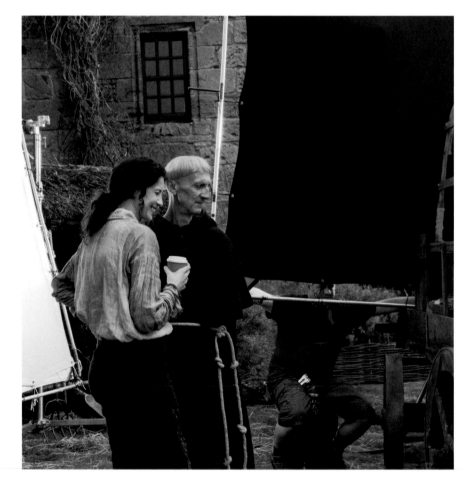

they struggle on the ground, I like the extremes. It shifts from him being delusional, then to the discovery of the burn mark with Randall's name on it, to having that conversation where he basically

tells her that he doesn't want to live anymore. To me, I have to say as hard as those scenes were, they probably have been to date the most rewarding scenes I've ever directed."

"My favorite moment might be sailing back to shore after we had finished filming the last scene of season one [on the boat to France]. It was a really long day, and we sailed back under full sail as the sun was going down. It was very quiet and beautiful. It was kind of a Murtagh moment."

—DUNCAN LACROIX

SEASON TWO

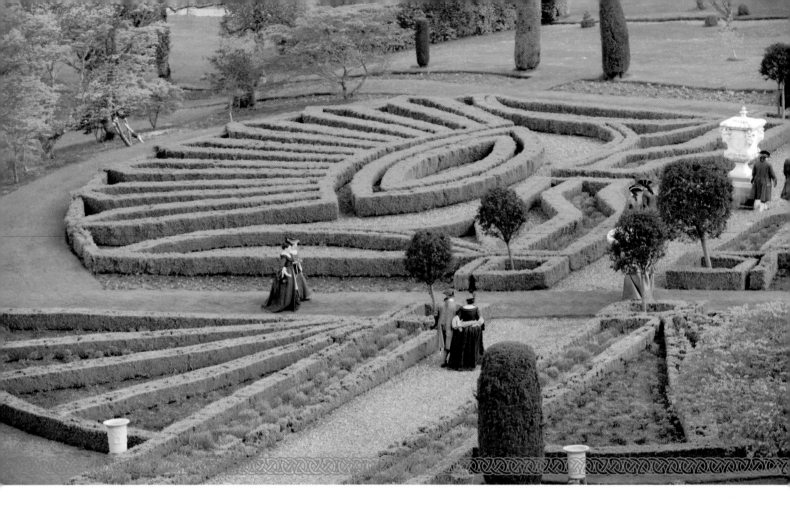

BUILDING SEASON TWO

When production began on season two, Ron Moore, Maril Davis, and producer David Brown had been managing the creative train from two continents for over a year, trying to streamline the hectic process. The show never really took the break there often is between seasons—the writers were planning, writing, and then pre-producing season two before season one filming ended. Moore, Davis, and Brown realized that they had to keep the plates spinning in order to stay ahead of the demands of the show.

"The experience with season one was pretty eye-opening," Moore says frankly. "It's just the immense scale of the show. The preps were more difficult—how many locations we went through and that the story kept moving from place to place to place. It was such a grind, so that kind of experience predominantly informed the second season.

It didn't make it easier, but you knew what you were getting into more."

Adapting Diana's second novel, *Dragonfly in Amber*, for season two meant determining the amount of hours needed to tell the story. "A lot of people ask why it was sixteen [episodes] for season one and just thirteen the second," Maril says. "We assumed, as *Dragonfly*'s larger, it would probably be more. But when we broke out the story involv-

ing Claire, there wasn't as much story. In the book, Jamie goes off and does a lot of stuff and then comes back and tells Claire about it, which is fine for a book, but obviously it's very hard to dramatize. The goal was how do we also get Claire involved so she's not just standing on the sidelines. From that, we felt thirteen was the right number."

Despite a lower episode count, the volume of work was actually larger, because of the location shift from Scotland to Paris. "It forced us to start planning even earlier than we did on season one," Moore explains. "Part of that planning meant, how are we going to deliver Paris?"

"We all knew we couldn't actually go to Paris, since Paris today certainly doesn't look like it would have back in the 1700s," Davis continues. "So we went to Prague. We did a scout very early on, before the season started, and realized that would be where we would probably film all the exteriors."

"With that, we then have to have enough sets in Scotland to cover that time before we go outside," Moore continues. "It meant Claire and Jamie's apartment is the closest thing to a standing set we were going to have in season two, and that affected the writing in that we needed to play a lot more in that apartment. Right away, we also needed a place for Jamie and Prince Charles to meet over and over again, which is a big part of

that story line, so we had to build the brothel as another one of our main sets. When you walk into those decisions early, all of the story lines revolve around those primary places, with secondary locations being Louise's and the hospital. We knew the brothel was Jamie's story and the apartment was both of their stories."

Davis says that, with those decisions in place, the production team ended up going on location

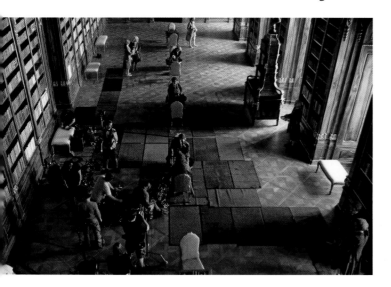

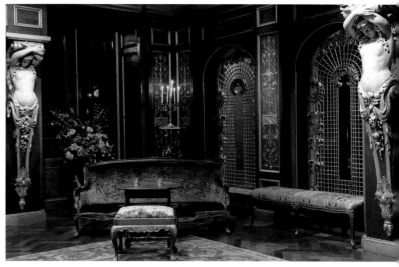

far less than they had anticipated. "We did one week in Prague, obviously, for the exteriors, and then we did Versailles [exteriors] at Drummond Castle in Perthshire, and Gosford House in East Lothian." Interior shots of Versailles were shot at Wilton House, in England.

In terms of the story lines, the tone and driving forces in season two pivot away from the romance and toward a political thriller with Claire and Jamie's scheme to stop the Jacobite rebellion. While some might argue that the audience initially connected with *Outlander* because of the heat between the Frasers, Moore says he was unafraid to expand the boundaries of the narrative.

"I didn't think the courtship romanticism could sustain itself much beyond a year," Moore says frankly. "If you look at the history of TV, there's a limit to how long the audience wants to wait before you finally get the 'two' together.

Once they do, it's a bigger challenge. With the books, [Diana] structured it such that the courtship was only in book one, and [in] book two you were dealing with a married couple. I liked that season two was going to evolve and it wasn't locked into this romance ideal."

As in season one, Davis says, they were also looking for opportunities to create new story by exploring minor moments outside the novels. In particular are the twists of Frank reappearing to open the

season and Claire returning to 1948. "You see [the reunion] in the book but not a huge amount," Davis explains. "He comes to the hospital and you don't see a lot of what happens after that. The more we talked about it, we realized it would be an intriguing way to start the season."

Meanwhile, how they chose to deal with Jamie's recovery post–Wentworth Prison at the end of season one determined how they would have to structure his story in season two. "The difference between TV and the books is that once you had that big, dramatic peak of Jamie and Jack in Wentworth Prison, I knew there wasn't going to be a full episode left in the season just to deal with Jamie's healing," Moore explains. "That doesn't work in television. In the books, [his recovery] becomes surreal and is very internal, and that wasn't going to play onscreen. But if we move the repercussions into the next season, it feels like it's playing out the aftermath in a more realistic way."

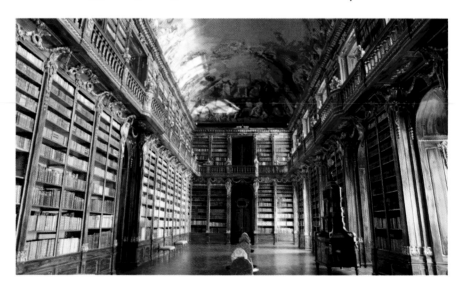

The question then became how long Jamie should struggle with his PTSD into season two without it negatively impacting the love story between Claire and Jamie. "It is a part of him for the rest of his life, so it's not going anywhere," Davis states. "But at what point do [Jamie and Claire] become intimate? We struggled with that and ended up putting that scene in 'La Dame Blanche' because we felt any sooner—and even talking to the actors about it—just seemed too soon. That caused a little bit of reworking in the beginning from our original scripts, because we felt we were doing a disservice to his character if we didn't address it."

Looking at the broader picture of the season as a whole, Moore explains that returning to Scotland clearly became the dividing line of the season, and the rest of the episodes became the war story marching toward Culloden. "Once you go down that path, it dictates all the other stories you can and can't tell and fit into the blocks," he says.

Having learned from season one how important it was for him to be in the editing room, shaping the final episodes, Moore handed over actual script-writing duties to his team for the back half of the season. "The show had matured with all the writers and producers and department heads, so it became easier to delegate," Moore says. "You want to do that, not just for your own sanity but to open up creatively to other points of view and other inspirations and insights."

It was nothing less than a fully collaborative effort figuring out how to land the season finale, "Dragonfly in Amber," which moves Claire's twentieth-century story forward by twenty years. Diana Gabaldon opens the second book in 1968, but in the TV series the producers decided to save that time-jumping twist as a cap to the season.

"We knew that there was no way to avoid the twenty-year jump," Davis explains. While that jump is relatively simple in a book

narrative, to play that out in reality meant they had to figure out how to age up Caitriona Balfe, re-create a sixties' aesthetic, and introduce Claire's grown daughter, Brianna, and the Reverend Wakefield's grown adopted son, Roger. "Certainly we talked about fudging it a little bit by shaving off a few years," she admits. "The problem with that, though, is obviously with Brianna's age, as you can't shave off too much. You don't want her to be sixteen, or it doesn't work with Roger."

Davis says figuring out how to shift Balfe's look by two decades was also a challenge. "Annie McEwan, the head of our hair and makeup department, in consultation with Caitriona, created this Mrs. Robinson look, with a crop-styled hair and a cross-back swatch of gray. We thought it was subtle enough. And then in talking to Caitriona, we realized she's had a handle on the maturity of aging herself up.

"There's such a gravitas to her," Davis says. "This is a woman who has lived through pain and suffering for the last twenty years. There's such a difference in her acting and how she comes across in selling the twenty years that [Jamie and Claire] have lived without each other. She's just brilliant in the way she fills that. You immediately forget about the age thing and you do believe she is a mother to this twenty-year-old girl. I think it completely works."

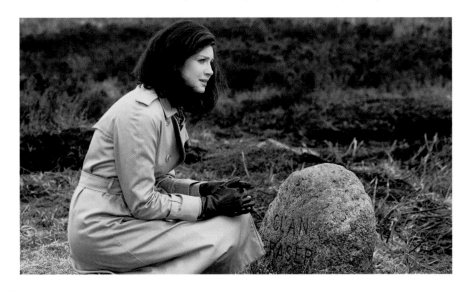

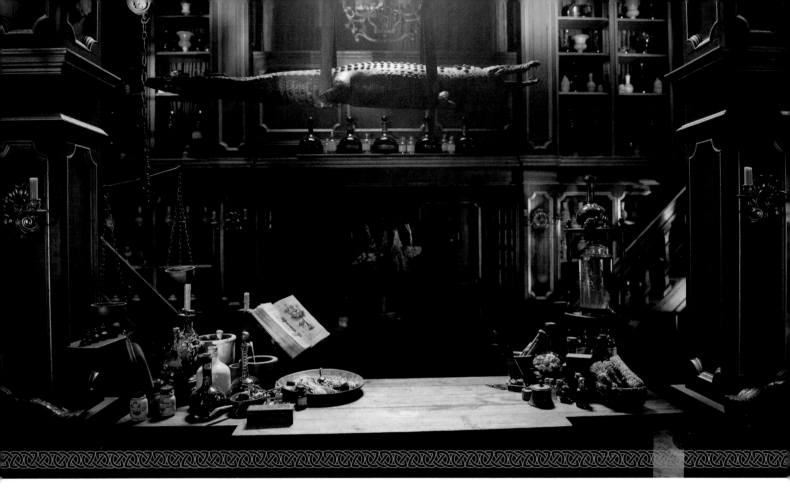

PRODUCTION DESIGN AND SET DECORATION: SEASON TWO

As a longtime fan of the *Outlander* novels, Jon Gary Steele knew what was coming in season two and says he and Terry Dresbach were very excited about the prospect of production designing and costuming the opulence of eighteenth-century Paris described in *Dragonfly in Amber*.

"We both love Paris. I mean,

> *"In Glasgow Cathedral, they had these speakers and little spotlights hanging at the top of these columns that we weren't allowed to remove. We had to make all of these little rubber roses and things that looked like parts of the architecture that you could stick over the speakers."*
>
> —GINA CROMWELL

who doesn't?" Steele laughs. "The eighteenth century is one of the most elegant periods of art, architecture, fashion . . . everything! We started prepping [season two] before we finished season one. We were building models and Terry was doing sketches for costumes, then showing it to Ron to get a jump, because we knew it was going to be so big.

"We tried to show the meticulous attention to detail in the architecture of Paris salons, private homes, shops, and brothels as a direct contrast to season one Scotland. Myself, set decorator Gina Cromwell, assistant set decorator Stuart Bryce, supervising art director Nicki McCallum, and the whole art department researched eighteenth-century Paris to get the details right and to make it correct architecturally, as well as show what a decadent and sexy period it was."

In the first half of the season, the Fraser apartment and Versailles were the focal-point sets built on the soundstages. Building on the lessons they learned from season one, Steele says, "I wanted to have hallways surrounding the larger rooms, to give more depth and allow the directors and DPs the room to dolly the camera from hallways through large openings to the interiors."

"There were so many corridors that we needed fifteen console tables," prop buyer Sue Graham says of the palace apartment. "We actually bought reproductions and had them altered and mended and gilded and painted to make them look correct for the period."

Gina Cromwell says every room was packed with detail work that added richness to every frame. "We had a full-time—sometimes two—tradesman working with us to do all of the upholstery and drapeage. We made all of the door furniture, like the handles on the doors and the

"The Culloden Visitor Centre was actually a brilliant set to do. We were making a museum that was of its time and it's everything I've always hated about museums. There wouldn't have been many people beating a path to go there. It was quite funny, just the way we could arrange the weapons in a way that's not even interesting or dynamic."

—GINA CROMWELL

windows. The cast-iron interiors of the fireplaces, which go all the way around, we had those made." Steele adds, "We had over two hundred fifty linear feet of tapestries printed to cover the hallways and give them a golden glow."

The dinner party in "La Dame Blanche" was another high point for the design team, with a myriad of details audiences won't register at first glance. Cromwell reveals that the wineglasses and the cutlery on the table were specially made for the episode. "We did it because acquiring three-pronged forks, which would be more appropriate for that period—we just couldn't get enough of them. We could get two, but we knew there [were] going to be somewhere around eighteen people dining." Graham adds, "It took an enormous amount of organization, but it was really satisfying to see [the finished set] at the end of the day."

Cromwell's favorite Parisian set was Master Raymond's apothecary. "There's a lot going on there," she reveals. "We had all of the apothecary pots made for us because of the quantities that we needed to go all the way around the room. The back room was incredible—we had something like a hundred forty skulls. I started to put them in and we made these alcoves for them, because in the book it says it's like *a honeycomb of shelves*, so they put the

skulls in them. Some of them were tiny little bird skulls, but it looked great when it was done. Lydia [Farrell], one of our assistants, is an artist by training, and she did some fantastic drawings that were slightly Egyptian and all over the walls. We were trying to give the impression of Master Raymond having wider experience of life and possibly time travel."

For Steele, two sets in particular topped his expectations. First was the blue daybed that served as

> "In March, we started planting potatoes around the back [of Lallybroch], where we have greensmen that work. We [planted] in batches, because we were never quite sure when we were going to start filming 'The Fox's Lair.' They ended up filming it in November, and all the plants had died. We managed to get a load of tomato plants, which do look a little bit like potatoes. It's very frustrating when you've gone to a lot of trouble to try and actually get potato plants to grow. In the end, Claire, our production coordinator, got on the phone and through sheer luck found a scientist who had been doing some work on some potatoes in a greenhouse and hadn't got round to chucking them out. We sent a truck up and came back with a load of potato plants, right at the eleventh hour."
>
> —GINA CROMWELL

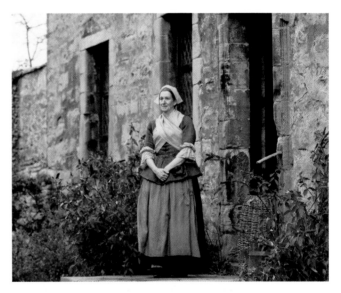

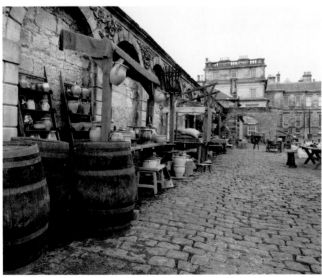

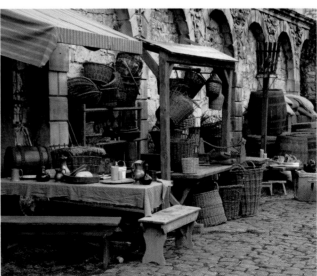

the setting for Claire and Jamie's intimate rendezvous in "La Dame Blanche." Steele explains that it has "blue-mirrored squares amongst different silks and gold leaf. The back of this daybed opens, and the doors are mirrored on one side and silk on the other as they slide into pockets. It was designed so that when Claire's having all these parties, she can be sitting here looking back at all of the guests milling around."

Another highlight for Steele is King Louis XV of France's hidden chamber. "The Star Chamber was actually the first dome I ever built," Steele says. "The plaster man cast it, then we pierced it with holes for stars. Then there was a snake crawling on the ground underneath it, and Claire walks through in this giant dress. It is really stunning stuff."

For the return to Scotland and the last half of the season, Cromwell says, the decoration got more military-oriented. "We had cannons to make and massive amounts of campsite stuff," she details. "There were about seventy tents we ended up making [for the battles], and of course they would CGI more. Flags also came into play, because we're going to war."

Late in the season, "Dragonfly in Amber" gave the entire team one more major challenge: an entirely new look called for by the shift to 1968. "I watched a load of sixties movies and got a load of sixties books and magazines from the period," Cromwell says. "You're not looking at that trendy look that people reproduce now as the sixties, but we had to go back to looking at 1968 *Ideal Home* magazine. You get more of a feel for the [era] rather than what people cherry-pick from the period and use now. What's so interesting about 1968 is that it's actually really quite modern."

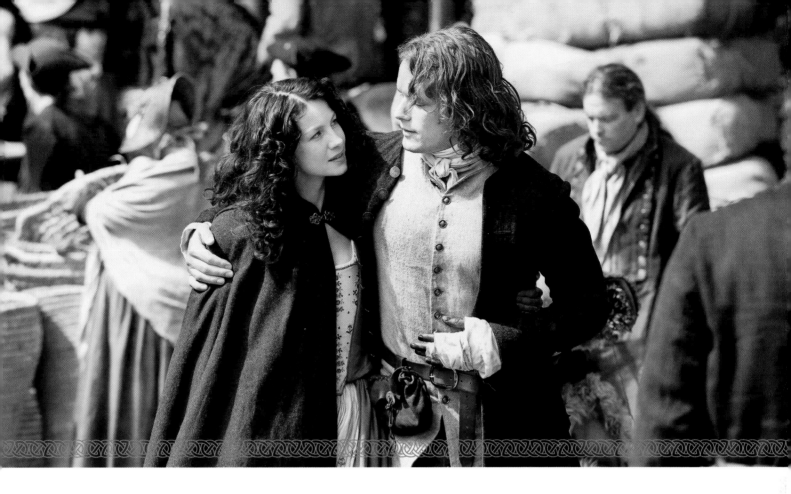

EPISODE 201: THROUGH A GLASS, DARKLY

WRITER: RONALD D. MOORE DIRECTOR: METIN HÜSEYIN

"Through a Glass, Darkly" was a complicated episode in that it had to open a brand-new season, surprise the audience with Claire's return to 1948, and set up the complex political arc in Paris that would drive much of the second season. Ron Moore penned the episode, with director Metin Hüseyin establishing the distinct visuals that would define the look of the sophomore season.

> "The whole episode was like a symphony based on the Claire and Frank theme. I still think it might be one of the best scores I have ever written. I was so emotionally involved—some of those themes of her and Frank, I was weeping when I wrote them. I just had tears pouring down my face as I'm trying to capture this moment in music."
>
> —BEAR MCCREARY

"The most challenging part was setting up the second half of the episode and getting all of the political story correct," Moore says. "A lot of things had to be accomplished: telling the audience what Claire knows, what the plan is, dealing with the time-travel aspect and the wine-cargo scene and the smallpox to set up St. Germain. As a writer, I enjoyed most the first half, with Claire and Frank's story," he shares. "It was fresh

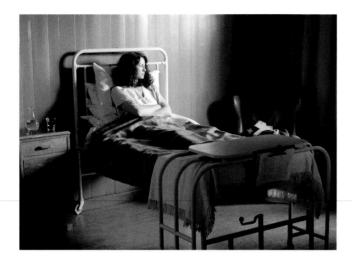

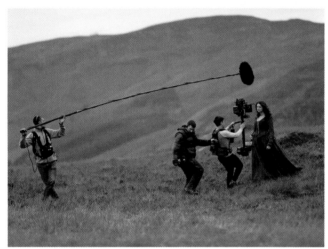

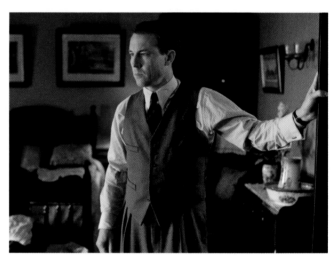

territory and not really delineated in the books, so it was like a blank page. The first half was all emotion, when the second half was more plot."

"I thought it was all beautifully written," Hüseyin says, "so we had to beautifully act it and shoot it." He began the season by filming the reunion scenes with Claire and Frank. "The most difficult scene probably was the scene after Claire tells Frank [what happened to her], because it is just two people talking. I always look at scenes as pieces of music, and you need an introduction, you need a first movement, a second movement, a quiet bit, a

"Does Frank entirely believe Claire's story? I don't know. I think he chooses in that moment to accept it on its own terms. I think there well may be a bit of him that's not sure that it's not a bit of magical thinking on Claire's part. Whatever the truth of the story, the physical reality of the child is undeniable, and so really that becomes the main thing he has to digest and make a decision about. Where he arrives in the end is a flawed but practical decision but one that is based upon great love. In a way, you could argue it's an even greater act of love to accept the child and accept her back, even though he can see that she doesn't love him the same way that she did. I think the light in her eye's not the same."

—TOBIAS MENZIES

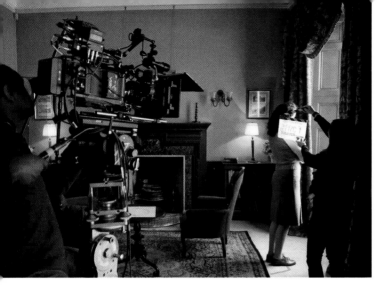

> *"Tobias and I felt so grateful that we had these amazing scenes to play, because it is so tragic. Frank is coming to Claire after experiencing these years of loss, yet he is so open and willing to take her back. Claire is just unable to love him in the way she used to and unable to give him anything back. She is going through her own grief and her own loss. It really is so layered and so complicated, with two people who are experiencing their own tragedies and are unable to bridge that gulf."*
>
> —CAITRIONA BALFE

loud bit, and then you need a big finish. So it was just working out how two people would negotiate their way through this thing that no real person has ever had to go through."

After establishing the parameters of this new stage of Frank and Claire's marriage, the series shifts back in time to Claire and Jamie's arrival in Paris. "The highlight of the whole episode was the transition from the 1940s to the eighteenth century. The airplane and Claire coming down the stairs, the music and reaching out her hand, and then it becomes Jamie—when we figured that out I was very excited," Moore says. "There was a lot of VFX work involved to make sure that the plane looked real, when there's no plane there in reality, so when it all came together I thought it was magnificent."

Shifting to France, Hüseyin was guided by Moore's vision that those elements "be brighter, more colorful, more lively" and a bit wider in scope. "The characters are bigger, so at the beginning we need to see where they are and where everything is. We rarely go in tight, because we need to see the wonderful clothes they're in and the wonderful sets they're in."

> *"When Frank is telling the reverend what he's just heard and then he compares Frank's situation to Jesus, Joseph, and Mary, Frank blows up. Frank swears in that scene, and he didn't originally. When we were rehearsing it, Ron just came up and said, 'Get him to say "fuck" there.' He did it, so that's what the little boy [Roger] hears, which completely made that scene."*
>
> —METIN HÜSEYIN

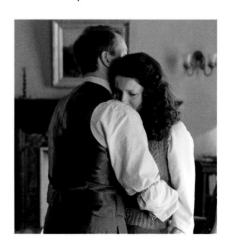

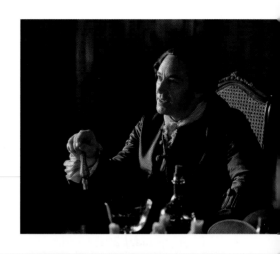

"The dock scene was the very first appearance of the character, so I was walking around with my cane, trying to compose myself and look cool. I was trying to compose the character too, as that was the very first time I was getting in the [costume]. Cait and Sam were so lovely that I was asking myself, 'How am I going to hate them onscreen when they keep making me smile?' They were just adorable."

—STANLEY WEBER ON HIS FIRST DAY AS LE COMTE ST. GERMAIN

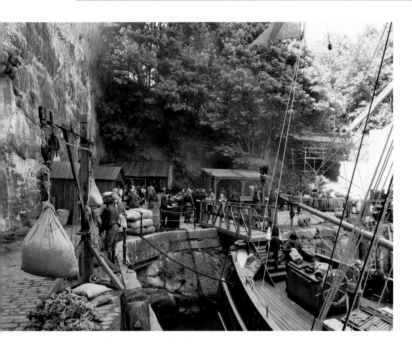

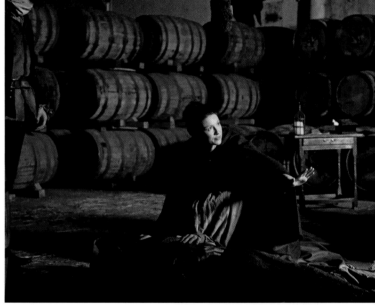

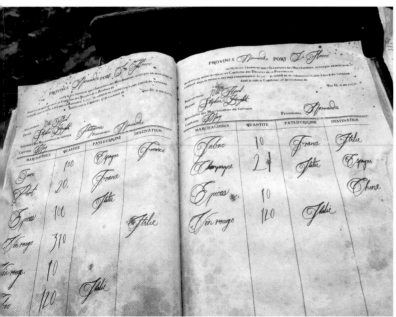

"The comte was such an interesting, striking character. I looked him up and I found out that he was, among other talents and trades, a composer. My historian, Adam Gilbert, found me a handful of what would be his most famous melodies, and I picked the one that I thought would work the best for him, and that's his theme. Every time he's on camera, you hear a very particular melody. In fact, to hear it really clearly, listen to the end credits of [episode] 201, which are a full-on statement of that theme."

—Bear McCreary

"At the end of season one, when Jamie leaves on the boat, his hand is completely black and blue. When he gets off the boat on the other side, I wanted the skin to look damaged. But I didn't want something that was going to peel away, and I wanted something that was going to be really fast, because it adds extra time to Sam's makeup call. I mentioned to him about using paper for skin, and he told me that his mother actually makes paper and sculpts with it. She sent me some for me to use. So when we first see the hand, when the bruises go on, I color it up underneath and leave the paper on top, then use spirit gum over the top of that, and when it dries, it contracts and gave us this lovely texture."

—Wendy Kemp Forbes

"In season two, we have this hand scarring, so there's a way that I have to hold my hand now, because one of his fingers is straight and the other tendons are busted. Now his hand and his back are affected. It is interesting to see this man get older and how his body is changing. It is odd, and I keep finding myself now, in moments when I'm feeling slightly tense, holding my hand in the way Jamie does. It is so odd. It's like a safety thing."

—Sam Heughan

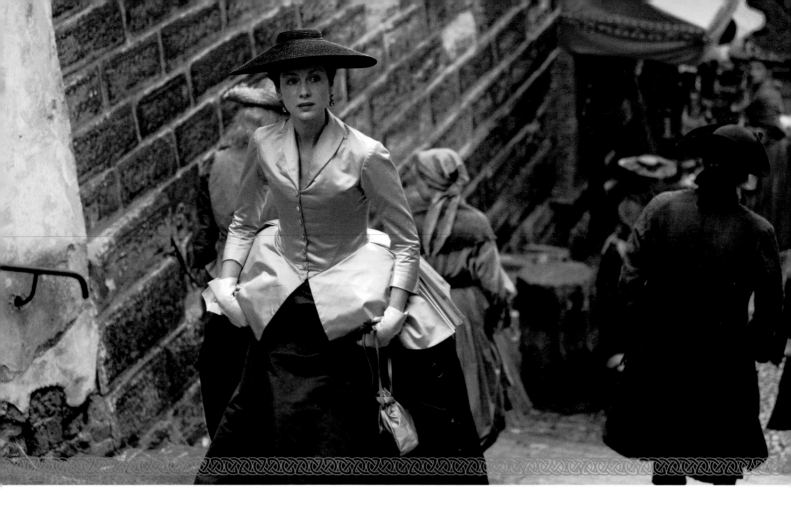

EPISODE 202: NOT IN SCOTLAND ANYMORE

WRITER: IRA STEVEN BEHR DIRECTOR: METIN HÜSEYIN

"Not in Scotland Anymore" expands on the first glimpses of France we saw in episode 201, as the Frasers start to immerse themselves in Parisian life. "Since I wrote a lot of the darker shows in season one, I was going to start out with a lighter one, introducing everyone: Duverney [Marc Duret], Master Raymond [Dominique Pinon], Louise [Claire Ser-

> "We had a duel in a Parisian park, which was very much to get Jamie back to strength after his hand was nailed. [Jamie and Murtagh] are using it as a discipline and an exercise to get his strength back. At the same time, Murtagh was pushing Jamie. He wasn't being soft on him at all."
>
> —DOMINIC PREECE

monne], and Mary [Rosie Day]," writer Ira Behr explains. "Of course, my first thought was, *We start out with a scene where Jamie is having sex with Black Jack*," he laughs.

Opening with Jamie's nightmare serves several functions: establishing his PTSD after Black Jack, illustrating how it's affecting his relationship with Claire, and opening the door for the episode's big reveal. "The idea was, you start

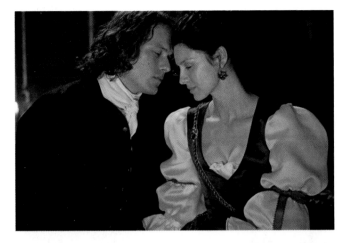

off with the definitive statement that 'Jamie, Black Jack Randall is dead.' Then you end the show with, 'Black Jack Randall is alive!' It sets the stage in a big way."

The lack of intimacy in the Fraser marriage was another tricky issue the writers wrestled with. "I would've kept Jamie in a rougher place," Behr admits, "but I understand that it's a TV show. We're only doing thirteen, and the fact is [Jamie and Claire] are not having sex, which for *Outlander* is a big thing. I get it. We're not here to totally bum people out. However, at the beginning of the episode he's in bad shape. And the scene with the swordplay with him and Murtagh—

it's a fun scene, but you can see he's still not in the best place."

Even a lighter, over-the-top scene like Claire getting inspired by Louise de Rohan's waxing became a jumping-off point to tackle Jamie's serious issues. Behr explains, "Claire has shaved her 'forest,' but how do you play that with a guy who doesn't know anymore if he can ever have a normal sexual relationship? We don't want to make this a candy-coated, silly show. You've got to have the truth of what happened. How it plays finally is [Claire's] trying to reawaken him and he wants to be reawakened, which is what we want. He's willing to come back, but ultimately he can't."

The episode also helps introduce new French-speaking cast members, many of whom director

"I failed my French exam at school. I've spent quite a lot of time in Paris on holidays, so I picked up a bit of pidgin French. We spoke to Guillaume, the French tutor. I wanted Jamie's French to be learned from being in the military, so we looked at using words or phrases that would be slightly more crass French that he learned while he was away fighting with the French Army."

—SAM HEUGHAN

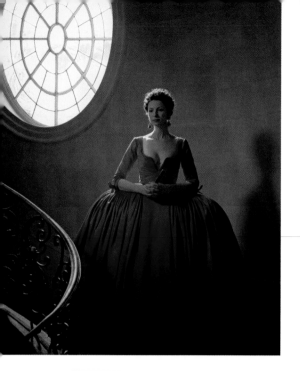

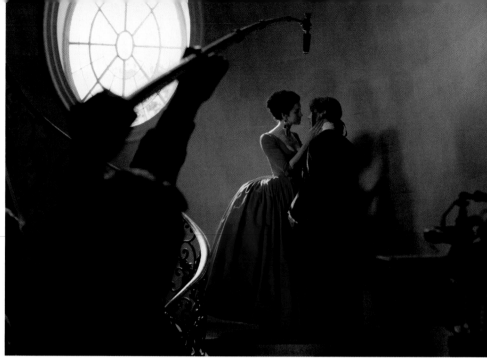

> "Fans don't understand eighteenth-century construction. A lot of them were taking it very literally [that Claire's dress] is cut down to her belly button. It couldn't be. What I did with Claire was the same trick I did with Geillis: I removed the corset. Caitriona is not corseted in that gown, and that makes it scandalous. That allows [Jamie], when he looks down into her cleavage, he can see pretty far down there."
>
> —TERRY DRESBACH ON CLAIRE'S INFAMOUS RED DRESS

Metin Hüseyin was responsible for helping to audition and select. "All the French actors were just adorable," Hüseyin says. "Every single one of them was so excited to be doing something where they could speak English."

Behr was also impressed with Andrew Gower's turn as Prince Charles Edward Stuart. "Gower is a very quirky, interesting actor, and he was a great get. It's fun watching

> "It was one of the most famous scenes in the books, so I was a bit worried. I was wondering how they will shoot it, because Louise had to open her legs. Metin was shooting the scene and he explained to me at the beginning that 'we will not see the camera between your legs.' It was very funny. On my own, I looked on the Internet about how [women] were taking care of [themselves] in the eighteenth century, and I didn't find anything about it. But at a Jean-Honoré Fragonard exhibition, there was one sentence where it was written the women didn't like hairs a lot. That's it."
>
> —CLAIRE SERMONNE ON LOUISE DE ROHAN'S WAXING

him," the writer says. "What I realized, not at first but once I was deeply into the script and realized what we were doing and what was coming ahead, is that Charles is the villain of this season—a different type of villain. In fact, if things work well, he becomes a character that you feel for. As the season goes on, even if you think he is wrongheaded and making mistakes and isn't the man for the job, he does win you over to an extent."

"My favorite moment might be the reveal of Versailles, where we cut from Claire in the red dress; then you hear this symphony come in and timpani. I've never used timpani on this show before and it just creates this mystery, like where are we about to go? Then the brass comes in and suddenly we're in Versailles and it's amazing. It almost creates this delirious sense of total shift that I think creates tension. When we're hearing new sounds, it makes us sit up a little more on the edge of our seat and wonder what's going to happen."

—BEAR MCCREARY

"The cut of the costume is absolutely critical, as they do demand a certain amount of physical discipline just to move around in them. I had a number of very good wigs, which make a huge difference to the way that you hold your head and the way that you comport yourself generally. The shoes too. Absolutely critical."

—SIMON CALLOW

"What Simon Callow did [in the final scene], I couldn't have asked for more, though it wasn't what I was expecting. He played it with a lot more malice. He's not just telling Claire, 'By the way, Black Jack is alive, and I think it's amusing.' He's digging it in. I was totally shocked, but I thought it worked like gangbusters."

—IRA BEHR

"There was a lot of comedy in the scene, but I still had to be the king. Even though he really had a bad stomachache, he was still 'on his throne,' and the scene was funny."

—LIONEL LINGELSER ON KING LOUIS'S INTRODUCTION ON THE COMMODE

SPOTLIGHT:

ANDREW GOWER AS PRINCE CHARLES EDWARD STUART

As an actor, taking on the role of a historical figure is often both exciting and daunting—exciting to draw on real-life events to fuel the performance, and daunting because there's the responsibility to authentically honor the person who existed. So it was for Oxford School of Drama graduate Andrew Gower, who needed to transform himself into one of history's more misunderstood figures, Bonnie Prince Charlie.

The Merseyside, UK, native admits that, going into production on *Outlander*, he knew very little about Prince Charlie. "I knew of his name but never exactly where he fit into Scottish history," Gower explains. "When it came into my mailbox, so to speak, it was an education on both fronts for me, especially the Jacobite history. It's just fascinating."

Gower says for *Outlander* he wanted to perform the character from the script but infuse in his perfor-

mance the spirit of the real man. "Frank McLynn, who is a writer that specializes in Scottish history, is the only chap I could find who wrote a biography on the prince," Gower reveals. "For preparation, and also during the whole shoot, [his book] was my, so to speak, Bible.

"I read his whole childhood up to the moment where he landed in Paris, and that's where [my character] began. I never read ahead unless I knew it was actually included in the episode," Gower emphasizes. "Ultimately, *Outlander* itself isn't about Bonnie Prince Charlie; he's just one of the people who Jamie and Claire

come across. But it was helpful for me to feel my character throughout."

Gower says his most surprising takeaway was how sad Charlie's life was. "His relationship with his father is the most fascinating relationship I've ever read on paper," the actor says. "It's heartbreaking. You understand his desperation. [His efforts] are not just about having a purpose in society again. It's actually about the love of his father, I would say."

Despite that dejection Gower found running through his character, *Outlander* depicts a rather flamboyant era in the prince's life as he took up resi-

dence in Paris. "This is a man who, from the moment you meet him, exudes desperation," Gower says of his character. "But also he's been brought up in the peacock environment of Paris and Italy, and fashion and religion. Unfortunately, through what happens in Paris, he's not received at the courts with King Louis. He spent eighteen months in Paris as a kind of outcast. I think that is where I started bringing in snuff and alcohol and women, because there was a lot of time I felt his anger and guilt and regret. To have that much anger and regret at the age of twenty-three, twenty-four, I can't imagine it. He's

clinging to Scotland when he's got really no idea what it is."

Gower says getting to chart Charlie's infamous journey to Scottish soil, and then his utter defeat, was a fascinating journey to play. "One thing I do hope that people get from it are the moments where you just want to pick Charlie up and hug him and look after the guy. Sam and I were talking about that. He's obviously a very strange and very tiring prince to deal with, but I do think somewhere in there there's a respect on both fronts. At the very end of the piece, there's a respect from me, not as a leader but as a human."

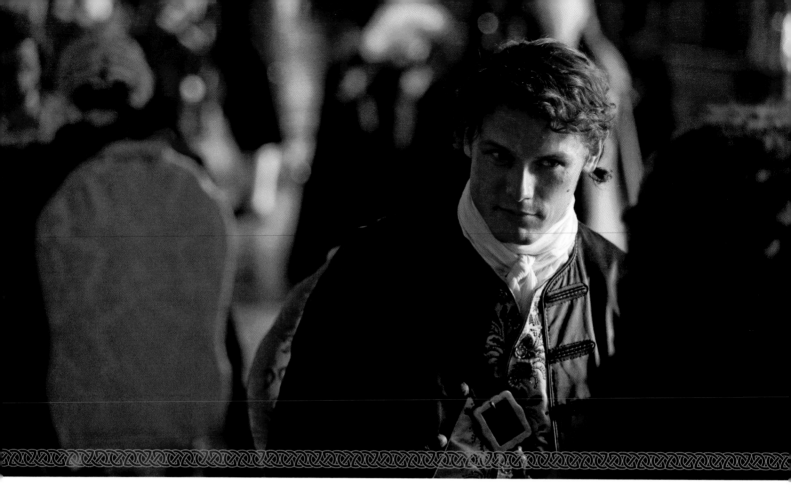

EPISODE 203:
USEFUL OCCUPATIONS AND DECEPTIONS

WRITER: ANNE KENNEY DIRECTOR: METIN HÜSEYIN

The Fraser plan to subvert Prince Charlie's funding opportunities is in full swing in "Useful Occupations and Deceptions." But at this point in the plotting, that means Jamie is incredibly busy and Claire is barely a player in her own game. Writer Anne Kenney says the writers'

room labored to shift Claire from "bored" observer to active participant. "She's a person who is used to being bendy and useful," Kenney details, "so just sitting around having tea with a bunch of ladies is not going to be enough. [Claire's asking,] 'Where I can make a contribution to the world?' even though

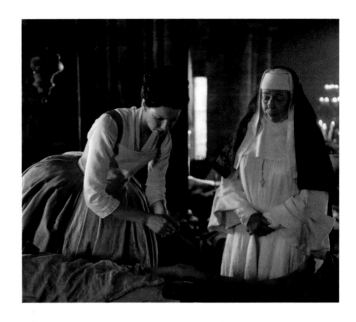

it's not exactly doing what Jamie's doing. That was challenging because they're on a mission together but their roles in it are very different. We had to find ways to keep her active, sympathetic, and keep some tension in their relationship."

Kenney says broadening Claire's world in Paris meant they could turn to characters from the book—like Mother Hildegarde (Frances de la Tour) at L'Hôpital des Anges and Master Raymond and his exotic

apothecary shop—to expand their series narrative. "Those characters are definitely in the books," she says. "But trying to keep them tied into the main story is challenging."

In the case of Master Raymond, Kenney says, they invented material to get Claire to his store. "We came up with this whole story about Murtagh fooling around with the housemaid, Suzette [Adrienne-Marie Zitt]. Then the reason Claire is going to go see Raymond is to get some kind of birth control, which then leads to what the need of the scene is." In this case, it was introducing Mother Hildegarde, as well as the connection between Raymond and St. Germain.

"Raymond and St. Germain do have some sort of relationship," Kenney explains. "We definitely wanted to emphasize that so that you could see who's your friend and who's your enemy."

As one of the point people involved in casting, director Metin

Hüseyin says he was pleased to introduce French child actor Romann Berrux to international audiences as the orphan pickpocket Fergus. "I went to Paris and auditioned a bunch of kids, and to me, it was obvious," Hüseyin says about choosing Berrux. "He's a super-smart kid and he's got such a sweet energy to him."

Kenney says the writers embraced weaving Fergus into the

story. "He becomes a very important character, so we needed to lay him in because we know where it goes in the long run," she explains. "We did change it up a little bit from the book, in that the way Jamie and Fergus meet is slightly different. But he was a fun character to write and the actors just love Romann on the set."

> "A character that has a really iconic theme was Master Raymond. It has a quirky accordion-solo component, and that's me playing the accordion on it. I just thought there was something playful about him and yet mystical, so playing that kind of melody really worked."
>
> —BEAR MCCREARY ON MASTER RAYMOND'S THEME

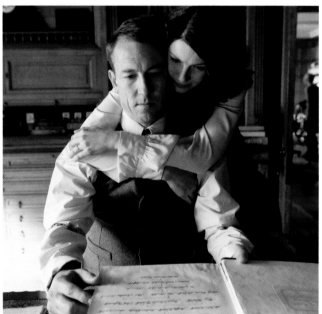

> "Sue [Morrison] is our production/props buyer, and one of her jobs is to find our animals. One of the more fun parts of my job is that Sue comes to me and says, 'We have these dogs. Which one do you think you like?' She showed me one picture of this dog named Scamp, and I said, 'He's perfect already!' That was him, and I swear to God, we saw no one else. That was one of those times when Sue just read the description from the book and got the perfect dog. Then we got to meet him and give him a little audition. He was fabulous. He's just perfect and he's great in the show."
>
> —MARIL DAVIS ON CASTING BOUTON

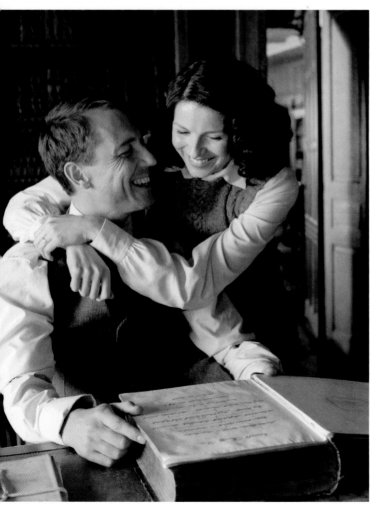

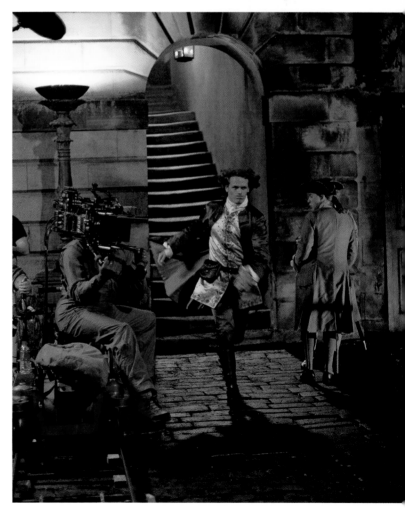

EPISODE 204:
LA DAME BLANCHE

WRITER: TONI GRAPHIA DIRECTOR: DOUGLAS MACKINNON

Writer Toni Graphia admits she was nervous about writing her first episode of the second season, "La Dame Blanche." In particular, she was thrown by the idea of scripting an eighteenth-century dinner party. "I thought, *How am I going to make that exciting?*" she laughs. "But as soon as I was working on it, I fell in love with it. And I

> "[The pregnancy] is another part of Louise. It's another part of how it's hard to be a woman in this century, and to have a baby in this century, and to have lovers in this century. Maybe she's a little bit gossip girl, but she's also a woman with feelings."
>
> —CLAIRE SERMONNE

got to [write] Claire and Jamie getting back together."

Bringing that much-anticipated moment of intimacy to the screen was the responsibility of director Douglas Mackinnon. "I didn't want it to be overly graphic," the director explains, "but I wanted to make sure that people got it was kind of a hot scene as well. I think the key thing for us was deciding to use

that daybed in the living room as the place where it all happens."

"[Jon] Gary Steele made that amazing daybed, and we kept saying, 'Who can have sex in there?'" Graphia jokes. "At one point we had Murtagh and the maid having sex in there, but then we thought, we need to make it really special when Jamie and Claire do come back together. We wanted it to be on the heels of an argument, and we liked that he goes and escapes somewhere else, then she just comes and finds him."

"There is something really beautiful about it," Mackinnon says of the space. "It is very secretive and mysterious and we could get beautiful light into it, so that was a slightly different take on it rather than it just being in the bedroom."

Afterward, Graphia was able to repurpose a key speech Jamie gives Claire from the *Outlander* novel into this episode. "The speech about the blade of grass was actually

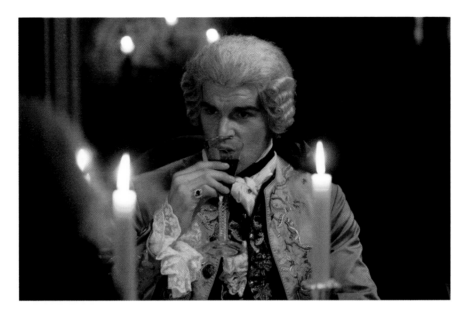

Maril [Davis's] idea," Graphia reveals. "She has an encyclopedia in her head of usable moments [from the book] that we have to play. She remembered it and she came to me and said, 'I love this scene. You've written it beautiful, but I really miss the blade-of-grass speech. Do you think it would work with the making love?' I promised her I would find a way to work it in, and I think it works in the scene."

As to the dinner scene that initially frustrated Graphia, she says the logistics of filming the sequence ended up being incredibly difficult. "We didn't know how many people would fit around the dinner-party table, because the dresses stick out three feet," she says. "They're three feet wide with the hoops, so we had to coordinate with the costume department. We did a dress rehearsal—no pun intended—where we actually had some extras come in and put on the clothes. Luckily, we did fit all six-

teen people, but that's because we decided to only have four women and the rest men."

Mackinnon says he loved filming the banquet and subsequent fight at the end. "We had two and a half days total for the whole thing, so we had to manage it very carefully," he details. "We had three cameras and, in terms of the ban-

> "[Charlie's pushing of Louise] I think is more like when you have something taken away from you and it's not your choice to have it taken away. He wants to make the decision and she made the decision for him. I think he fell for her, but it was a kind of distraction from reality."
>
> —ANDREW GOWER ON PRINCE CHARLIE'S FEELINGS FOR LOUISE

quet, we just shot one side and then we shot the other side and just worked our way around the table, really. We also had the best home economics team who was doing the food for us. Yet even with the best food, it doesn't do well after a day of filming either," he says. "The most important thing, it should look like there is a meal going on. People are having a boisterous time, and then a serious time, and then a fight.

"It's so hard to put into words everything that Jamie feels, or that I felt, in those scenes back in season one in Wentworth. Jamie is struggling to put into words what he's lost as a man. He has lost this shell, this fortress, and actually Claire was his fortress. Black Jack Randall ruined, or soiled, for him the memory and the thought of Claire. It is a very revealing moment for Jamie to tell her, and I guess it is a modern thing for him. Men at the time wouldn't express their feelings or reveal those sort of things. That is the wonderful relationship that they have, and she sort of forces him to reveal that and in doing so makes them closer."

—Sam Heughan

"Ron was very clear with the tone that he was looking for," Mackinnon says regarding the unexpected eruption into fisticuffs at the end of the night. "For me, one of the tricks of that tone is to have a lot of fun but there is a serious undercurrent in there. Even though the fight was a little bit 'push me, pull you,' you didn't expect that anyone was going to get hurt properly."

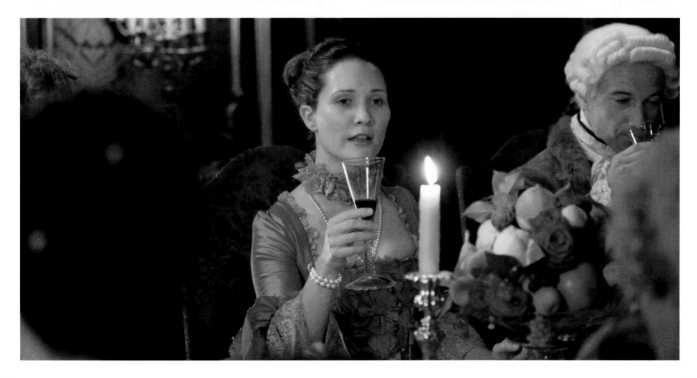

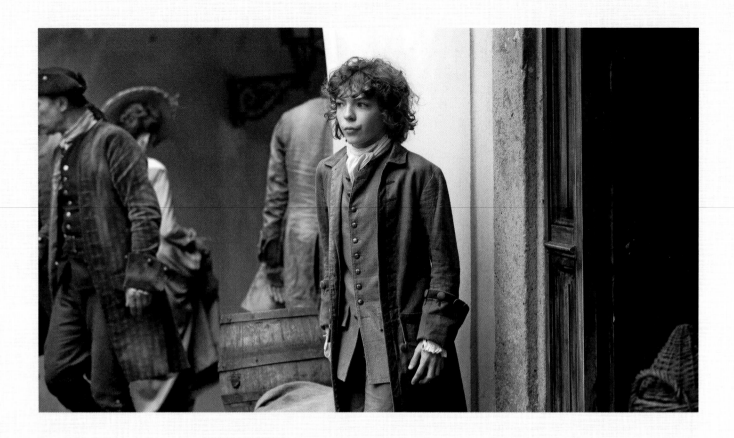

SPOTLIGHT:

ROMANN BERRUX AS
CLAUDEL/FERGUS FRASER

A cting from the young age of six years old, Romann Berrux has spent the last decade cheerfully establishing himself as a respected child thespian in French television productions. But when *Outlander* put the call out to French actors to audition for new roles in its sophomore season, Berrux suddenly had the opportunity to step outside his regional comfort zone on a grand scale.

"*Outlander* was the first time I did a casting in English," Berrux says. "I always acted in French before. For

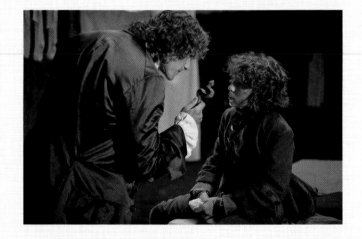

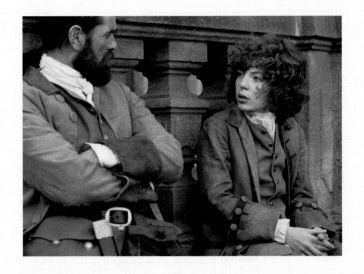

me, it was a little bit of a challenge to do that. In my head, I said, *Just try it for fun.*"

At his audition, Berrux says, he read one of Fergus's brothel scenes for director Metin Hüseyin. "He was very nice and explained to me all of the plots and what was happening, who was Fergus, and what was *Outlander,*" he remembers. "He said he is an orphan who lived in Paris in a brothel at the beginning of the season. He basically tries to survive. He doesn't have any parents, or maybe you can consider that the girls at the brothel are a little bit like his moms, but just a little bit."

Berrux impressed Hüseyin and all the producers, easily winning the role of Fergus. With that, Berrux says, he was off to Scotland to shoot interiors. "It was very new," he recalls. "I had never been to Scotland before, and I really liked it, actually. But the longest days were when it was raining all day. From the morning to the night, it was raining. It never stops. I know it is Scotland, but it is pretty weird."

Berrux says his first day filming on set was the scene where Fergus meets Claire for the first time. "The first thing he says to Claire is, 'You have got nice breasts,'" he laughs. "For him, he is so used to saying that and it was normal. He thought Claire was going to give him food because he gave her a compliment, but she is like, 'What?' And I am like, 'Give me money, please. I just gave you a compliment.'" Berrux says Caitriona made the scene very easy for him. "We didn't know each other

and I had to tell her things like that, but, you know, it was fun, because she is very nice."

Berrux says his first scene with Sam Heughan was the dramatic chase in "Useful Occupations and Deceptions," when Fergus is put under Jamie's employ as a thief. "We shot that scene during the night of my birthday, and that was a very nice birthday. I did half of the scene, because the other half was done by a professional [stunt person]. But it looked good. He shakes me quite a few times, and, yeah, [Sam] is quite strong."

Berrux says that after working on the series for about six months, "I learned so much from *Outlander.* I mean, everything was positive. I met very, very fantastic people." It also made him eager to try for more international roles. "I think I can do more movies in English," Berrux says. "Obviously I still have a French accent when I speak, but, you know, it's just a little French accent."

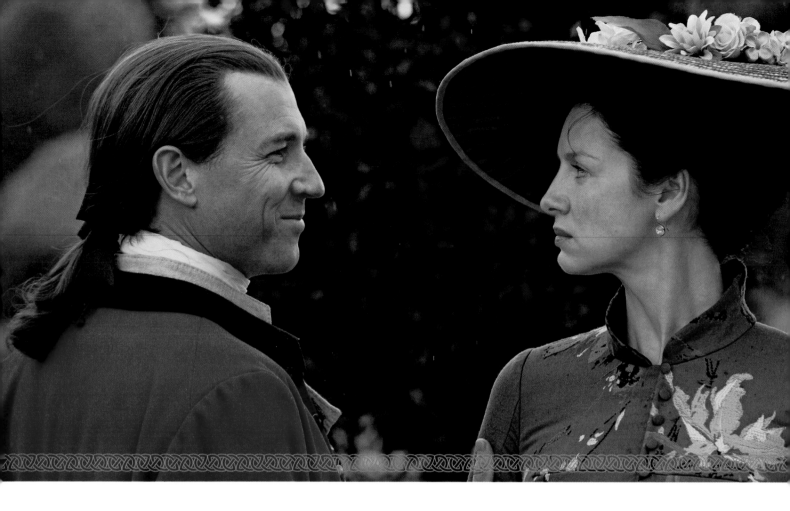

EPISODE 205: UNTIMELY RESURRECTION

WRITER: RICHARD KAHAN DIRECTOR: DOUGLAS MACKINNON

Once the survival of Black Jack Randall was revealed in the season premiere, viewers knew it was only a matter of time before Jamie's nemesis would appear in France. "Untimely Ressurrection" provided the setting for that much-anticipated reunion and its repercussions. The task of crafting the episode landed on the shoulders of first-time writer

> "When Jamie gives Claire those apostle spoons, it leads to a really sweet conversation. They have huge things going on, but this is another huge thing. And it's a moment of, 'Will I be a good parent?' and I'm a new father as I was writing that."
>
> —RICHARD KAHAN

(and *Outlander* writer's assistant) Richard Kahan.

"The title, 'Untimely Resurrection,' really speaks to [that scene]," Kahan explains. "It really felt like a slow burn." The crucial moment was saved for the last half of the episode, so Kahan says the first half of the narrative functioned like a roller coaster working up the hill, focusing on a lot of character inter-

actions. "There's a lot of scenes in this episode where it's two characters sitting down and talking, from Claire and Alex to Claire and Mary, so it was always about finding that emotional connection I could tap into."

When it came time to shoot the Versailles scenes, director Douglas Mackinnon says, he wanted to make sure he created an environment where the actors could do their best. "I like to make sure the organizing of the production doesn't take over the storytelling, and that is what the actors feel when they turn up," he explains. "They don't feel the weight of the entire unit landing on this castle in the middle of Perthshire. I try to encourage a—hopefully—relaxed but serious atmosphere on the set, where people can have a bit of fun but do the serious work as well."

No work in this episode was more serious than the fateful moment when Jamie sees Black Jack again, with Claire and King Louis in the royal gardens. "The stuff with

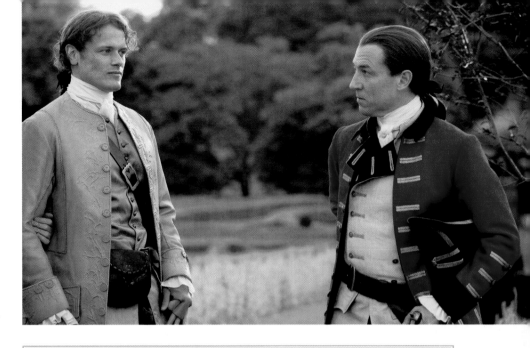

> "The moment that Jamie sees across the garden this bright red coat, it's just so huge for him. There is an excitement but a fear. There definitely is still this strange bond between Randall and Jamie that is about someone's honor. Tobias and I talked about that [Randall] is injured. He did not come out of Wentworth himself either. He also has physical injuries and maybe mental ones. It is just interesting to see that balance of power between Randall on the descent and Jamie on the rise."
>
> —SAM HEUGHAN ON JAMIE'S REUNION WITH JACK RANDALL

Black Jack at Versailles was challenging," Kahan says. "There were a bunch of different iterations of it before we got to what we see now. What finally got me through that was something that was talked about in the [writers'] room, that of seeing a different Black Jack. We know that he's alive, and Jamie knows that he's alive, and we see Jamie's reaction to that, which is different than what we think it's

going to be. It's also the first time we're seeing [Randall] in person, so you want to feel like there's an evolution to that character. I found the idea that Black Jack got what he wanted from Jamie, in a certain sense, so he's not the same malicious, pointed Black Jack. There's a certain lightness to him, which ends up coming across really creepy. It's fantastic and makes you really uncomfortable as a viewer.

"There's an obstacle for everyone in that scene, from Claire to the king, which made it juicy to write," Kahan continues. "The king is there and he's facing an English officer. Now, obviously that's not a threat,

because he's the King of France, but England and France were on opposite sides of a war at that time, so there's not a lot of love there. We get the opportunity of literally bringing Black Jack to his knees with the fact that the king can do that. I think he doesn't realize what a victory that is, but we as an audience do, and that's a pretty fun moment."

Mackinnon says watching that scene unfold was very special. "I always feel like I am on a great show when characters turn up and they can stand about in a space and almost do nothing and yet you almost know exactly what everybody is thinking," he laughs. "The joy of that scene is that everybody had their secrets. And I loved Jamie arriving as well, sword fearlessly drawn, heading toward the King of France with his archenemy standing beside his wife. It was so rich dramatically; I could have filmed it for weeks and I wouldn't have gotten tired of it."

Yet there is further drama still to come in the episode, this time between Jamie and Claire, when she

> "I think it's pretty explicit in the novel, and in the series, that the Duke of Sandringham has the hots for Jamie. He thinks there's always a chance something might happen, in that regard. The fact that Jamie's married is an irrelevant detail to Clarence. I think that Jamie's a very trusting man at heart. I think he finds it quite hard to believe that Sandringham is as absolutely ruthless and brutal as [Claire] knows that he is. She knows, but Jamie just doesn't."
>
> —SIMON CALLOW

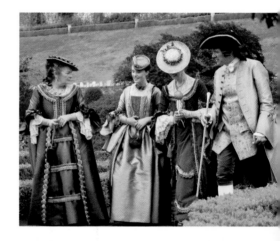

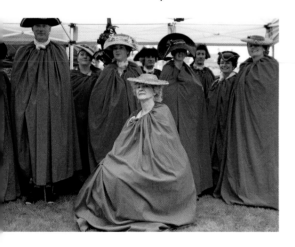

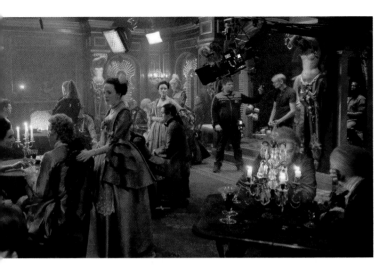

begs him to spare Randall's life for a year to ensure Frank's existence in the future. "The most interesting thing for me in that scene is seeing all the weight that Claire and Jamie have, and their history together arriving in that room, and they have to explore it," Mackinnon says.

"With that final shot: I always had an image of a tableau of a husband and wife on either side of the frame, and we go out on that, so there's just a real sense of dread," Kahan says of the episode's close. "I was really happy with how that turned out."

"The argument between Jamie and Claire at the end was a big release on the pressure valve of what they've both been going through on these parallel paths. There was such a disconnection between them for so many episodes. Claire is trying to inspire him to go do this thing, and that ends up meaning that he's very much an absent husband. They are like two ships passing in the night, with her having to put her pregnancy aside and suppress what should be the most exciting point in her life. It should be something that bonds them and unifies them, but they don't seem to be able to celebrate that at all. So when they finally have this argument, I think that was such a pivotal point because it felt like it was the first time that Claire got to actually speak in a real way about what was going on with her."

—CAITRIONA BALFE

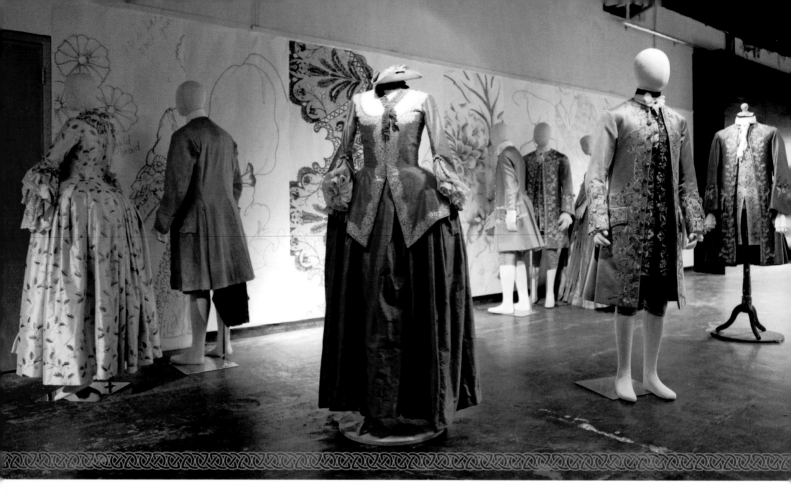

COSTUMES: SEASON TWO OVERVIEW

The opulence and majesty of King Louis's Royal Court of France dominates the narrative and visuals of the opening episodes of *Outlander*'s second season. Costume designer Terry Dresbach and her team were tasked with producing some of the most sumptuous, era-accurate frocks and finery ever seen on television, a much different direction

from the organic woolens of the first season.

As a longtime reader of Diana Gabaldon's books, Dresbach was fully cognizant of what was coming in the second book, so her attention turned toward France even in the throes of season one. "About halfway through season one, I just started screaming and yelling about season two," Dresbach laughs. "Ev-

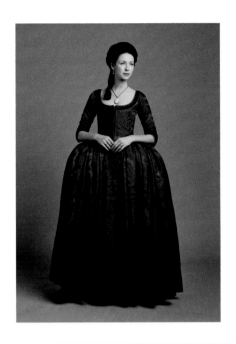

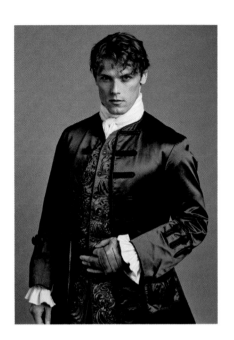

erybody was looking at me like I was crazy, because we were all just barely making it through season one. 'Why is this woman talking about season two?' My own husband was like, 'Why is this woman talking about season two?' But I knew the books. I knew that if we didn't get a big head start, they were not going to be able to shoot. We would not be able to costume the world.

"Fortunately," she says, "I am married to Ron. He trusts me, and

"Claire in season two is not the Claire we saw in the beginning of season one. This is the Claire who has made a choice. This is Claire who has decided to stay, who has decided to remain married to [Jamie]. She has walked away from her previous life in a clear, conscious choice. It was very important that there be a lot of strengths and purpose in her choice to stay and how they were revealed in her costumes. [In Paris] for the first time, she's got the money to stand in a dressmaker's shop and decide how she wants to look. You have to see that she's got a goal, she's on a mission. She needs to create a certain impression. She needs to overpower. She's also a modern woman of the forties. It just seemed to me that she would reject as much of the things that took away her autonomy and her personal power as possible and yet still be able to fit in."

—TERRY DRESBACH

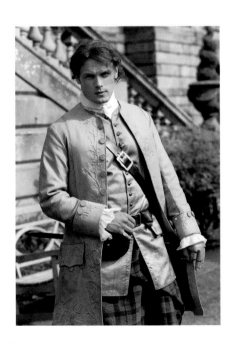

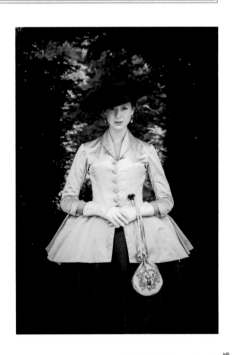

he listened. Maril knows the books too, and she listened. So I started designing season two about halfway through season one."

Again starting with tone and character, Dresbach was able to research the region and era of clothing more readily than for Highland Scotland, narrowing down a design focus. "I did a look book for season two for the palette and tone of the show," she explains. "I wanted to pitch an overall look and feel for how I wanted to do the costumes, relating to how we lit [the series]

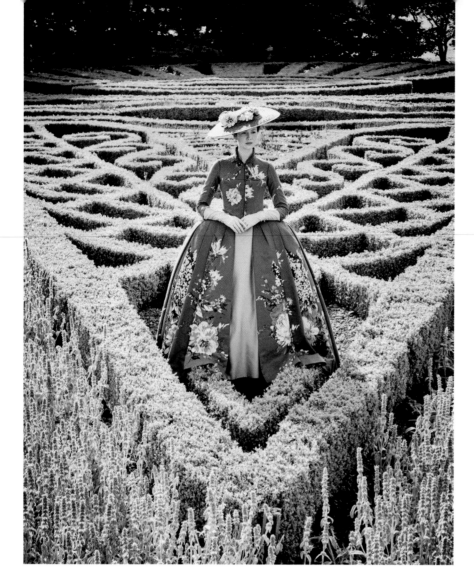

even with long-lead timing, to produce that volume of costuming. "We have a workroom of twenty-five or thirty," she details. "They produce couture costumes for the principal cast. There wasn't enough time for them to make a thousand costumes," Dresbach says with emphasis. "It takes about two to three weeks to make an eighteenth-century Scottish costume for a principal cast member. It takes a couple of *months* to make an eighteenth-century French costume."

"It was hard because this is eighteenth-century Paris, so nothing's fast and nothing's simple," Dresbach says with an air of exhaustion. "If we were in Scotland, it'd have been much easier, but we're in Paris. We are in the land of detail, and we set this stupid, ridiculous standard for ourselves that we were going to be as authentic as possible," she laughs.

The remedy? Having the bulk costumes made commercially. "We found local manufacturers, like wedding-dress manufacturers, to make our women's gowns. But commercial-pattern making is not the same as costume-pattern making, so we had to hire a commercial-pattern maker to come in and work with our costume-pattern makers to adjust all of our patterns to commercial-pattern grade. Every costume has to be, more or less, different than another costume. It was about making them compatible to

and how we did the set design as well. I created probably a fifty-page look book that focused on color tones and the visual direction. A lot of that was based on the things that we learned doing season one, like the fact that when you shoot an entire show in candlelight it changes how everything reads. Gary and I did a lot of scrambling during season one to figure out how to deal with the fact that everything's so dark, making sure that you can see people. Reworking costumes, remaking things, re-covering furniture. So in season two, I wanted to do really powerful, rich colors

that would emerge from the darkness."

Armed with lessons acquired from the execution of season one, Dresbach says, she was able to plan more strategically for the Parisian block of episodes. "We had to become so creative in terms of coming up with how to do things in a way that no one anticipated, it served us well in season two," she details.

With an early estimation of about one thousand costumes needed to dress the principal, recurring, and background actors, Dresbach knew it wasn't going to be physically possible for her team,

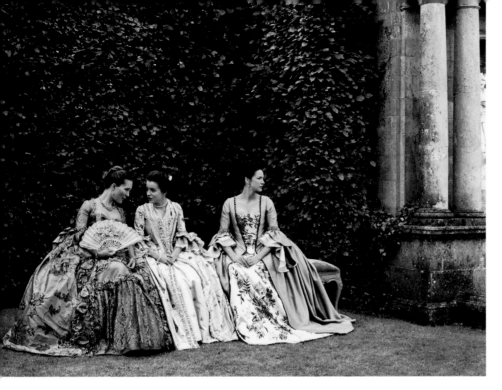

Attention then went to creating the signature looks for Claire and Jamie as they enter King Louis's court. "We know Claire and Jamie are in season two, so the first thing is to make all of their costumes, and that's based on the book because they're the only ones that are cast," Dresbach explains. "We know their measurements, so we can design and make their clothes without any delay. Then the goal is that when the production comes back up and running, because we're not taking any breaks, we don't shut down. When the production comes back up and there are scripts, that tells us all the other cast members. Essen-

all be cut together and produced together in mass manufacturing, as opposed to each costume maker takes a pattern and makes a dress, so that was incredibly tricky."

Back in Dresbach's shop, the team would then take the mass-produced dresses and add all of the detail work by hand. "In house, we made all the decorative bits that went on the outside of them, because that was the way that we gave them substance and made them individual."

To complete looks, Dresbach says, they used every resource they could tap. "We shopped on eBay for wedding dresses, wedding shoes, and dyed them," she reveals. "I've got six professional embroidery machines, and I have kids just out of college who are now making eighteenth-century fabric. All the fabrics you see in season two, we made. We dyed them, we embroidered them, we painted them; we

ran out of buttons pretty quickly, so we're making embroidered buttons by the score."

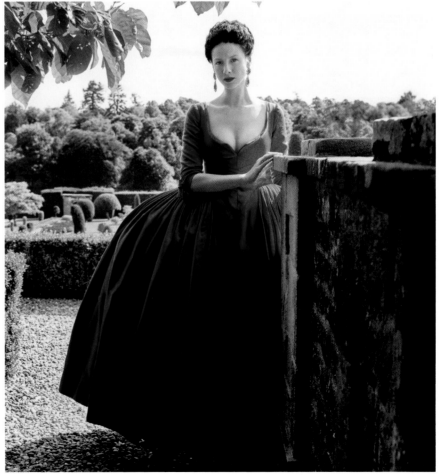

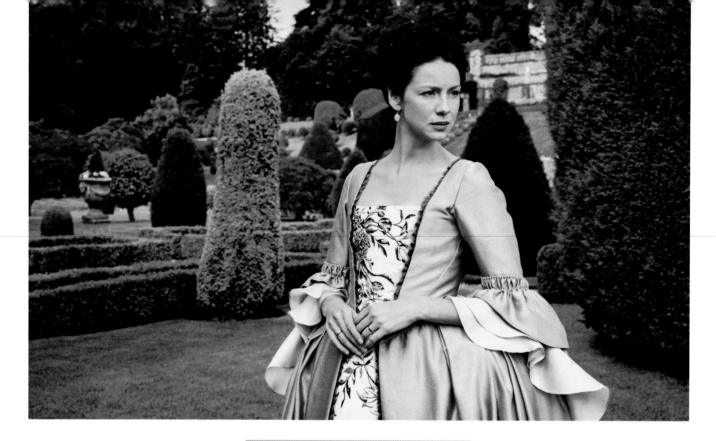

tially, we ended up with three phases: get all the extras done, then you get Jamie and Claire, the cast principals, and then you move to the Master Raymonds and the Louises, the Marys, and all of those guys."

Outlander returns to familiar territory by episode 208, as Claire and Jamie return to Scotland, with Prestonpans and Culloden on the horizon. Dresbach admits it was much easier to return to the established palette of the Highlanders. However, the costume team now had to dress two armies: the various Highland clans assembled and the British Army.

The challenge then became a very tight budget after the French expenditures. "We weren't so out of money that we couldn't have

> "If you research the late 1940s, you will find absolute echoes of the eighteenth century. Of course, if you research modern fashion, you will also find echoes of the eighteenth century, because in terms of fashion, it's an era that never dies. Fashion is ever continually fascinated with the eighteenth century."
>
> —TERRY DRESBACH

gone out and bought [costumes]," Dresbach says, "but by that point we were really exploring what can we do, what can we not do. Now everybody's just really spreading their wings and getting really creative." A direct result was that the painting techniques learned and perfected for the French costumes crossed over to the army of tartans.

"The next thing you know, some of our clan chieftains are wearing painted tartans," Dresbach reveals with a smile.

With the remarkable achievement of two ambitiously epic Outlander seasons behind her, Dresbach is still weary but clearly empowered by what her team has been able to accomplish. "We went from actually standing there naked, and now we have these toolboxes that are filled with every possible way that we can approach things," Dresbach reflects. "No doubt, as we keep going, there will be new challenges and new things that we have to do that we haven't had to do before, but the most important tool that we have now is the knowledge that we can do anything. We're all very proud of ourselves because we feel like, 'Throw it at us, bring it on!'"

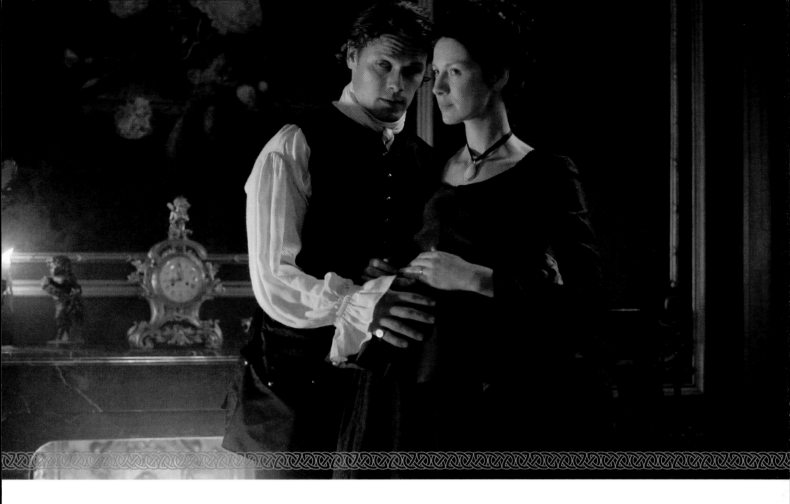

EPISODE 206:
BEST LAID SCHEMES . . .

Writer: Matthew B. Roberts Director: Metin Hüseyin

During the crafting of the script for "Best Laid Schemes . . . ," it was decided early on that the episode would end in a blatant cliffhanger, which would get resolved in "Faith." The challenge for writer Matthew B. Roberts was figuring out which stories should build up to the moment of Claire's collapse as she arrives at Jamie and Black Jack's duel.

The writers decided to weave together a lot of different characters' beats, some from the book and some original. "I had to reinvent the wine caper, and also visually I wanted to show Jamie getting smallpox, because I thought that was one of the fun things in the book that he had to [endure]," Roberts details. "I also loved the playfulness of the scene where

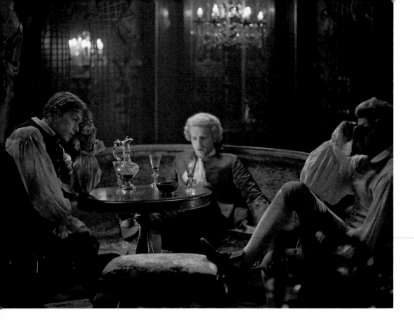

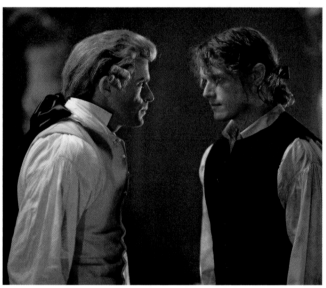

"I'm very tactile with [Jamie]. I think I touch his face more than I've touched anybody's face in a job. That's an Italian way of dealing with something, so that was a conscious choice I made. I respect [Jamie] as a soldier, his bravery. My reliance on him grows throughout the show."

—ANDREW GOWER ON PRINCE CHARLIE'S VIEW OF JAMIE

"How would anyone react to being told that one of their closest companions is from the future? The script had him accepting it, so I just played it that way. I think if we had gotten too bogged down with Murtagh's disbelief, the story grinds to a halt. I had certain reservations about playing it, but as we got to the scene where Murtagh first confronts Claire after he finds out, it just seemed to work and is now one of my favorite scenes."

—DUNCAN LACROIX

"I suggested that we should see Jamie tell Murtagh in Gaelic. The producers were wary but they said okay. The day before we shot it, I got [Gaelic consultant] Àdhamh Ó Broin to quickly write me a couple lines of Gaelic, and it works. We see this montage of Jamie telling him everything, and it just gives it a real weight. I think Duncan plays it beautifully where he punches Jamie. You can see in his face that he is disappointed and slightly upset with Jamie for not trusting him. Ultimately, I think, Jamie could probably say and do anything and Murtagh would have his back no matter what."

—SAM HEUGHAN

Murtagh's getting dressed, because I knew some very heavy emotional stuff was coming afterward with Jamie in the brothel."

One of Roberts's favorite moments was how they chose to portray Jamie finally telling Murtagh about Claire's origins. "When he actually tells Murtagh, we had to do it in a way that we don't hear him saying it, because we already know the story. In the room, I had said, 'If that was my brother and he held back that kind of secret, I would just go, "You're a dick," and, pow!, I'd punch him in the face,'" Roberts laughs. "It makes sense for [Jamie and Murtagh's] relationship, and I think people really understand it when they see it."

Shifting focus to a much darker

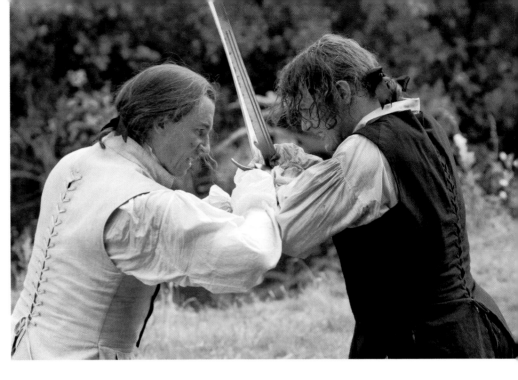

moment, the duel between Jamie and Randall was shot on location in Pollok Park, Glasgow's biggest central park. Roberts admits they underestimated the dedication of the fans who came to seek out the shoot. "There were fans all around, taking photos," he laments. "We

probably should have rethought that in hindsight."

"We shot the fight with long lenses so that it felt observed," director Metin Hüseyin says of the sequence. "On the day, we made the fight 'dirtier' by adding tiredness, Randall taunting and biting Jamie,

"The duel between Black Jack and Jamie was very important to me, to make that a very evenly matched contest. Tobias helped an awful lot in the way he portrayed Black Jack. He was very arrogant, so we had a lot of fun. I must say that Sam and Tobias, with fighting, make my job so easy. They're very skilled and they remember. You can work a routine out and show it to them once and they'll pick it up and they'll go with it."

—Dominic Preece

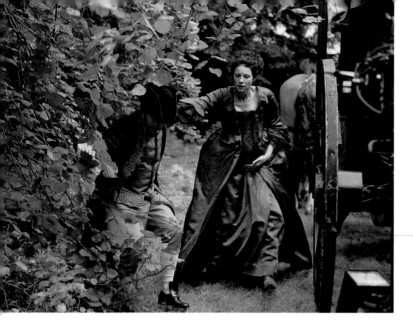

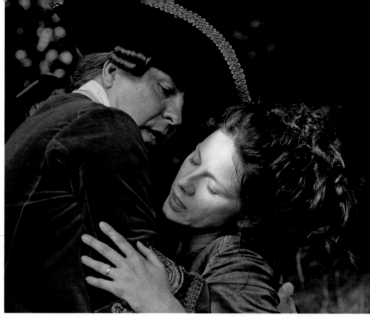

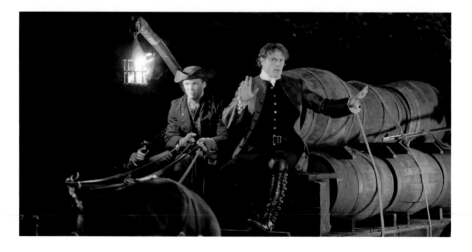

et cetera. The main difficulty was making the stab to Randall's nether region look [intended] but also a mistake by Jamie, who would have meant to run him through. Also tricky was timing Claire's call out to him and the horses of the gendarmes arriving. We were very lucky with the weather that day, and it felt like we had an epic day once completed."

SPOTLIGHT:

LIONEL LINGELSER AS KING LOUIS XV

While history remembers King Louis XV of France as "Louis the Beloved," his fifty-nine-year reign was marred by a variety of political and financial scandals. Yet the vice most associated with him to this day is his well-documented adultery with a range of women—from the bourgeois to former courtesans—that his subjects found distasteful and diminishing to his sacred role.

Thus it's no surprise that *Outlander* presents the rather grandiose and carnal version of the king as embodied by the very charming French actor Lionel Lingelser. Once awarded the role, Lingelser says, he took it upon himself to go beyond his general knowledge of the sovereign. "There is one book that I bought just before the start of filming that is very interesting and part of a huge collection released in that era, called *Les Chroniques de l'Oeil-de-Boeuf*, by Georges Touchard. It explains all the secrets of Versailles, and that interests me because [it focuses on] all the people who surrounded the king and could see through that little keyhole in the door, hear all the gossip, and see what was happening around the king and his cabinet.

"In the book, I also learned a lot concerning the women," Lingelser continues. "It was surprising to learn to what extent the women mattered. Louis was a 'skirt chaser.' He loved women, and he allowed himself to be led by them, notably Madame de Mailly and Madame de Pompadour, who took power. It was very interesting to see how he was overtaken by his mistresses."

The actor says that opened the door to him understanding the king's fascination with Claire. "Evidently there is a great attraction," he confirms. "He is weak in the face of her beauty, but he remains the king despite his feelings." Adding to that were the rumors of "La Dame Blanche," which Lingelser says made it to the king's ears. "He really doesn't know who she is, this mystical character. He feels that there is magic behind there. In the true history of Louis XV, he was attracted to astrology, and that's something that I kept in this role. So Louis is fascinated by Claire because she's a magnificent woman, but at the same time there are the dark arts. All the magic of that era is very present, and he's very attracted to it. There is the fascination, then the danger of it with Comte St. Germain or [Master Raymond]. He tries to be justified in that time and to have the heads cut off of those who could practice black magic."

Luckily for Claire, her beauty obviously trumped any perceived threats. "I think he was really crazy

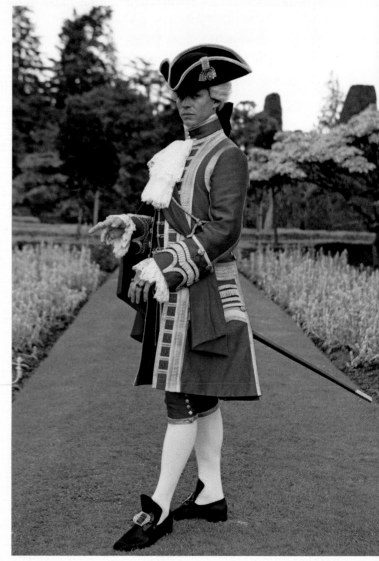

about her," Lingelser posits. "Yes, he chases women a lot, but he's very attracted to *that* woman." So much so that, in "Faith," he requires her to submit sexually in exchange for his release of Jamie from prison. Was that just a transaction or something more, despite the brevity of the exchange? "I really think he had emotions for her. But, yes, it was really quick for a love scene," he laughs.

EPISODE 207: FAITH

WRITER: TONI GRAPHIA 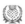 DIRECTOR: METIN HÜSEYIN

An emotional atom bomb of an episode, "Faith" charts the solitary journey Claire takes from utter devastation to reconciliation and new hope. Writer Toni Graphia says it was a script that evolved dramatically in the course of its birth.

"I called my first draft 'His Majesty's Pleasure,' because I was focusing more on Claire sleeping with the king in the Star Chamber," Graphia says. "The baby was there,

> "The little girl in the beginning was Ron's idea, because he wanted to start the season with Frank and Claire in the fifties. He and I together came up with the scene in the future at a library and she's showing the heron to the little girl. You see what Claire is losing, because this is the little girl she might have had."
>
> —TONI GRAPHIA

but it was more of the background story. The genius of Ron Moore is that he read the first draft and just said one sentence to me, which is, 'It's all about the baby.'"

With that note, Graphia says, she rechanneled all her focus. "There are a lot of elements in the story that were very personal to me, and I thought, *Maybe I'm a little afraid to even go there,*" she admits. But go there she did, starting the episode with more urgency. "It's

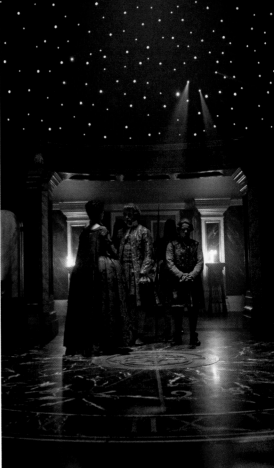

what I call an eighteenth-century *ER* episode, where there's triage and it's crazy as they're trying to save the baby. I wanted the excitement of that, and I also wanted to see Mother Hildegarde tell Claire she's lost the baby. It was skipped over in the book, and I struggled for a whole day with how she would say it. That's when I came up with 'She's gone to the angels.'"

Graphia says her other favorite moment is when Louise arrives to take the baby away. "I figured Claire just wouldn't let go of that baby," Graphia says. "She doesn't want to let go of that baby. She's almost in a fugue state, and her brain can't comprehend. I took Diana's words but put it in the moment where Claire is saying, 'Look at her. Isn't

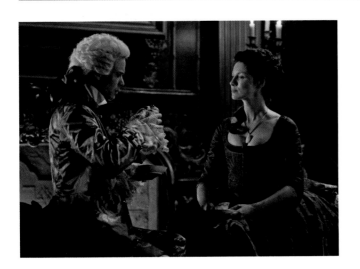

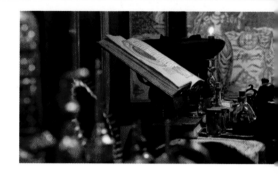

she beautiful?' I think that's the day that everyone on set cried."

Director Metin Hüseyin says directing that entire sequence was brutal but rewarding. "We did [the scenes] as much as we could in story order," he explains. "My job was to protect Caitriona. She knows what she has to do. I would tell her if it's too much or too little. She saved the biggest one for the end, when Louise takes the baby from her."

"Caitriona is an amazing actress," Graphia adds. "I don't know how we got lucky enough to have someone of her caliber on the show. In my script, I had way more voiceover. We took out over half the voiceover because her face is so expressive, you can just see it."

In the last act of the episode, Claire travels to the king's residence to barter for Jamie's prison release, which leads to the surprising Star Chamber sequence. "The argument

came up in the writers' room that we should split the episode, one being all baby and then another about the Star Chamber," Graphia says. "To me, the Star Chamber is an organic part of the trial by fire that Claire has to go through to make this journey to accept the baby's death and forgive Jamie."

"The Star Chamber was quite the scene to do," Hüseyin says. "We shot it over two days. The actors were in it and patient as we worked

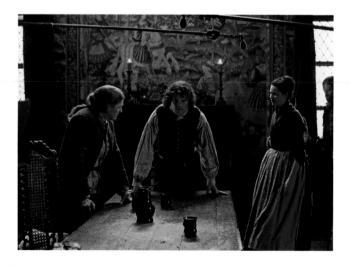

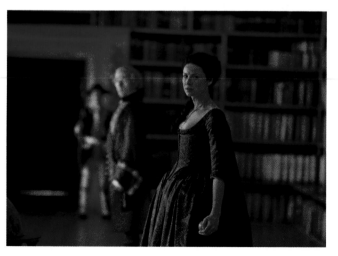

it through and improved it each time we shot it. The last shot, I put a Steadicam in there and the actors took it to another level and saw it as a fifteen-minute play. It was this amazing performance being done for us, and we shot the whole

scene. It was fun and they really enjoyed it.

"But the scene I'm proudest of is when Jamie comes back," Hüseyin continues. "It was about working out how we could top everything that we had done. These are two different people now, where they've both had time to think about what they've done. They'll never be the same again. They'll mature with the grief and sorrow into the next stage of their life. I think [Cait and Sam] killed it."

"It's the proudest I've ever been of anything," Graphia says. "If I quit writing tomorrow, I'm prouder of that episode than anything in my twenty-five years of writing."

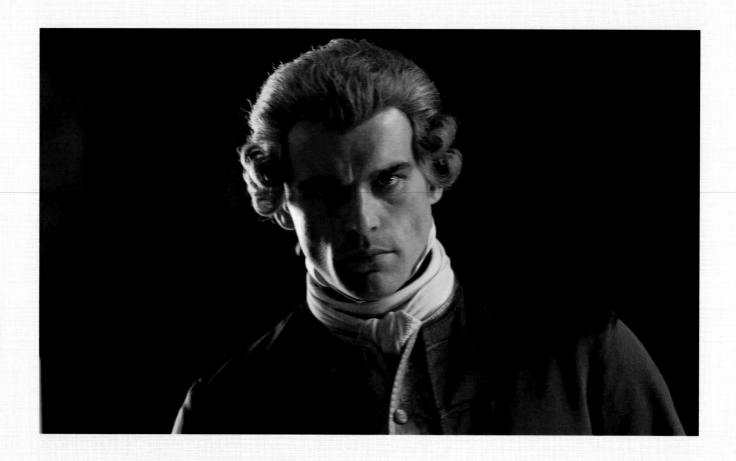

SPOTLIGHT:

STANLEY WEBER AS LE COMTE ST. GERMAIN

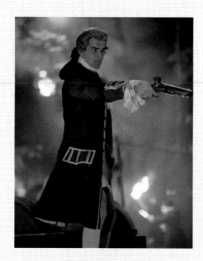

As with other actors on *Outlander*, French actor Stanley Weber initially came to the series with another character in mind. He thoroughly prepared to play the illustrious King Louis XV of France, a role he had assumed a few years before for a French TV movie, but it was not to be. Moving onward, as actors must do, Weber left to shoot the film *Pilgrimage*, in the remote Western Islands. But *Outlander* was not done with him yet.

Director Metin Hüseyin personally asked Weber to audition again, this time for the villainous Comte St. Germain. With help from his film cast, he did a scene from the Star Chamber sequence. "That was a cracking scene to get your teeth into, so I had a lot of fun," he remembers. "But I didn't know anything about [the char-

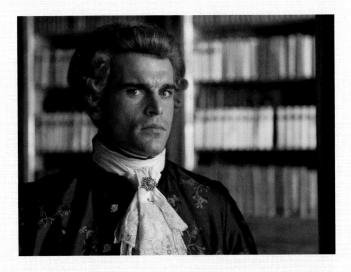

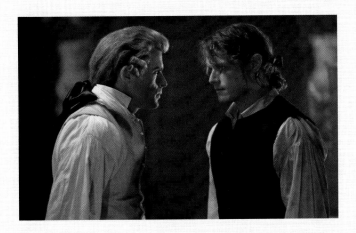

acter], so it was an absolutely dreadful tape that I sent directly to Metin. He was like, 'This is not good enough,' and asked me to do it again. I used all that aggression to put into the scene and it worked," he laughs.

Once cast, Weber says, he got down to building the character from both Gabaldon's book and the script. "I realized that his thirst for vengeance is unstoppable and quite exceptional, really," the actor explains. "It's part of what makes him interesting and curious. Some humans are monstrous, and St. Germain may be a bit more than some others, but he's thriving as someone quite invincible and vain. But then Jamie and Claire are in his way. And Claire is who he's going to concentrate all his hate, anger, and frustration. Why? I guess it's a bit easier on her than on the big lad that Jamie is," he laughs.

Interestingly, Weber admits that he created his own very specific backstory and motivations for St. Germain, which he tried to subtly weave into his performance. "I think he believes Claire is not what she pretends to be," he shares. "There was a seed in my head [leading all the way] to the last Star Chamber scene. I

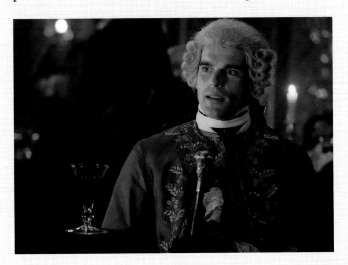

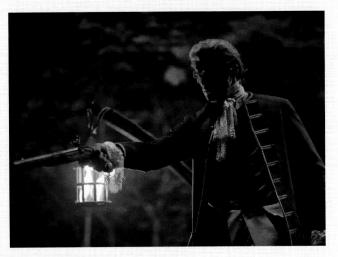

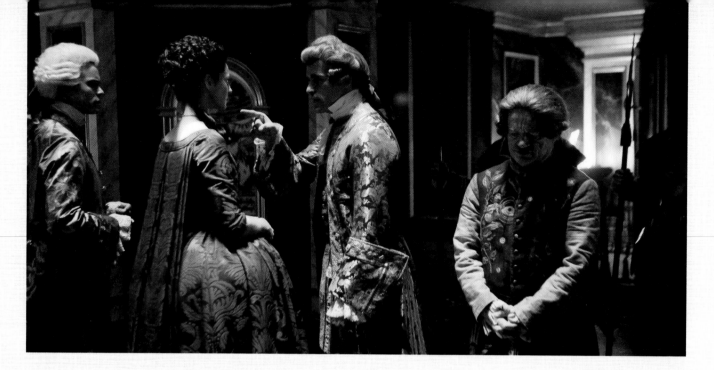

started to fantasize that Claire and St. Germain had an unexpected connection, where I thought they could both be lying about who they truly are.

"It made me think about a story my dad told me about the real St. Germain," Weber continues. "My dad is an actor as well, and he used to go to this nightclub and he told me, 'It's funny you're going to play this guy, because I actually met him.'" Weber details that his father remembered a very "phantasmagorical" character calling himself St. Germain who haunted the local clubs and supposedly crossed different time periods.

"I didn't mention it to anyone," Weber admits, "but it was in my head. It would be very, very pretentious to think that St. Germain is more than what I'm being given [in the script], but I do think that was very, very interesting in terms of interpretation for the Star Chamber scene. To think that maybe St. Germain has much more in common with Claire than people think," he says with a knowing smile.

It's a connection that certainly adds new dimension to Claire's, Master Raymond's, and St. Germain's grilling by the king in "Faith," which Weber says was a highlight of his entire arc. "Great lines, great suit, great partners, a snake, and stars on the ceiling—what else do you want to get into the zone, really?" Weber says of the sequence. "Your dialogue is insanely good, so you want to enjoy the moment, and it was much easier with Cait

being in front of me, and Dominique, who is a very famous, well-respected actor in France, at my side was a massive comfort and help. Plus, Cait was giving me everything on every take, which was so helpful. It's not obviously that easy to go into such a physical, tough condition when you're in the face of such a beautiful woman. You don't want to embarrass yourself by spitting and puking," he chuckles about his death scene. "But because she was so committed to the scene, that was just brilliant, and I had so much fun."

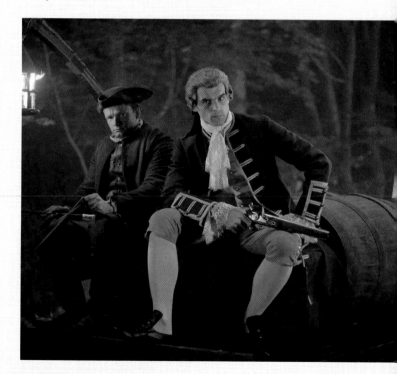

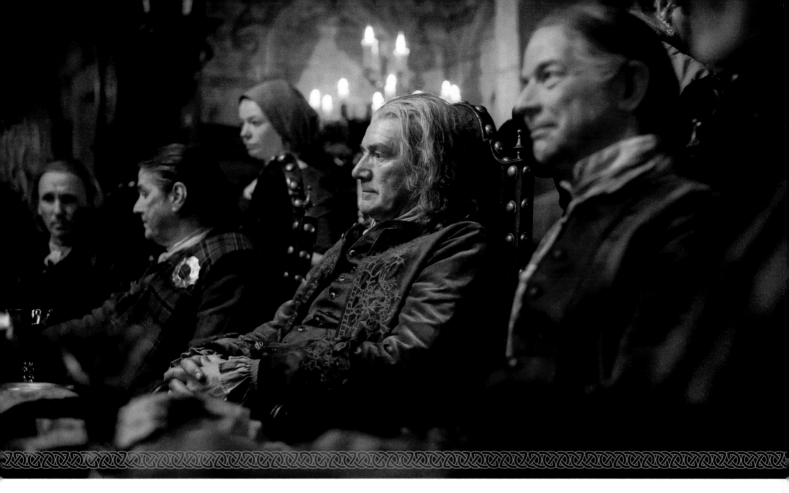

EPISODE 208: THE FOX'S LAIR

WRITER: ANNE KENNEY DIRECTOR: MIKE BARKER

After seven episodes spent in Paris trying to change history, the Frasers return to Scotland, specifically Lallybroch, to heal and rebuild. Writer Anne Kenney explains there was a clear agenda with the opening of the eighth episode of the season. "We wanted to be sure that Jamie and Claire, and their energy toward each other, had changed," she says. "We'd left them in such a sad place at the end of 'Faith,' so now the idea

> *"Both Claire and Jamie come back as very changed people. So much of France—we were talking about and theorizing about the war that was happening elsewhere. When you come back to Scotland, you're on the ground there, and what you are talking about is actually present. There's just so much more immediacy."*
>
> —CAITRIONA BALFE

is time has passed, and we wanted to be sure that they were very affectionate with one another and that you really felt like some healing has happened here."

Director Mike Barker returned to the series almost a year after working on season one and was thrilled to anchor the show in Scotland again. "For me, the whole *Outlander* thing is the Highlands. It's kilts, it's a woman trapped between two men—that's what's ex-

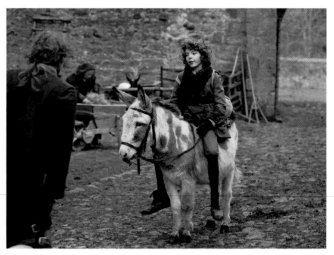

citing about it for me," he enthuses. "So coming back and reintroducing Scotland, to be honest, it was great."

> "Coming back to Scotland was a sigh of relief. It was like putting on a comfortable pair of shoes again. I think Scotland is where they are comfortable and that is their home. Likewise, it was so nice to get some of our actors from season one back. It was like a big family reunion."
>
> —CAITRIONA BALFE

But time at the homestead is fleeting, as the impending war demands Jamie's attentions once more. "One of the challenges was that we didn't have a lot of real estate to give you a chance to settle into Lallybroch before everything blew up again," Kenney explains. "You see Claire and Jamie working together and also still struggling with 'Can we change the future?'"

That plan is challenged immediately when Jamie discovers his name has been forged on a letter aligning himself with the Stuarts,

> "When Fergus comes to Scotland, after a few days, I think, he starts to trust them and to like them. It is the first time that we see people actually trust him and to think about him and care about him."
>
> —ROMANN BERRUX

making him a traitor to the Crown anew. Instead of running, he tries to enlist the men of his grandsire, Lord Lovat (Clive Russell), to fight. "Something that we played,

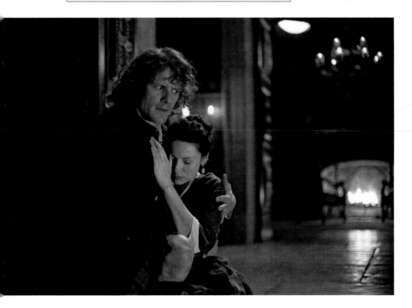

maybe even more than what's in the books, is the idea that Jamie, if he hadn't known about the future, would have wanted to fight for his people," Kenney explains. "He would've wanted to win this thing, so now when he gets a second bite at the apple, that's what he's going to do. Now he's really able to engage with what his own instincts would be, and that would be fight and win."

The problem is, Lovat is a cantankerous, misogynistic, double-dealing lout, who vexes Jamie at every turn during their stay at Beaufort Castle. "We were delighted to get Clive Russell," Kenney says. "He doesn't look like the character in the book, who's this slobby, stumpy guy. But I liked that [Russell] was this big, tall man, because he was more imposing; as Jamie's this big tall guy, you think, *This whole family is a bunch of giants!*" she laughs.

"[Lovat] is ultimately a really straightforward, no-nonsense character," Barker adds admiringly. "That's what's great about him. I loved shooting those scenes around the table where he was watching his own son [Simon] watching Laoghaire."

Laoghaire's return is another major plot point of the episode, as she appears as Colum's servant at the clan meeting. "We needed Laoghaire back so that we could massage her a little bit," Kenney explains. "We really felt like we had made Laoghaire worse in the show than in the book, and we needed to make Laoghaire not such an evil character." That was the primary motivation behind the arc culminating in Claire asking Jamie to forgive Laoghaire by episode's end.

> "Once we got back to Scotland, it's all about weathering and filth. It's a technique that was developed with prosthetics, which was flicking color on [actors] rather than painting or brushing it on. There's a lot of flicking of different colors just to get spots of color and broken-looking dirt on everyone."
>
> —ANNIE McEWAN

"Lallybroch is usually an opportunity to take stock, to quietly reflect, and [watching Jamie] seems like a really beautiful opportunity to do that. It's funny, a baby comes on set and everything gets very quiet and very calm. It's a lovely thing. In that moment, I just wanted to tap into that feeling of a newborn in the house and what that means to a family and the thoughts that brings up for everybody around it. I just thought it's a really beautiful, quiet, low-lit thing. I didn't want to overdo it, to overact it, to try to push any emotion that it didn't need."

—LAURA DONNELLY ON JENNY AND CLAIRE OBSERVING JAMIE WITH THE BABY

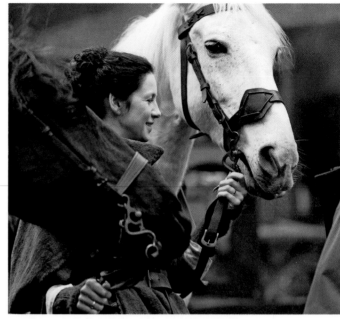

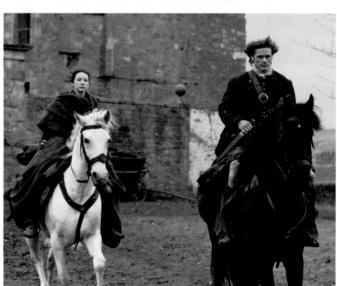

"With the hand touch, we're into the territory where he doesn't know if he's going to see Jamie again. He's still the laird of the MacKenzies, that's business, but this is family, so that moment says, 'I hold you dear to my heart.'"

—GARY LEWIS ON COLUM'S TENDER FAREWELL TO JAMIE

"Colum really does care for Jamie and everybody else. When I'm saying to him, 'Jesus, you're gambling with Lallybroch. Don't do it,' Colum's not stupid. He's very much aware of the imbalance of forces, and even back then historically, the true Jacobite clan leaders were telling Charles that the very minimum required would be like six thousand French troops, arms for ten thousand more men, and a substantial war chest. There's a strong chance that Colum would know these things, and he had given it to Jamie between the eyes: Without outside support, this is lost."

—GARY LEWIS ON COLUM'S TOUGH STANCE WITH JAMIE

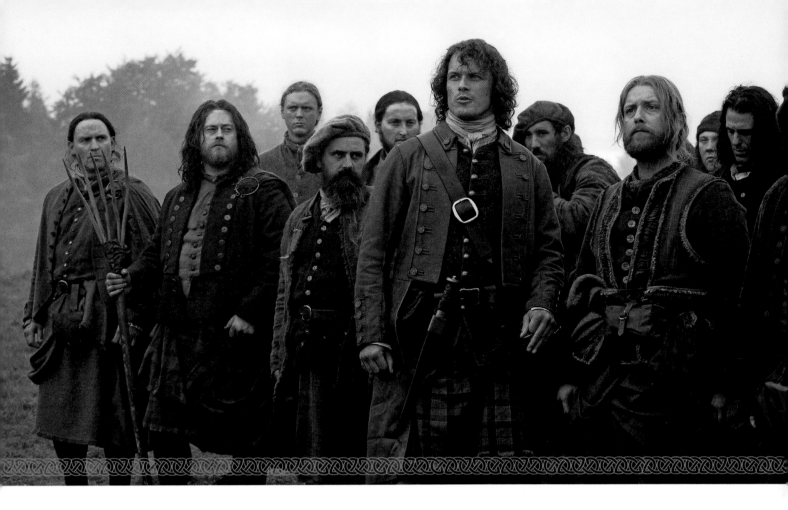

EPISODE 209: JE SUIS PREST

WRITER: MATTHEW B. ROBERTS 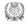 DIRECTOR: PHILIP JOHN

With the clans moving toward war, writer Matthew Roberts says, he was thinking about how to make the episode personal for Claire. "The one thing the book doesn't do is ever tell us what she went through in the war, mentally," Roberts explains. "So I pitched that and Ron was like, 'That might be a good idea.'" Roberts says the two decided that going back to the forties in Claire's flashbacks could help

> "Jamie's a Highlander through and through, but he's had training in France. As young kids, they're brought up fighting and they're always in a brawl. He's a great fighter, with and without weapons. What stands out with him is being a soldier, so what he's brought over from that is this structure and this discipline, and that's what he's teaching the Highlanders."
>
> —DOMINIC PREECE

illuminate her own harrowing experiences.

"I'd already done a forties scene in 'The Way Out,' in the opening scene with Claire and Frank at the train station," Roberts says. "Writing that scene, I loved it. I wanted to get back to that again, so I wanted to tell my war story." Roberts ended up creating an original narrative about Claire meeting two American soldiers in the field, an experience that serves to parallel the

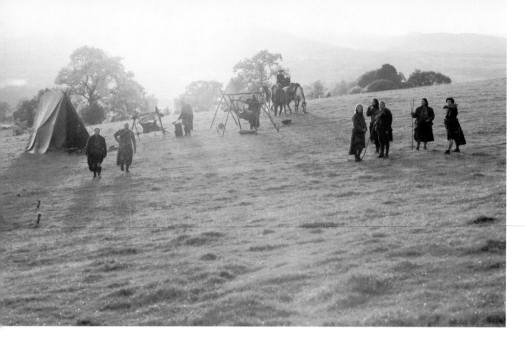

"You don't see much of the drilling, just Murtagh kicking, hitting, and screaming at them. There are some great comic moments. Great little vignettes of Murtagh drilling them or Dougal showing them how to kill a British officer with a big straw man that he is laying into in the most ferocious, crazed way."

—Philip John

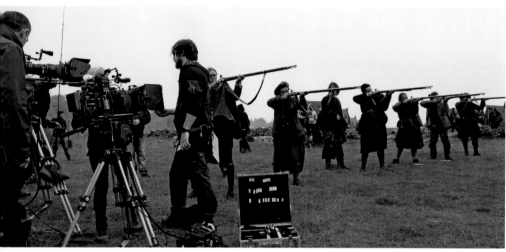

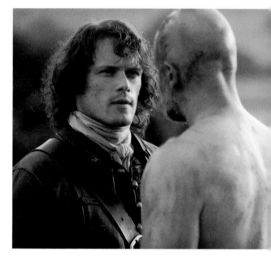

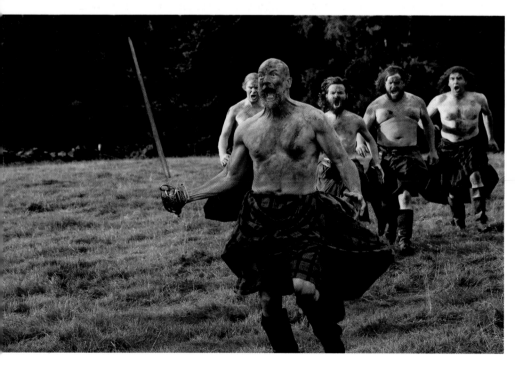

"Dougal is a fighter. He is not someone who wants to stand around talking about fighting. When he sees what Jamie is proposing regarding drilling them into shape, there is a sense that Dougal understands that the power has shifted. When he talks to Jamie, he's talking to a different Jamie than he was at the end of the first season."

—Graham McTavish

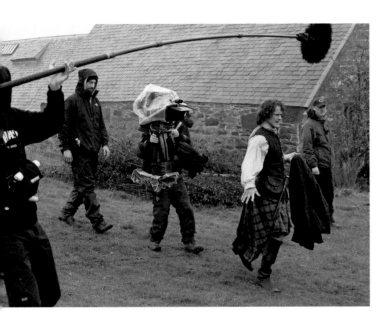

anxiety the characters are experiencing in this episode.

Philip John was tasked with directing one of the most action-packed episodes of the season, and to his delight, the unruly Scottish climate was very kind to him and the crew. "The weather did precisely what we needed all the time," he says. "We went up to the training camp for an opening shot across the hills into the Highlands. We had horses in a massive setup with lots of training warriors walking along through this landscape, so we just wanted it to be clear. Every time we visited that place, it was always in clouds. The day we shot it was immaculate, a blue sky, and it was just like heaven.

"We had a big, epic landscape, but the key to it was staying close to Claire," John continues. As Claire navigates the camp, the environment drags her back to World War II. "Her flashbacks are actually flash-forwards to World War II, so there is a complexity there that I

think you need to simplify. PTSD is characterized by awful flashbacks, emotional surges, fear, and panic attacks, so we did a lot of work in the training camps because there were lots of triggers for that there. For example, she walks past the muskets firing and it triggers a massive memory of an episode during battle in World War II, and suddenly you're there. It was about trying to stay within her head as much as possible to witness the

horror of what goes on with the two [soldiers]. All of the time, you're trying to create a landscape in her head, because obviously this is all stuff that she is recalling in the past."

John also got to reintroduce the bulk of the Highland cast to the narrative. "Angus, Rupert, Dougal, Jamie, Claire, and Murtagh: They all come back together in an uneasy alliance. They all work really hard together to get these [Fraser clans-

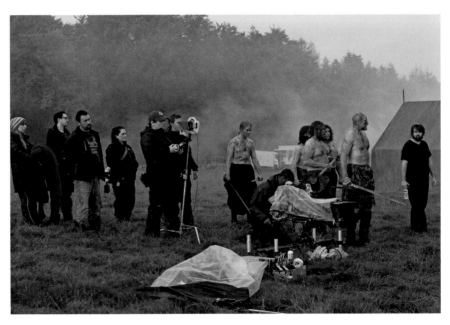

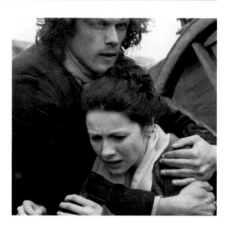

men] trained. They are all farmers, so they have no real clue."

As Claire observes the recruits throughout the episode, Jamie comes to see what it's doing to her, watching the slow walk to a war she hasn't been able to prevent. Roberts explains the emotional confrontation: "Jamie's reaction is, 'I'll do the right thing and send you home.' She's like, 'Yes, but that's the thing that would kill me worse.' I think what gives the episode a nice balance is, Jamie has a job to do, yet he's sensitive enough to know that his wife's struggling with something. She's struggling with something, but she knows that if she lets it play up too much, it's going to

hinder him from doing his job and it's all going to go to shit. The balance of the couple is once again driving the story. If they can work as a team, usually good things happen. It's when they don't work as a

team that bad shit happens." John adds, "The very last shot of the episode, they look at each other and she says, 'Je suis prest.' She's ready; she's prepared."

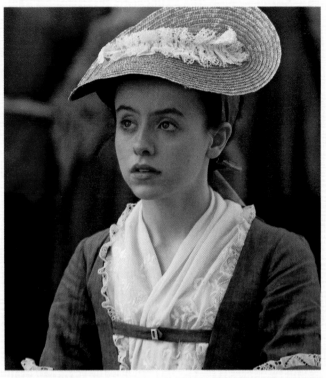

SPOTLIGHT:

Laurence Dobiesz as Alexander Randall; Rosie Day as Mary Hawkins

With the high stakes of the Jacobite uprising running as a current through every moment of the second season, it's easy to lose sight of the sad story of Mary Hawkins and Alexander Randall—quiet, good people, unable to chart their own fates, and used as pawns by the Duke of Sandringham and by Claire Fraser to ensure lineage for Frank Randall in the future.

Yet, rather than interpret their characters merely as victims, actors Rosie Day and Laurence Dobiesz were able to turn their respective roles into admirable fighters, willing to stand by each other to the very end. "Mary's stuck in this world where men are trying to control her life, and then as the series goes on, lots of awful things happen to her, unfortunately," Day says. "But by the final few episodes, you see her grow up and take responsibility for herself and fight back."

Dobiesz says Alex's loyalty and love for Mary is what

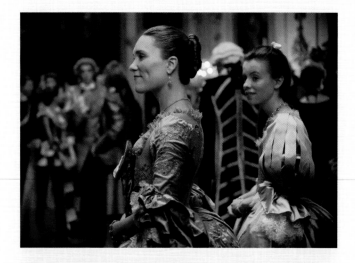

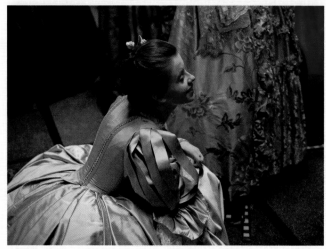

"Claire takes Mary under her wing. I think she feels very sorry for her. Then quite early on, Claire figures out who Mary is to her timeline and realizes that she's quite important, so she needs to figure out what she's going to do about all of that."

Meanwhile, Dobiesz says *Outlander* was the job that finally allowed him to work with his unofficial doppelgänger, Tobias Menzies. The actor says for years people, including his wife, have pointed out their facial similarities. It was only when he was called to read for *Outlander* that it dawned on him "that I would potentially be playing Tobias's brother. Maybe if I had my ear to the ground a bit more and was thinking outside of the box a bit, I could have followed Tobias's career," he jokes. "I could have made sure he's got a younger brother cast more often." Instead, this marked their first collaboration, and even then it took the penultimate episode

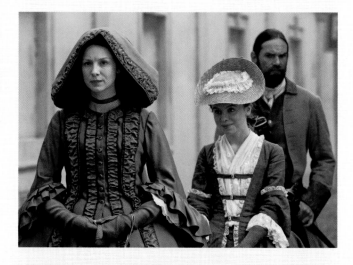

distinguishes him throughout the series. "Alex is a nice guy," he says earnestly. "That sounds a bit weak, but he is kind, yet he doesn't come out unscathed. He dies and it's pretty horrible, but he goes out on a hopeful note."

Once Day was cast, reuniting her with Sam Heughan, with whom she had previously worked on a film, Mary was actually aged down to fifteen years old, which helped her tap into her vulnerability. "I learned how to do a stammer," the actress explains. "I've never done an impairment, in terms of speaking, but we have a wonderful voice coach who taught me how to do it, because that was really important. Mary stammers her way through the early episodes, and as the show goes on, she loses it and she gets a bit more confident."

Day says it's through Claire that Mary sees what a confident woman can be. "The first time Mary is introduced to Claire, she won't leave her side." Day smiles.

of the second season for the two to meet.

Yet, before they got to that climactic moment, Day and Dobiesz had to sell a romance with limited screen time. "You don't get to see Mary and Alex at home doing their thing, falling in love," Dobiesz explains.

"You get snippets of what Claire sees." He says joining the show together in season two helped them bond quickly. "Rosie and I were up in Scotland, shooting together, and we were already looking out for each other because we were entering this huge series that already existed. Relationships already existed, so it was nice that their dynamic came naturally to us."

In "The Hail Mary," everything comes to a head for the couple, as Alex's consumption and imminent death force them to enter into a devil's pact with Jack Randall, brokered by Claire. "Alex ends up asking quite a lot from Jack, and that's an extraordinary act of love and sacrifice, which would go against everything that Jack would want. And I'm sure people are screaming at the screen, 'God, don't do it! There must be another way!'" Dobiesz jokes. "But Alex doesn't know the depth of the darkness his brother's delved into, be it from love or from some cognitive dissonance. They are fundamentally very, very different at the core. So we know that in order for Alex and Mary to call upon Jack for help, they wouldn't have done it if they didn't see that there was some lightness, that there was some love there."

Dobiesz admits that Jack's final moments with Alex further cement Jack's darkness. "I'm not sure that Jack walks away from it a changed man. Jack's glimmer of light, which Alex brings out in him, you see it shut down again, and you worry about what Jack might be capable of if he wasn't walking to his fated death," the actor says. Knowing that certainly leaves the audience, and Day, feeling more hopeful for Mary in the end. "I think she's learned a lot from being around Claire," Day says.

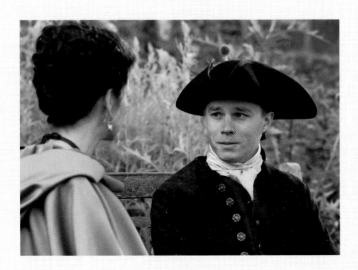

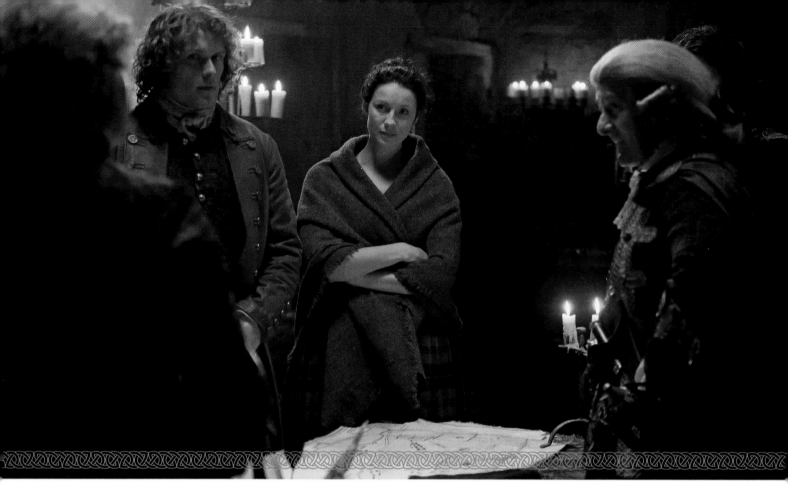

EPISODE 210 : PRESTONPANS

WRITER: IRA STEVEN BEHR DIRECTOR: PHILIP JOHN

War: It's what Claire and Jamie have been trying to prevent all season, yet it still arrives at their door in the tenth episode of the second season. In the writers' room, the episode remained up for grabs until writer Ira Steven Behr walked in with his vision. "I came into the room and I just pitched out how I saw the show. I don't think anyone's done that before or since," he explains. "I wanted it told in flash-

> "We all know about Prestonpans, being Scottish and growing up with our history, so to be shooting it was very exciting. I think everyone involved was very excited about it—not only the actors, but also we had all of these amazing extras that were all reenactors. It was just nice to be back in the action stuff after all the politics of the first half of the season."
>
> —SAM HEUGHAN

backs. Angus [Stephen Walter] was going to sustain an injury we did not think was serious, but at the end it was going to turn out to be fatal. We win the Battle of Prestonpans, but we lose Angus, so even in victory there is sorrow."

The writers then had to decide who would ultimately die in the battle. Rupert or Angus fit the bill of emotional weight, Behr says, but choosing which one incited a heated debate. "Angus alone, I felt, would

"It becomes less about what the prince wants and what the prince can do and more about other people making decisions for him. He relinquishes control of his army to these older has-beens, so to speak, one of whom is a drunk and the other is a retired gardener. Basically he's handed over control to Murray and O'Sullivan without even an agreement. With that, the prince just becomes more and more frustrated. You see his old habits creeping back in again, because old habits die hard."

—Andrew Gower on Prince Charlie's ineffectiveness

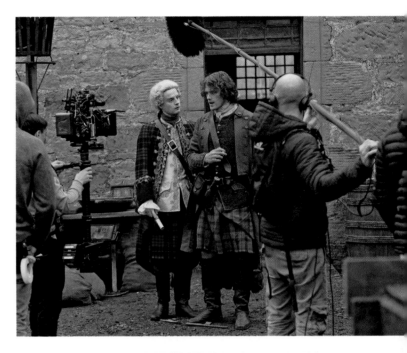

"We had cast these guys, Ross and Kincaid, and suddenly these two guys become really important, because we decide these guys have to be their own Rupert and Angus. They go through the same thing. They're not heroes. Angus is trying to do the same thing with Rupert, who won't be having any of it. And at the end of 'Prestonpans,' Rupert takes the sword and mourns his friend."

—Ira Steven Behr

be more interesting. Ron thought Rupert alone would be more interesting. And then it became, I'm not going to convince you, and you aren't going to convince me." Behr admits he gave in grudgingly. "At the beginning, it hurt a lot. But everyone is right: This is much better for the show."

Prep and execution of the Battle of Prestonpans ended up being a hugely exciting task for director Philip John. "The battle scenes gave me a chance to put a spin on them in a way that I was left free to carry

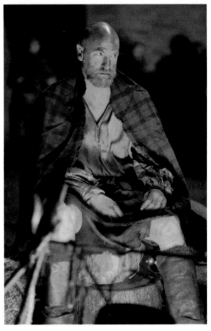

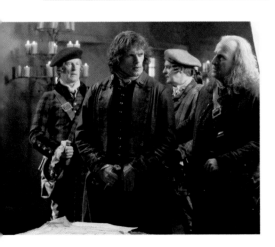

"I very much wanted to portray Dougal as first and foremost a formidable warrior, but this was somebody who, let loose, could wreak havoc amongst anybody who put themselves in front of him, especially unseasoned troops. When I was doing the fighting, I wanted it to be very ugly and messy and not elegant, just brutal as it would have been. There was no sense at all that I wanted to show any sense of giving them any quarter, any sympathy. There was going to be no prisoners as far as Dougal was concerned. These people had to be exterminated."

—Graham McTavish

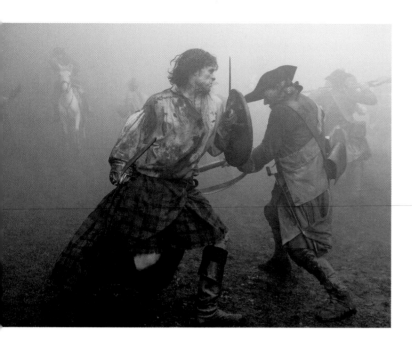

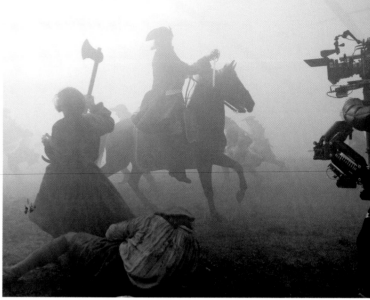

out. I said, 'Look, I want to do the war this way. I want it to be pitiful and terrible.' They were like, 'Cool, go ahead,'" he says. "So we had these fight sequences that we tried not to make too galactic. It needed to be grim, not elegant, and upsetting. We have lots of shots of young men with arms lobbed off, sobbing. It was just trying to find the brutality, the truth of war."

For the battle staging itself, John says, ingenuity helped them achieve historical accuracy. "In a very fortunate way for the Jacobites, the Battle of Prestonpans was fought in mist," he explains. "It was a pure piece of chance that somebody told them there was a path through this impossible bog directly to the British camp. We figured that not only gave us something visually extraordinary to explore, but I wanted Jamie to be the audience and fight for his life and for the life of his comrades. We had major problems in terms of controlling mist outside. Shooting inside a studio was a problem, because there wasn't a studio available. So,

brilliantly, they brought a huge tent that was probably about eighty by thirty yards, and we plunked it on the field and then we pumped the smoke inside. We shot everything in there, and it just looks absolutely amazing."

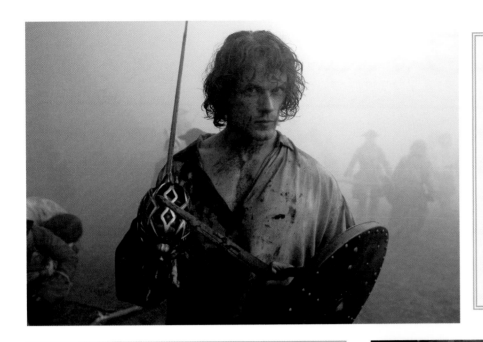

"Using one of these [straw] effigies for Dougal to basically show the killing zones, that was my idea. Then Graham took it to a different level. He basically went berserk on this straw effigy. He just destroyed this straw man, which you then see portrayed in the actual battle itself. It looks really good."

—DOMINIC PREECE

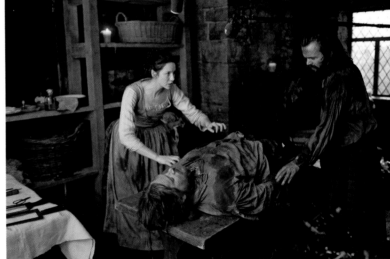

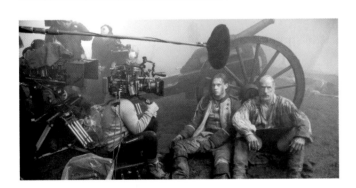

"[Angus's] death took about three days to film. There was definitely a dark tone on that day, especially the afternoon. I was very sad to see [Stephen] go, to be honest. It is definitely not the same without him."

—GRANT O'ROURKE ON THE DEATH OF ANGUS

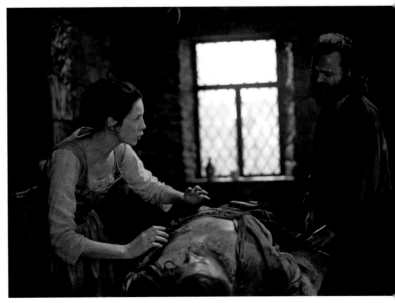

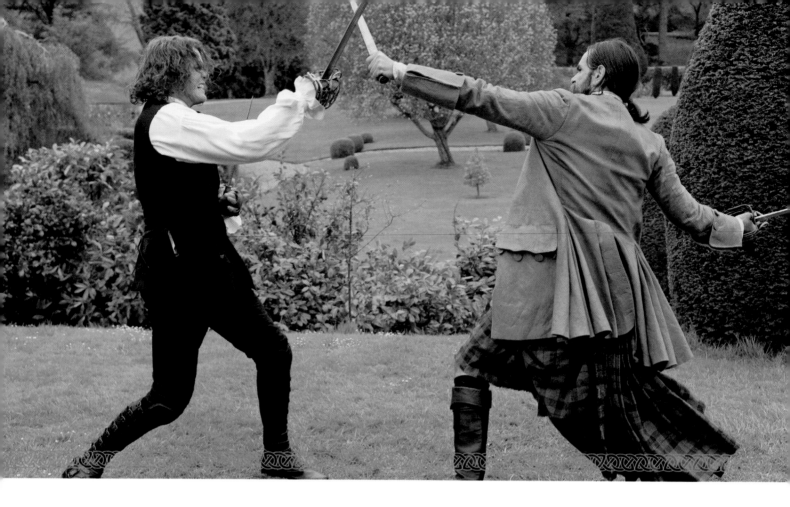

STUNTS AND ARMORY

For every battle, duel, or fraught horseback chase featured on *Outlander*, there are teams working behind the scenes to ensure that every single person involved looks eighteenth-century authentic. Heading that team are stunt coordinator Dominic Preece and armorer Jim Elliott, who work in tandem choreographing, training, and acquiring the gear for every physical encounter featured on the series. Each is an industry veteran, with Preece working on Marvel films from *Thor* to *Guardians of the Galaxy*, and Elliott creating props and arms for films like *Cloud Atlas* and *Under the Skin*.

STUNTS

Developing and executing the stunts on *Outlander* means Dominic Preece can merge both of his backgrounds—stunt work and horse work—into one job. "Although I've been a stunt guy for quite a long time, I originally got into stunts through horses and I specialize in them," he explains. Because the series utilizes the animals as primary transportation,

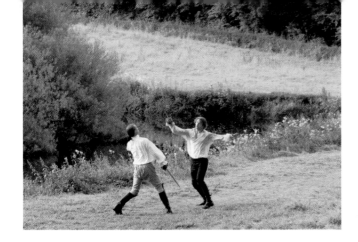 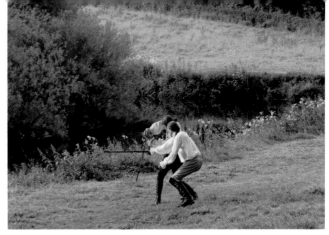

Preece has had to put the cast through both physical and equine boot camps to get them all confident and looking at ease for the camera.

"We started doing fight techniques in the boot camp, which followed on through both seasons," Preece says. "I was very keen on wanting them to be rough and ready." Luckily, Preece says, he's got a cast, from Sam to Caitriona to Graham, who want to do as many stunts for themselves as possible. "Obviously, the young guys want to do it all themselves," he laughs. "Every now and again you've got to rein it in a little bit and just say, 'Hang on a minute. This is why we have stuntmen.'"

Preece says much of the cast had no prior experience horse rid-

ing, so they had to get comfortable with their steeds. Doubles can only be used with action scenes that incorporate camera techniques to mask the stunt riders, so the cast often had to be up on the horses themselves. "We had a five-week boot camp where all the actors came in, sometimes once, sometimes twice a day, just to get used to it. And for the horses to get used to the actors.

"Sam and Cait, from the very beginning, I knew it was going to be no problem with those two," Preece says. "They loved the riding. Cait in the first season particularly—she chose this big, fat cob called Travis. She just loved this horse. But in season two we changed the horse. Again, she loved that horse as well, a Spanish gray horse named Protos."

In both seasons, Preece maintained a stock of core horses for camera. "We upped that, obviously, when we had to," he explains. "[We] always have a lot of black horses and a lot of dark-gray horses, so we can interchange them quite a bit without anybody knowing too much."

As to the high number of combat scenes, Preece says the show can

do more than most because of the proficiency of the actors. "They do all the fights," he says. "In certain fights, sometimes what we'll do is get a stunt double against an actor, and then we'll change it around so that each actor does their bit."

On any given day, Preece carves out time to get the talent involved up to speed with what's going to be needed of them. "We have such a tight schedule, and with Sam being so busy I can barely see him," he explains. "Rehearsal time is limited, but that's the beauty of [the actors]; they just pick it up very quickly. What we tend to do is, we'll get together and talk about the fight. Then we video it so they can take it home with them and they can watch it. Then, on the day they come in, usually in the morning,

 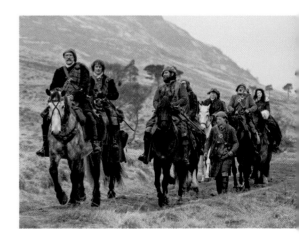

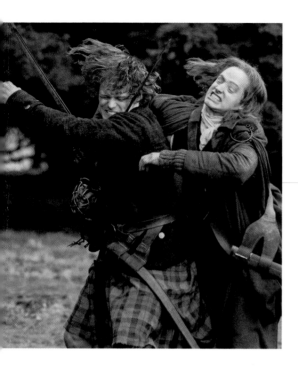

ARMORY

Outlander uses a lot of swords, muskets, knives, and other weapons, and in each case Jim Elliott is the man responsible for finding it, acquiring it, or making it. Elliott is usually a property master in TV and film, with a specialty in armaments, but he rarely works exclusively with them, as most productions don't need that kind of focused expertise. But because *Outlander* has so many plot points involving combat, skirmishes, and even the Jacobite rebellion, Elliott was able to focus solely on weapons as the series' armorer.

"I have to say it shocked me a little bit," Elliott remembers when Jon Gary Steele and former supervising art director Dave Arrowsmith hired him. "I wasn't expecting that, because twenty-four/seven on a show of this magnitude is very rare, but I welcomed it."

Unable to use any modern weaponry (other than in flashbacks to World War II), Elliott says he had to build his stock from the ground up. "There is a cottage industry in the UK for reenactors, so there are a few [historical weapon] suppliers," Elliott says. "For our hero props [or primary-character weapons], I go through sword books and look for the correct mid-eighteenth-century weapons. Then, fortunately for me, we have a local Glasgow sword-maker, who is a genius. I can show him a picture of a sword and he can fabricate that for us."

Elliott says he also purchases actual weapons and then makes reproductions, or multiple copies, but that path is often time-consuming. "I can go and buy 1740s weapons, but if I have to get something from Canada or Germany or India, there is Customs, and you can't rush them. They take sometimes twelve weeks for me to get a firearm, and then I have to get it proofed in the proof house to make sure that it can take the charge and the barrel's

you try to get ten minutes with them again, just to walk through the fight slowly.

"What happens with fights, and this happens with stuntmen as well as actors," Preece continues, "is you'll learn a fight and then I'll say, 'Let's see it half speed.' With fights, if we do it too quickly, people think it's rubbish. You've got to slow it down and put the little beats in the gaps."

> "Every Frenchman in the French court had to wear a sword. It was etiquette. You did not get in to see King Louis if you weren't wearing a sword; therefore, we had one hundred fifty extras dressed up to the nines. We had to have a hundred fifty different swords, so I then had to find French swords, which are very different from the Scottish basket hilts. The French swords are more like an epee blade: small, narrow, and very ornate handles. It was to show off your wealth. You were a peacock, and you dressed like a peacock."
>
> —JIM ELLIOTT

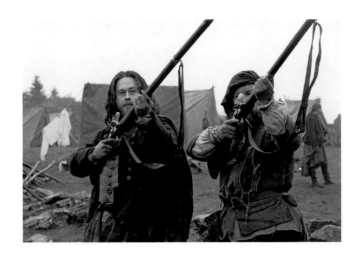

not faulty before I can put it in the hands of an actor, for insurance purposes. If it's a firearm [in a script], I need at least twelve weeks' warning. If it's a sword, and [our fabricator] isn't really busy, we get it within three to four weeks."

The weapons seen in a stunt sequence are usually three different weapons employed at different times. "For any hero sword, we have three versions to take along every time," Elliott details. "You've got the hero weapon, which is steel for close-ups. Then you have aluminum for any stunts or fighting, and then you also have a third sword, which is a rubber copy."

When muskets or flintlocks are used, Elliott is responsible for making sure they fire safely. "In the past, I've always stayed away from black powder, or gunpowder, because it's so unpredictable," Elliott explains. "And the lovely Scottish weather doesn't lend to firing muskets in the rain, hence the old saying, 'Keep your powder dry.' So when you're using gunpowder, you then have to approach the government for an explosives license.

"We are using live gunpowder with no musket ball, obviously," Elliott continues. "If you stand in front of it, it can still kill you. With live gunpowder, you have to be at least twenty to twenty-five feet away from the end of a Brown Bess [aka a British Land Pattern musket] or you will get sprayed with fire and gunpowder flames."

Elliott also custom-fits weapons to the show's core cast. Two of his favorites to equip are Sam Heughan's Jamie and Tobias Menzies's Black Jack Randall.

"When you see Sam with the belt over his shoulder and the sword sitting on his right hip, that's called a baldric," Elliott says. "Those have to be made with punched holes and fitted to the thighs so that every time they go on, they're exactly sitting comfortably for them to draw the sword. And they've got a lovely buckle in the front, which will always be in the same place on the costume, over the shoulder and over the plaid.

"In season two, Sam gets a new sword with new leather work, and a new dirk," Elliott continues. "Sam

likes telling the story of the dirk we got him. It's handmade and hand-carved. The sword-maker made an exact copy [of one] found left on the battlefield at Culloden, [which] was in a museum. It's got a lovely chrome finish and sharkskin handle. They used to make them out of sharkskin, or ray skin, so that when you were in battle and your hand was sweating or wet, it would catch a good grip on the handle."

As for Black Jack Randall's signature saber, it came out of a back-story discussed with the series' producers. "They said [Randall] had been fighting abroad in Europe in the past. In those days, the officers bought their own weapons, so it would be plausible for him to have a different sword from another officer, because if [a soldier] had the money, they would buy what they wanted." Elliott says he was thinking of a small drawing in a book he found with a Prussian saber from the 1730s. "If [Randall was] fighting abroad, say in Austria in the Austrian wars, he could have come back with one of these sabers."

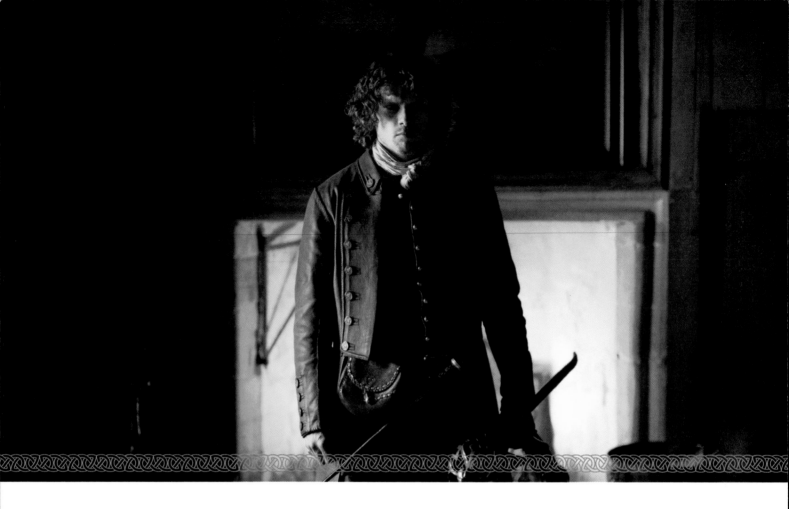

EPISODE 211: VENGEANCE IS MINE

WRITER: DIANA GABALDON 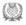 DIRECTOR: MIKE BARKER

Books are a frequent source of inspiration for new television series, but beyond the raw material it's rare that the original author gets invited to write for the show. In Diana Gabaldon's case, she says the idea came up during her very first meeting with Ron Moore and Maril Davis. "He asked me whether I was interested in writing a script. He relaxed visibly

when I said no," she says with a smile. "But I explained that I might be interested in trying a script at some future date."

As Gabaldon spent more time with the *Outlander* creative team, friendships and a natural rapport developed. In the process of reading scripts, watching dailies, and edits, she grew to have a better understanding of how the writers'

room functioned. At an event for the series, Gabaldon remembers, writer Anne Kenney offered to do a script with her. "Conversations happened, and eventually collectively it was decided I would write one on my own," Gabaldon says.

She was assigned "Vengeance Is Mine," so Gabaldon flew to Los Angeles to join the *Outlander* writers' room to break down the script together. "That was a lot of fun," she says. "It was like doing crossword puzzles with a friend."

From there, Gabaldon outlined

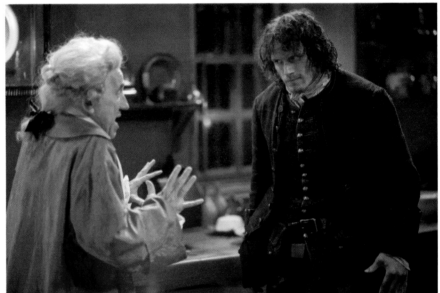

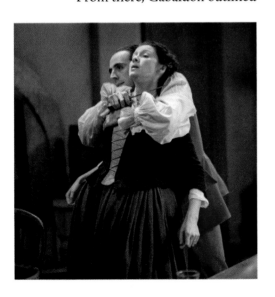

the episode in two days and then wrote the script in about three weeks. "Ron went through that and gave me notes. Then the studio and network gave me notes. The most entertaining one was: *We love the script. It was very solid, but our main concern is that it sounds too much like Diana*," she laughs. "Ron went through it and helped with that."

Gabaldon then flew to Scotland to help pre-produce her episode on location with director Mike Barker and the heads of departments. "Everyone was terri-

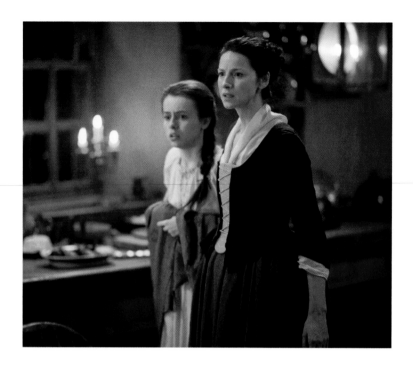

fied," Barker laughs. "It was like the governor was turning up. But I have to say, Diana is possibly the best fun on the set, and she's also the most pragmatic. If I said to Diana, 'I don't like this. It doesn't work because of this and this,' then she says, 'Okay, fine; then change it.' I really, *really* enjoyed her presence on the set. I found it a breath of fresh air."

Diana says the script for the climactic conflagration inside the Duke of Sandringham's outpost ended up going through quite a few changes on the set. "I wrote a version of the beheading that is very close to the book," she explains.

"But it was rewritten by a combination of Anne and Ron to get Mary's licks in, as they thought she ought to get her revenge. But [Ron] also didn't want Jamie to look like too much of a hero, which always drives me crazy because Jamie actually is a hero," she says. "So his idea was that Murtagh should kill both Danton

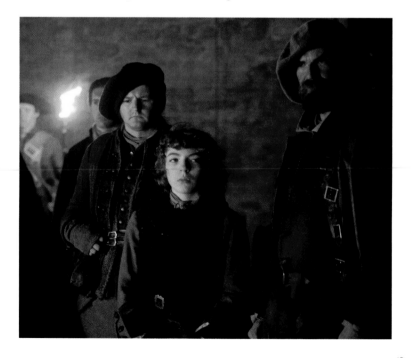

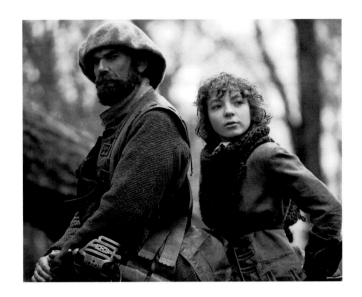

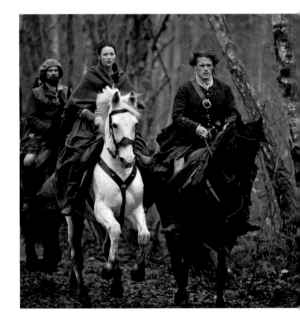

and the duke. Then Claire had to rescue herself, because we don't want her to look helpless.

"But I was grinding my teeth, thinking that it didn't work," she says. "And sure enough, it didn't work.

"The [story] was all physical. It was like moving chess pieces, when it is a really *passionate* scene. A lot of energy is flowing through there, but the emotional energy isn't where the physical flow is. I said I think the physical flow needs to follow the emotional energy. It turned out that Sam and Duncan had been talking [the same thing] over in their car on the way home. The next day they tried a rehearsal with Mary killing Danton, and Murtagh killing the duke. Duncan, God bless him, picked up the ax and swung it back, then delivered his line in such menacing Gaelic that the whole room's hair stood on end," she says. "It worked so perfectly that there wasn't any question that we wouldn't do it that way."

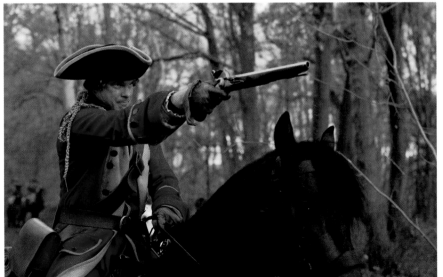

"Yes, they made a head cast. I'm very claustrophobic, and they were very kind and made it up in bits and pieces for me. They used to not be able to do that, but they can now. It's a brilliant head. I don't know who's got it now. I'd want it, or perhaps I could send it to Madame Tussauds."

—Simon Callow

SPOTLIGHT:

RICHARD RANKIN AS
ROGER WAKEFIELD MACKENZIE;
SOPHIE SKELTON AS BRIANNA RANDALL

There's an appropriate symmetry in the fact that the *Outlander* producers cast Brianna Randall and Roger Wakefield MacKenzie in a similar time frame and the exact order as Claire and Jamie. Fans of Diana Gabaldon's books know the pair are destined for epic things, which means the produc-

ers needed to find actors who would be able to grow into the various demands of their characters' adventures for, hopefully, many seasons to come.

While the roles were originally written to debut at the end of season one, then were pushed to the start of season two, they were eventually woven into the season two finale,

"Dragonfly in Amber." That translates to almost a year of searching and, for actors Sophie Skelton and Richard Rankin, almost that same span waiting to hear if they were going to win their respective roles. Having auditioned for more than four different characters in the series, with Wakefield being the last, Rankin says, "I had, in my head, thoroughly buried Roger Wakefield MacKenzie by that point. He was always on the horizon, but I never quite caught up to him."

"Bree was one of those [roles] I really wanted, because I related so much to the character and didn't want anyone else to play her," Skelton says. "Then a year [after the first audition], I got an email from my agent saying they wanted me to read for the part of Brianna in *Out-*

lander. I was like, 'I think I've already done this one,' and that was the only way that I knew that it had not been cast."

Rankin was cast first, and he hit the ground running, developing his take on the character while remaining fully aware of the *Outlander* fandom's high expectations. "It's not necessarily a very safe way to prep the character, keeping in mind what fans may think, because that may not always be the best way to approach a character," he says. "But the information that I had about Roger when I started filming was quite limited. He is introduced in book two at the top and tail of that book, so what I did was read as much as I possibly could ahead, just to get a feeling of what

Roger was like in the books. I'd at least have an understanding of the character that everyone expected and have an understanding of the character that was written. So I read up to *The Fiery Cross* to give myself a good idea of just how Roger ticked and also to get Diana's version of Roger, which was important to me.

"I loved the character," Rankin says. "He is so different from me in every way.

"The conversation came up time and time again, especially with a couple of producers and [me], about where to pitch Roger at the start," the actor details. "He could be this cocky, bookish professor. Or you could play that he's got a real sense of clumsiness about him. You can throw a pair of glasses on him and he's tripping over his own feet and all that. I needed to think that there is a strength in him that maybe he doesn't know himself, or is not aware of it, but there is something in him that has yet to flourish. That was a different anchor point for me."

Meanwhile, Skelton passed her chemistry reads with Rankin and Caitriona Balfe in December 2015, after which she was finally cast and revealed to the public. Skelton says she started to get into character by focusing on Brianna's physical look, poring over season one episodes to look for qualities she could capture from Cait and Sam to build family traits. "There's a cer-

tain frown that Sam does and a certain movement with the lips that Cait does when she folds her arms. I also grew up doing ballet, and Cait has that same stance, with the straight back," she explains. "All those things I tried to copy."

Skelton says that she actually possesses naturally curly hair like Heughan's, but it's disguised to match the styles of the sixties. "We've gone for the ironed-out look," she says. "She's on trend.

"I remember when I was reading the book, I pictured Brianna in this brown miniskirt, with long beads and a very sixties high-neck yellow top," Skelton says. "Then I went in for my fitting with Terry [Dresbach] and it was exactly that, which was really cool."

Once on set, Skelton says, she and Rankin bonded quickly as the new kids in town. "We were fresh, eager, and excited, and they were all ready to wind down," Skelton says, having joined at the end of the season. "I think our first day was a sixteen-and-a-half-hour day or something. So it was quite nice to have a person who's going through exactly what you are in terms of intensity."

During the shoot, Rankin did almost all of his acting with Balfe and Skelton, and he says it was a lot of fun being the man between two very headstrong women. "He is very much caught between the two of them at one point," Rankin says. "There's this fiery, stub-

born redhead on one side and Claire Randall, who is just as intimidating, if not more, on the other. He finds himself caught in some sort of tennis match between the two of them."

"Cait and I had a few chats about where their relationship is at," Skelton says. "In the book, Claire and Brianna are quite close when we first see them in Scotland. But in the script, they tried to put a lot more dysfunction. There was already a bit of anger there, so it was left to [ramp] up when Brianna finds out about Jamie."

As to the attraction that blooms between Roger and Bree throughout the episode, both actors reveal that the series is initially going to play that connection slower than in the books. "You need somewhere to go," Rankin explains. "But there is something that immediately smacks Roger when he sees her. He is like, 'Who are *you* and what are you doing at my dad's funeral?' It is very distracting."

How their journey will unfold remains a third-season mystery, but "the story is amazing," Rankin promises.

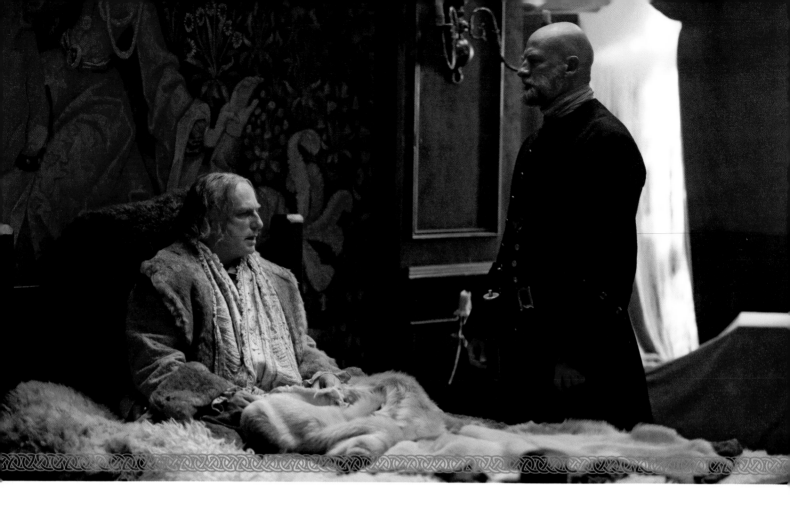

EPISODE 212: THE HAIL MARY

WRITERS: IRA STEVEN BEHR AND ANNE KENNEY DIRECTOR: PHILIP JOHN

"The Hail Mary" serves to tie up a myriad of loose ends as the Battle of Culloden looms. The script was co-written by Ira Behr and Anne Kenney for efficiency—they split the script down the middle, and Kenney wrote Claire's story arc while Behr dealt with the fraught relationship of the Mac-Kenzie brothers.

"It's a show about two sets of brothers," Behr says succinctly.

> "Colum is putting to the side the whole issue of faith and religion, because it's time for him to leave the planet. He's reaching out to Claire to help him. In the end, it's clear he really loves and respects her and realizes how important she's going to be for Jamie, who really loves her."
>
> —GARY LEWIS ON COLUM'S RELATIONSHIP WITH CLAIRE

"Black Jack is having his moment with his brother and his goodness is fading away, and then you have Dougal, who is the man that Colum cannot love, but in Dougal's eyes Colum made him who he is. Not because Colum meant to, but the fact that he couldn't keep his ass on that saddle [meant] that his brother turned out to be mortal, fallible. It changed the course of who Dougal might have been. And the fact that at the very end his brother shows

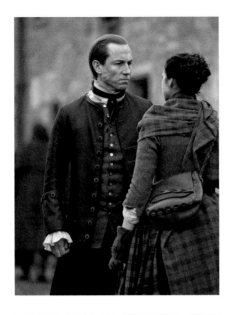

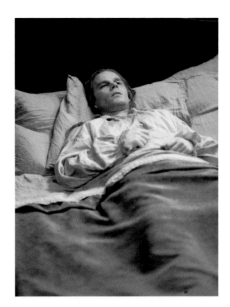

up not to join but basically to give one last unbelievable, painful rebuke to Dougal, I thought that was an interesting thing."

Director Philip John says he was especially happy with the brothers' last conversation. "Colum has taken the [poison] and [Dougal] doesn't know, and neither does the audience. Then Dougal tries to make peace and to let his brother know that he cares for him and [to ask him to] please reconsider. But he doesn't realize that Colum has passed on. He's trying to put it to rest but now can never do it. Of course, Graham plays it beautifully, as does Gary. You have those two actors going at it, which is a winner. There is nothing much I can do to improve that."

Kenney says she was motivated for her part by the desire to portray Claire and Black Jack's final meeting. "In the book, Claire comes upon Alex and Mary and knows

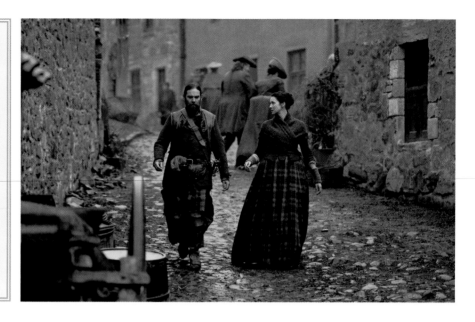

that he's very sick, but Black Jack is the one who approaches her, out of nowhere, and then he strikes the deal," she explains. "We didn't believe that Claire would say no to helping someone. One way we could turn that was she knows that she can't save him. When Randall says, 'Please,' then she doesn't seem so coldhearted when she decides, *I could save thousands, perhaps, if I strike a bargain with this guy*, so she's the one who says, 'I'll help your brother if you will give me intelligence about the British Army.'

"We then wanted her to be active in the whole marriage of

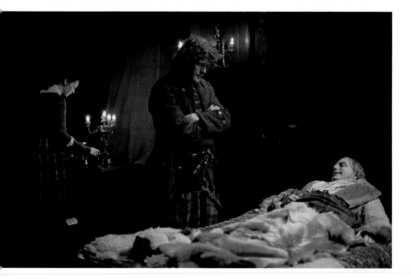

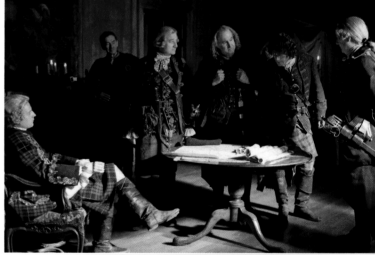

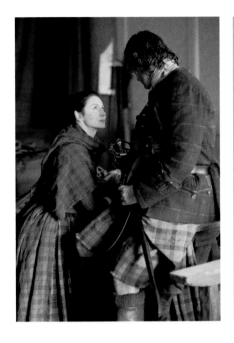

"*I love the fact that Rupert almost dies at Prestonpans. And Rupert almost dies at the church. I hope that people will be watching that, thinking that he is dead. He is a goner and then he is just straight back up. Rupert will live forever. It feels like that. But it also feels like a nice, gentle reminder to the fans that the TV show is different from the book now.*"

—Grant O'Rourke

Mary and Black Jack, but the problem was, of course, why would she?" Kenney continues. "We were able to come up with the idea that Jack has an officer's pension, so if he dies, then Mary would have money to live on. He also has a little bit better name of family, so that would give her maybe some standing in society and her own family might welcome her back. Claire knows that, if history plays out, Jack will be dead in three days. Hopefully you hate Jack enough that you don't think that she's an awful person for wanting to do that," she laughs.

In filming the last moments of Alex Randall's life, John says, they were able to capture an alternative version of the events in the script, which was ultimately woven into the final edit. "You prepare every scene to the nth degree in your head but know it is going to change when you get on set," he explains. "I'm very comfortable with that. It is very organic. Like that wonderful scene that evolves into one of the grimmest weddings I have ever shot, in that Alex wants Jack to marry Mary to look after her. Mary is terrified of Jack. Jack looks at her like she is the next meal."

John says Alex's death and the aftermath weren't working, and he told the cast as much. "Tobias says, 'What about this?' He jumped on the bed and pounded Alex's head with his fist. It is a scene I have literally never seen before as a grief scene."

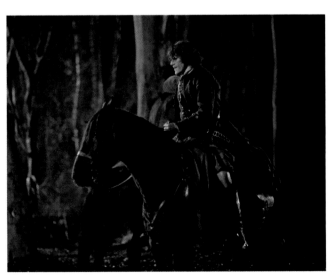

EPISODE 213: DRAGONFLY IN AMBER

WRITERS: TONI GRAPHIA AND MATTHEW B. ROBERTS 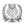 DIRECTOR: PHILIP JOHN

The last episode of season two changes the very fiber of the series, setting it up for a quite different third season. Due to Ron Moore's responsibilities as showrunner, the writing of the finale fell to Toni Graphia and Matthew Roberts, who wrote the episode together, passing scenes and drafts back and forth throughout the process.

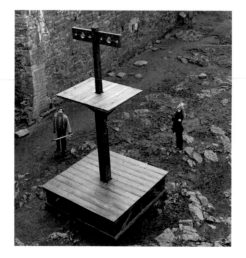

The episode needed to shock the audience with a time jump of twenty years, establish the strained mother/daughter relationship between Claire and Brianna, reintroduce Geillis, and go back to Culloden for Claire and Jamie's emotional farewell. Graphia admits it was a lot to juggle, but they started the episode by writing the confrontation between mother and

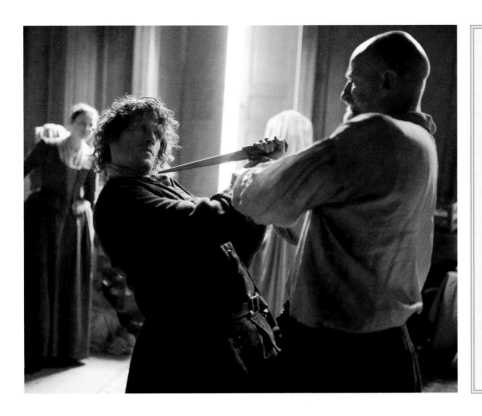

daughter. "We used it as an audition scene for Brianna," she says. "We needed an emotional scene where she breaks down, so that we could really see acting ability. We didn't have a scene like that, because that scene isn't in the book. We actually wrote that scene weeks before we ever wrote the script by itself. We didn't even change a word; it's the exact same in the episode."

Next, both writers wanted to see Geillis return to the narrative but needed to figure out how to do so in a way that worked within the framework of the story. "We realized very quickly that we can't have her meet Claire, or she would know Claire in the eighteenth century," Graphia explains. "Then we came up with, how about if she meets Brianna? We were always interested in what made Geillis want to go back to the past. We don't know about her past. We thought, if Roger is a college professor and Bree is in college, maybe Geillis can be giving a speech and Bree goes to the speech and goes up to talk to her."

But despite these changes, Claire and Jamie's goodbye at the stones was adapted faithfully from the books. As it happens, that moment was the first day of production on the episode.

> "We got [to the Craigh na Dun location] that morning and the whole floor was dusted in the most beautiful snow. It was just magical. Then of course the sun came up and started melting it all. The great thing is that we had been filming all of the lead-up to [the goodbye] quite close together, so it felt very immediate. It felt like the necessary conclusion to this whole long season that we had been building up to. It was very emotional and heartbreaking. I think even some of the crew got a little bit verklempt. If she wasn't pregnant she would just die by his side, but she has another life to consider, and that is the power of motherhood and the power of your passing on your line. For him as well. He must see that child safe. He must see Claire safe."
>
> —CAITRIONA BALFE ON CLAIRE AND JAMIE'S EMOTIONAL GOODBYE

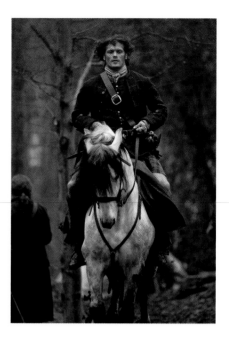

Director Philip John says the scene with Jamie leading Claire back to the stones was shot as a dance. "You have Claire and Jamie going against the flow," he explains. "Claire is saying, 'I can't go. I don't want to go.' And you are aware, having seen all of these thousands of warriors, exhausted, walking toward their death, that Jamie is going to make sure this happens. The cannons start the battle, so time is imperative. Then they have a conversation at the stones, which is incredibly emotional and beautiful. He leads her through the stones and she goes through. It gets to me even thinking about it," he says. "I shot the scene on the side where she fell through the stones in episode one. The emotional outpouring that came out of when she realizes she was back in the future, Jamie was dead, creates enormous mourning."

Graphia says that for her, the most emotional point of the episode is Claire's visit to Culloden. "The scene encapsulates the whole episode, which is that she doesn't want to set foot on Culloden Moor. It's a place of death and destruction, yet it's the resting place of the man that [she loves]: 'I should be under there with him, but I'm not. I have to go back and tell him goodbye.' It's just very powerful."

> "The scene at the gravestones at Culloden was really amazing. You see this woman who is very poised and has almost closed the door on her heart for twenty years. Then she sits down and you almost see the old Claire again. The minute that she starts talking to Jamie is where she lights up. This is where she exists as the woman in her heart. The girl in her heart will always be the same age, in a way. She is talking and saying goodbye to the person who has meant the most in her life and has consumed every fiber of her being."
>
> —CAITRIONA BALFE ON CLAIRE AT CULLODEN

Of course, that scene helps set up the powerful ending, where Claire is told that Jamie actually survived Culloden and suddenly everything she's believed for two decades is turned upside down. "It's the most extraordinary scene," John says. "They see Geillis, having burned her husband, run into a stone and disappear. Then Claire looks at Bree, and Bree looks at Claire, and they come together. There has been this sort of melancholy until the very last scene, when Claire realizes that Jamie is alive in the past. Then she turns and she looks up at the stones; the sun is coming up and it hits her in the eye. It is like this major realization. He is alive."

"We wanted you to like Brianna and Roger as you see them moving through the wake of Jamie and Claire's love and history. Fort William is part of that wake. We don't want Roger and Bree to be a fun, cute couple. We want them to be steeped supernaturally in the history and see that their love is meant to be, the way Jamie and Claire's was, by where fate is taking them. He innocently takes her to Fort William on a sightseeing thing, but there's other forces at work."

—TONI GRAPHIA

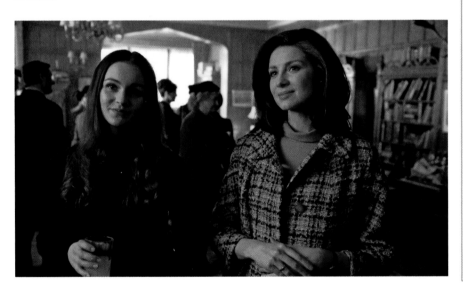

"We tried to make [Claire] a flavor of the sixties, so that if you knew the story and where she came from, the clue was there or, in retrospect, the clue would be there. It's going to echo what we'd already done, because what we've already done was echo the sixties in all her looks. Really, her hair was as much sixties as eighteenth century."

—ANNIE McEWAN

"I think it's a pretty provocative way to end a TV [season]. I've never seen anything like this, where you've not only moved timelines back into the twentieth century but jumped that timeline by twenty years. Claire is twenty years older, with a grown daughter. Simultaneously, Jamie does the tearful farewell to Claire in the eighteenth century to go die, then you learn in the sixties he might have survived after all and Claire wants to go back. It's a head-turning way to end the season. It has the potential to be the best episode of the season."

—RON MOORE

CONCLUSION: LOOKING FORWARD

On June 1, 2016, Starz announced that Claire and Jamie Fraser's adventures on their network would continue, with an official pickup of two more seasons. Season three will cover the plot and characters of Diana Gabaldon's novel *Voyager*, while season four will tell the stories inside *Drums of Autumn*.

Before the entirety of season two's episodes had even aired, Ron Moore, Maril Davis, and their team of writers were already thinking about how to adapt those books and continue to expand the terrain and the spider's web of characters, they will encounter in those tales. With the multiple-year commitment, the work now begins in earnest to break the intricate stories contained within the pages of the books for the realities of television production. It's an adventure the executive producers are more than ready to tackle, for the characters and the show's fans.

"It's been quite an adventure for all of us the last two seasons," Davis reflects. "We've traveled all over Scotland, captured France in all its glory, and suffered through the ravages of war. We're looking forward to the challenges of season three and beyond."

Specifically, Moore explains, "It's interesting, because season three will be unlike the previous two. We have a big story to tell about what happened to Jamie in those twenty years after the Battle of Culloden until he meets up with Claire again. That's a pretty exciting thing to do in a TV series, to age a character that long. A lot of shows will do an individual episode where you jump into the future and do a one-off episode, but this show is going to keep moving. It's really fun to think about how we evolve that character and what it

will be like when the older Claire and Jamie reunite.

"And in season three, we have to decide what's the Claire story, because we cover some ground in season two reserved for season three," Moore continues. "I think we'll see more of her story in the twentieth century, seeing more aspects of her marriage to Frank before his death and how it influenced Brianna's life growing up, so you have the context of who Claire is in 1968. Then we go out to sea and Jamaica! It's an amazing thing. Season three will be, yet again, a whole new *Outlander*."

Of that tease to an exotic change in locale, Davis offers, "We always refer to *Outlander* as a traveling show, because Claire and Jamie rarely stay in one place for very long. Seasons three and four will be no exception. Season three will find us back in Scotland, 1940s

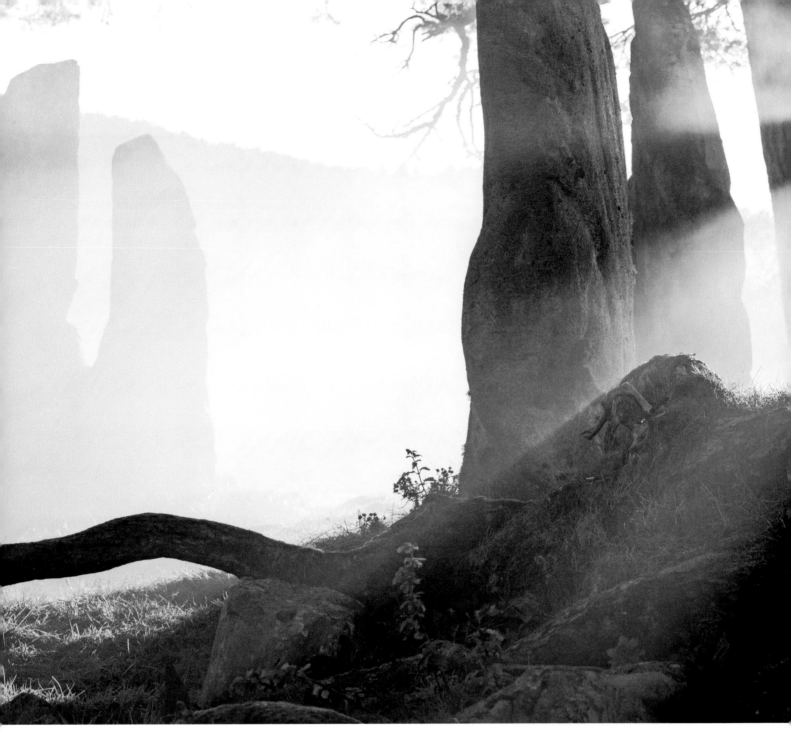

and 1960s Boston, and then on to Jamaica, and come season four, well, I guess you'll have to wait and see! But, like Claire and Jamie, we'll be older and wiser.

"Along with us for the ride is our amazing crew headed by our fabulous producer, David Brown," Davis says with pride. "In a UK system where people rarely stay on one show for more than one season, we take pride in the fact that our crew going into season three is mostly unchanged from the crew that started with us on this journey three years ago. I like to think it's because we serve the best banoffee pie in the UK, but it's more than that. We're a family. We all truly care about each other. And every-one takes enormous pride in their work. We're in the trenches together every day, through thick and thin, mud and rain, and more mud. We've all had to figure out how to make this show together."

Rest assured, the *Outlander* faithful are ready to reunite with the Frasers to see what adventures await.

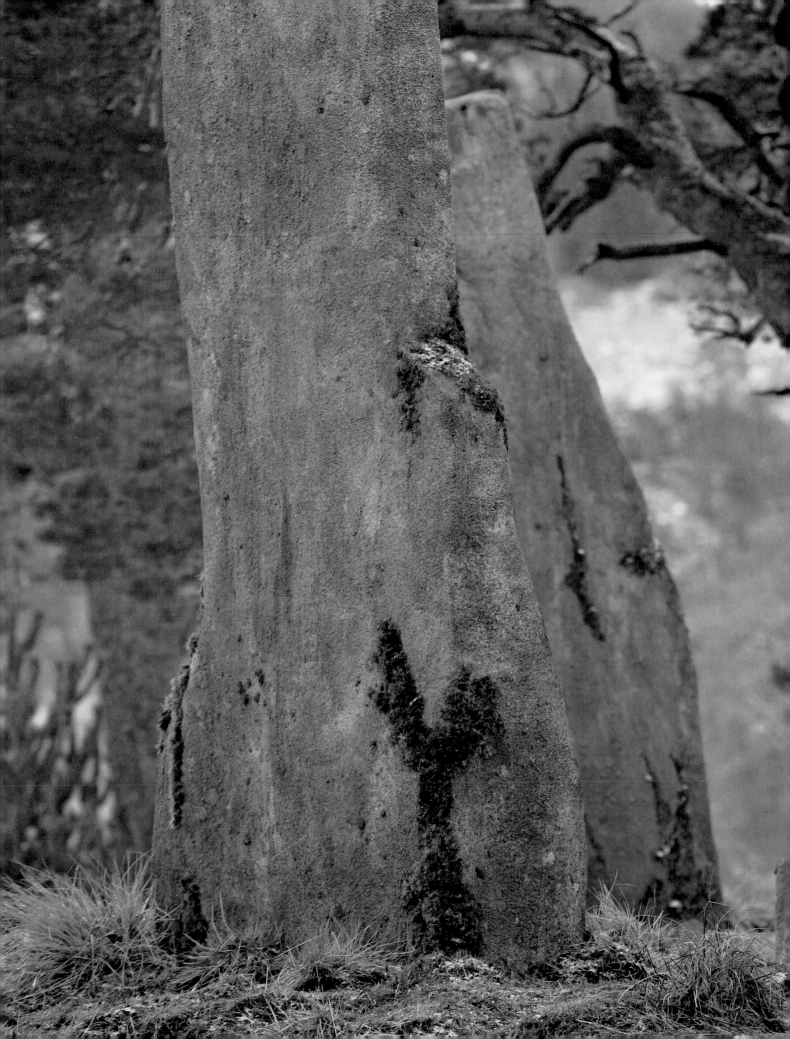

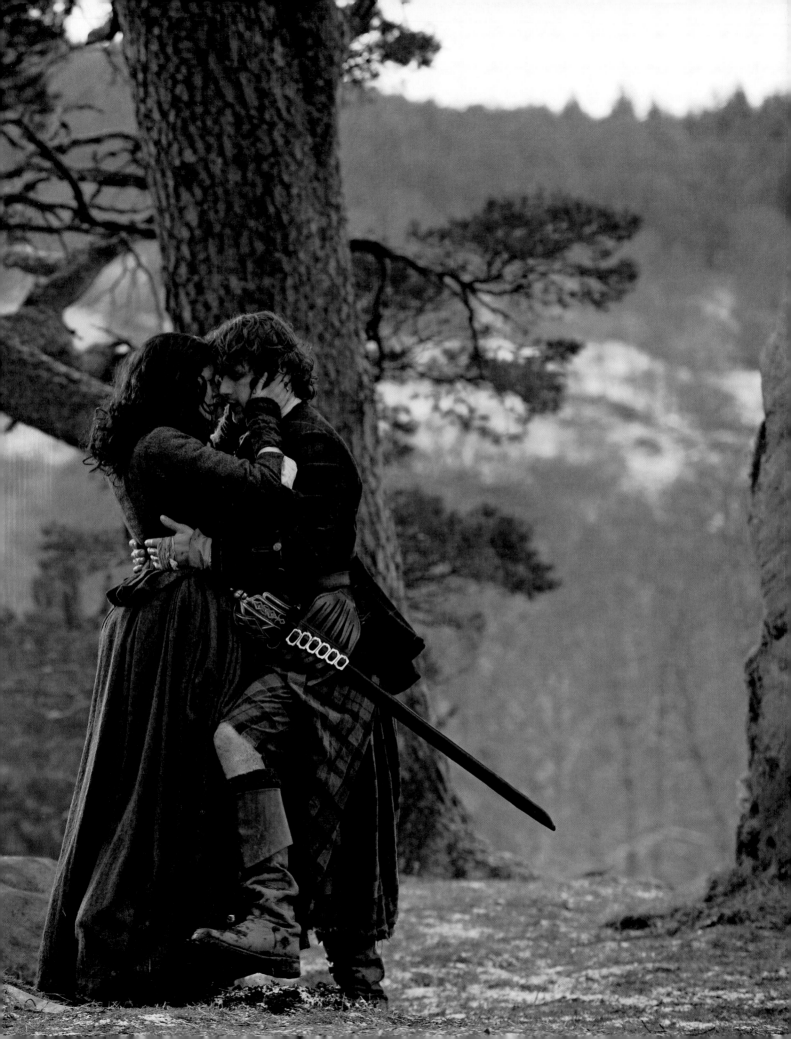